# BESPOKE STYLE

ビスポーク・スタイル

A Glimpse into the World of
British Craftsmanship

長谷川喜美 著
撮影 エドワード・レイクマン

Text by Yoshimi Hasegawa   Photo by Edward Lakeman

Published by Banraisha Co., Ltd.
Kudan Central Bldg. 803, Iidabashi 2-1-4, Chiyoda-ku, Tokyo, Japan 102-0072
http://www.banraisha.co.jp/
E-Mail letters@banraisha.co.jp

BESPOKE STYLE：Glimpse into the World of British Craftsmanship
Copyright © 2016 by Yoshimi Hasegawa and Edward Lakeman
English translation copyright © 2016 by Banraisha Co., Ltd.
All rights reserved. Printed in Japan.

ISBN978-4-908493-03-4

# Contents

**7**     A Brief History of Men's Style
メンズファッションの歴史はスーツの歴史である

18世紀のグランドツアーとスポーツ 9／ダンディズムとジョージ・ボー・ブランメル 12／スーツはパワー（権力）と結びついている 14／エドワード7世とウィンザー公（エドワード8世） 15／スポーツとミリタリーが生んだマスターピース 18／ハリウッドの台頭 20／第二次世界大戦後のメンズファッションの動向 22／イタリアン・パワー 23／ロンドン・コレクション・メンとビスポーク 24

**26**     Classic Masterpieces
物が語るスタイルがある

バブアー インタナショナル・ジャケット 26／ブリティッシュウォーム・オーバーコート 28 オックスフォード・シューズ 30

**32**     chapter one: Tailors
- 32   Henry Poole ヘンリー・プール
- 48   Gieves & Hawkes ギーヴス＆ホークス
- 62   Chittleborough & Morgan チトルバラ＆モーガン
- 78   Thom Sweeney トム・スウィーニー

**92**     chapter two: Shoemakers
- 92   George Cleverley ジョージ・クレヴァリー
- 106   John Lobb ジョン・ロブ
- 122   Foster & Son フォスター＆サン
- 136   Gaziano & Girling ガジアーノ＆ガーリング

**150**     chapter three: Shirtmakers & Accessory Houses
- 150   Turnbull & Asser ターンブル＆アッサー（Shirts シャツ）
- 166   Swaine Adeney Brigg スウェイン・アドニー・ブリッグ（Leather Products & Umbrellas 革製品＆傘）
- 176   Lock & Co. ロック＆コー（Hats 帽子）

**190**     chapter four: Luxury Service
- 190   Berry Brothers & Rudd ベリー・ブラザーズ＆ラッド（Wine & Spirits ワイン＆スピリッツ）
- 204   Floris フローリス（Fragrance 香水）
- 214   Truefitt & Hill トゥルフィット＆ヒル（Grooming グルーミング）

**222**     Bibliography/First Appearances
主要参考文献・初出一覧

"ビスポークBespoke"の語源は（話し合う）という
意味を持つBe-spokenだとされている。
ビスポークによって作られるスーツや靴は、個々に顧客を採寸、
その数値から型紙をおこし、顧客の身体に合わせた数回の仮縫いを経て完成する。
現代において、ビスポークは多くの時間と熟練の職人技を要する、
真に贅沢な実用品だといえる。
かつては王侯貴族のために作られた、最高峰のクラフツマンシップを誇る老舗は、
ロンドンのメイフェアからセント・ジェームズのエリアにかけて集中している。
この土地は深淵な歴史的背景と現在まで続く卓越したクラフツマンシップを継承し、
このような場所は世界中で他に類をみない。
本書はスーツに始まり、靴、シャツ、フレグランスに至るまで、
これらビスポークの製品を作ってきた名店を通して、
世界に冠たるメンズスタイルを築き上げてきたロンドンのビスポークの文化を紹介している。
同時に、その文化を支えている人々、
「ものをつくりだす人々」のドキュメンタリーでもある。
この地に宿る歴史と、人々のもの作りへの飽くなき情熱を、私は敬愛してやまない。
本書を正統なるメンズファッションを愛するすべての方々に捧げる。

The origins of the word 'bespoke' lie in its old meaning of 'discussing',
in the sense that a bespoke product was 'arranged' or 'ordered'. Bespoke-made suits and
shoes involve taking measurements directly from the individual customer,
transforming those numbers into a pattern,
and perfectly forming the resulting product to the client's body through multiple fittings.
Bespoke wear requires many hours of work by talented and experienced craftsmen,
making it the ultimate luxury product.
The area between London's Mayfair and St. James's districts is home to many famous
stores that have proudly served royalty and the nobility with the utmost in craftsmanship.
Given the depth of its history and the resulting legacy of workmanship that continues even today,
it is an area unlike any other in the world.
I would like to introduce you to London's bespoke culture, taking you on a tour of the tailors,
shoemakers, shirtmakers, and perfumeries that have established this city as a
world capital of men's fashion. In particular, I would like you
to get to know some of the men and women who carry on these traditions today.
I have no end of love and respect for the insatiable passion of these individuals,
who embody the history of this area.
I dedicate this book to all lovers of authentic men's style.

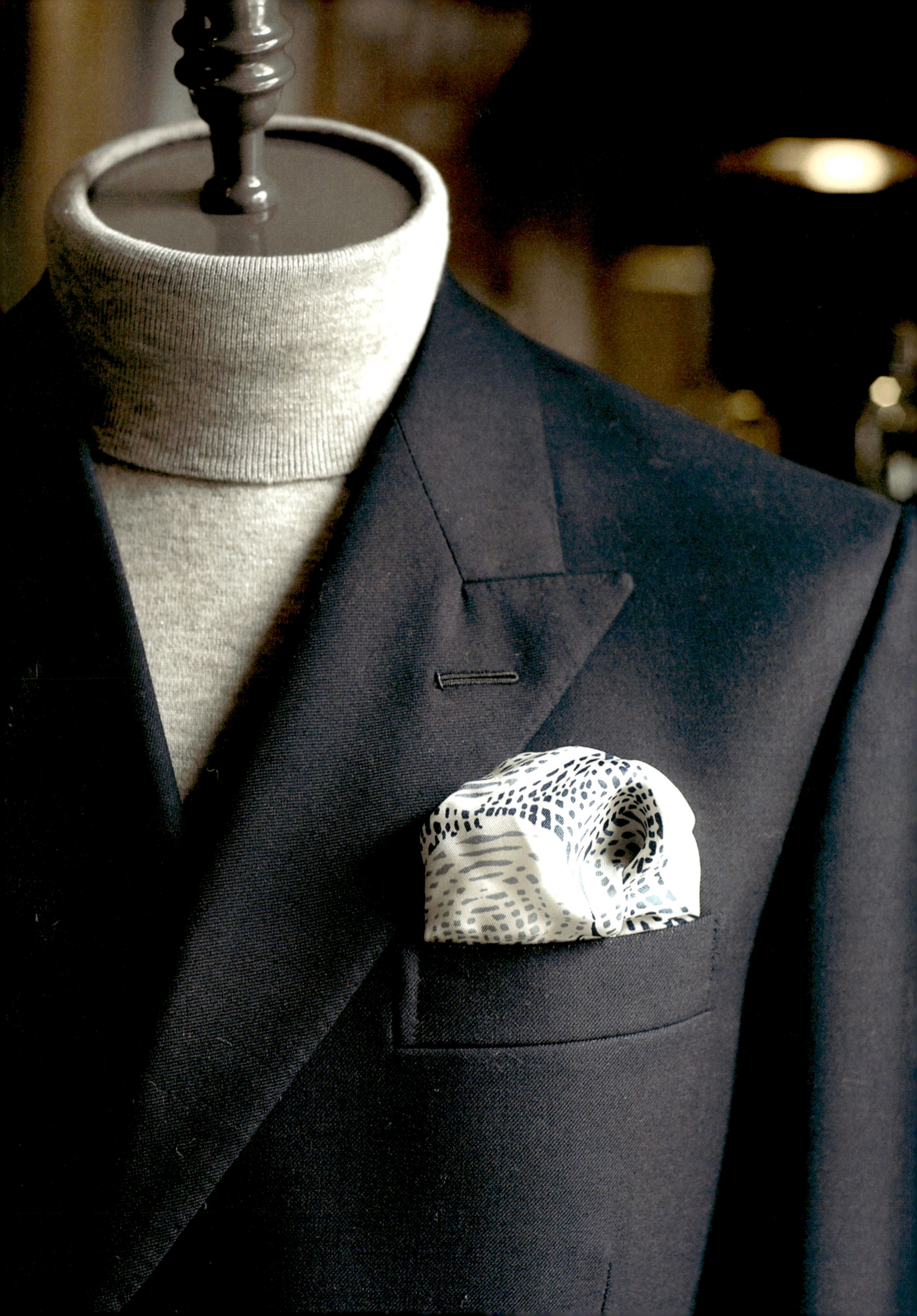

# A Brief History of Men's Style
メンズファッションの歴史はスーツの歴史である

「スーツは現代の男の鎧である」という言葉がある。

かつて女性にとって衣装は自らの商品価値を高めるものだったが、男にとって衣装は戦闘のために存在していた。中世の鎧は体を保護する役割から発展して軍服となり、機能性のみならず、男性の肉体的美点を強調することで戦闘の士気を高めた。

同時に、スーツは20世紀以後の資本主義社会において、社会に参加し、相手に敬意を示す、社会性の証しでもある。これはスーツの本質を表している。

果たしてスーツを着用するのに歴史を知ることは必要なのだろうか？

驚くべきことに、19世紀に完成した男の服装の規範は現代においても大きく変化していない。例えば、男性の上着が右前身頃、つまり左前であるのには理由がある。これは利き手の右手ですぐに剣を抜く事ができるようにといった中世の時代からの名残である。単にスーツの形状ばかりでなく、スーツを着用するためのすべてのルールには意味があり、時代を経てそれは完成された。

かくしてメンズファッションはルールを知ることなしに装うことはできないようになった。厳密な規定の中でいかにオリジナリティーを演出するべきか。そこにメンズファッションの楽しみを語る人は多い。スポーツと同様に、ルールを熟知することでより良いプレイをすることができる。それはファッションについても同じことがいえるのではないだろうか。

すべての答えは歴史の史実の中にある。

例を挙げると、パターンや紋章といった意匠にはそれぞれ固有の意味が存在している。レジメンタルタイや紋章、スクールマフラーなどは軍隊や学校で所属や階級を明確にする目的から生まれた。こうした歴史を知れば、そのルールを無視して、柄だけを模倣し、その団体に属しているわけでもないのに知らずに着用してしまうといった失態は避けられる。

さらにイギリス英語とアメリカ英語では服装に関する呼称が異なることも知っておいたほうが便利だ。イギリス英語ならば、上着は本来ならコート、現代ではアメリ

Some call the suit the modern man's armour.

Women have used clothing to increase their appeal for ages, but until the relatively recent past men's clothing was designed for battle. The armour used in the Middle Ages evolved into military uniforms, which were not only functional but further enhanced morale by emphasizing male physical prowess.

In the capitalist society that developed in the twentieth century, the suit became a social symbol indicating respect to those one wished to do business with. Surprisingly, there is little difference between the norms of the masculine wardrobe as perfected in the nineteenth century and what we are familiar with today. As an example, men's jackets have buttons on the right to better allow right-handed duellists to draw their swords, a relic from the Middle Ages. Not only the form of suits but also the rules for how they are worn have meaning behind them, and these are the result of many centuries of honing and refinement.

This has reached the point to where one cannot properly dress oneself without knowing the rules of men's fashion. The trick therefore comes in learning to express one's originality within those strict provisions. There are many who say that therein lies the enjoyment of men's fashion; just as in sport, where a thorough knowledge of the rules allows for making better plays, the same can be said of fashion. And the key to making good fashion plays lies in its history.

For example, there are many designs such as patterns and coats of arms that have specific meanings. Regiment ties, crests, school scarves, and the like came from the need to show associations and ranks in schools and the military. Knowing such history allows one to avoid faux pas such as implying association with a group to which one does not belong.

It is also worth knowing some differences between

カ英語のジャケットでも通用する。現在でもスーツとして着用しない、単体で着用するべく作られた上着はイギリスではスポーツコートと呼ばれている。サヴィル・ロウのテーラーでは上着を担当する職人は伝統的にコートメーカーと呼ばれている。アメリカ英語のベストはイギリス英語ではウェストコート、同様にサスペンダーはブレイシス、タキシードはディナースーツとなる。日本ではどちらを語っても自由だが、スーツの起源がヨーロッパにあり、テーラリングの本流が英国と認識されているのは動かしがたい事実だ。

まず、はじめにスーツとは何かということから始めよう。通説では、1660年に王政復古を果たしたチャールズ2世の時代に、現代のスーツの基本となる上着、ウェストコート、トラウザーズ（日本でいうパンツ・当時は足にぴったりした形のブリーチズを履いていた）の3点セットが登場したとされている。

この時代は太陽王ルイ14世がフランスを統治し、フランスの宮廷文化が最盛期にあった。当然ながら服飾文化においてもフランスが最先端にして最高のレベルを誇っていたが、19世紀に入ると様子は一変する。1798年にフランス革命が起こり、ルイ16世が処刑され、それまでの華美な服飾文化は終焉を迎えた。フランスはその後もナポレオンによる共和制、さらなる革命、ナポレオンの失脚と情勢不安の時期が続き、男性服飾文化の中心は国際政治の中心となりつつあった英国へ移った。同時にこの時期に起こったダンディズム思想はそれまでメンズファッションの中心であった華やかな宮廷文化を否定し、新たな価値観による男性服の規範が生まれた。こうして現代の紳士服の基礎がほぼ確立される。

また、あらゆるファッションはドレスダウン、カジュアル化の歴史である。現在はジーンズがワードローブの重要な位置を占め、必要でない限りはジャケットを着用しない、タイを締めないなど、カジュアル化が著しく進んでいると嘆く人も多い。しかし、それは昔から変わらないファッションの一大傾向だ。その証拠に、フランス革命で否定された貴族のニー・ブリーチズは革命派のサン・キュロット（貴族が着用していたハーフ・キュロットではないという意味の造語。現在のトラウザーズ）にとって代わり、宮廷服のカジュアル仕様であった〝ディットーズ〟と呼ばれた上下同じ生地を使用した三つ揃いのスーツと燕尾服のカジュアル仕様であったディナースーツは現在では準正装の位置にある。

18世紀の宮廷ファッション、ベルベットの上着にぴっ

clothing-related terms in British and American English. For example, what the British call 'coats' Americans call 'jackets', while in England a coat designed to be worn without a suit is called a 'sports coat'. This is why Savile Row tailors specialising in such items are called 'coatmakers'. The British waistcoat is known in America as a 'vest', braces are 'suspenders', the dinner suit is a 'tuxedo', and jumpers are 'sweaters'. Incontrovertible, however, is the fact that the suit has its origin in Europe, and the mainstream of tailoring is in England.

Let us begin by considering just what a suit is.

The prevailing view is that the three core features of the modern suit—coat, waistcoat, and trousers (as opposed to skin-tight breeches)—first appeared in the era of Charles II, under whom the English monarchy was restored in 1660.

This was the era of 'Sun King' Louis XIV's reign, the heyday of court culture in France. France was of course for many years the cutting edge of fashion, but everything changed at around the start of the eighteenth century. France underwent revolution in 1798, and Louis' execution signalled the end of grandiose fashions. France went on to experience becoming a republic under Napoleon, another revolution, Napoleon's downfall, and continued unrest, all of which helped to shift the focus of international politics to England. The ideals of 'dandyism' that were arising there were a rejection of ostentatious court culture and a redefinition of the values underpinning men's fashion. In this way, the foundations of modern style were largely established in the nineteenth century.

Modern fashion has seen a trend toward the casual; fashion purists lament how blue jeans have become a vital wardrobe item, jackets are worn only when necessary, and ties have in many cases become optional attire. However, we must keep in mind that such casualisation has always been a significant influence on the history of fashion. Consider, for example, how the culottes (knee britches) worn by the nobility deposed in the French Revolution became symbolic for the sans-culottes revolutionaries.

What arose to replace court fashion were the more casual three-piece suits and tailcoats—remarkable in that they were each cut from the same cloth—that

たりしたサテンのブリーチズはウールのラウンジスーツへと主役の座を明け渡した。夜のイブニング・テールコート（燕尾服）がディナージャケットに代わり、昼間のモーニングコートやフロックコートはスーツへと代わった。このようにカジュアル化はいつの時代にも絶え間なく起こっている。

現代のドレスコードはカジュアルになったとはいえ、最低限のルールは厳守されている。モーニングコートは今でも結婚式、アスコット競馬など上流階級の集まり、外交儀礼のときに着用される。ドレスコードに〝ホワイトタイ″とあれば、ホワイトのボウタイとテールコート、〝ブラックタイ″とあれば、ディナージャケットにブラックのボウタイを着用する。ダークネイビーのスーツに黒のボウタイがあれば、ディナースーツとして代用もできる。〝ラウンジスーツ″とあれば、ダーク系のスーツ、シャツは白、タイもダーク系でフォーマルに装うことができる。

## 18世紀のグランドツアーとスポーツ

18世紀、英国では貴族の子弟がヨーロッパへ修学に行くグランドツアーが盛んに行われた。フランスを経由してイタリアに渡り、古典的教養とルネッサンス文化と美術を学ぶことが目的の異文化交流は、メンズファッションにふたつの大きな功績を残した。

ひとつめはイングリッシュ・テーラリングをイタリアに伝播したことである。英国と極端に気候の異なるイタリアで、自分たちが英国で作らせたツイードやフランネルの代わりに、イタリアのテーラーに自分たちのスーツを与えて、同様のものを作らせた。こうして実際のスーツから仕立てを学んだため、特に南部ナポリでは型紙を重視せず、フィッティングで調整する仕立てが発達したと説く人も多い。

一方、英国が学んだのはフランスやイタリアの鮮やかな色彩感覚と装飾的ディテールだった。フランス宮廷の影響を受けた高い鬘、極彩色の上着、レースのクラヴァット、飾りのついたニー・ブリーチズとバックルやリボンがついたヒール付きの靴を履いた彼らは、当時、〝マカロニ族″と呼ばれた。このときすでに、メンズファッションの世界では英国、つまりアングロファイル（イギリスびいき）が世界を席巻し始めていたが、この後に登場するボー・ブランメルに代表される〝ダンディズム″とこの頃から貴族の間で流行し始めた〝スポーツ″がこの傾向に拍車をかけた。

現代においても、ヨーロッパの上流階級の馬文化に

became the semiformal dinner wear of today. The velvet jackets and skin-tight satin breeches that were the height of eighteenth-century court fashion made way for woollen lounge suits. The tailed coats that were worn as eveningwear became dinner jackets, and the morning coats and frocks worn during daytime became suits. There is thus a long history of the 'casualisation' of fashion throughout the ages.

Even so, while the dress code of today is more casual than in the past, there remain some strictly enforced rules. Morning coats are still worn at wedding ceremonies, at meetings of the upper class such as the Royal Ascot, and as a matter of diplomatic protocol. One wears a white bowtie and tailcoat to a 'white-tie affair', and a black bowtie and dinner jacket to a 'black-tie' one. A dark navy suit and black bowtie can at times substitute for a dinner suit. Formal dressing in a lounge suit calls for a dark suit, white shirt, and dark tie.

## The Grand Tour and equestrian sport

During the eighteenth century it was popular for the children of nobles to take the 'Grand Tour', where they would learn something of Europe by heading to Italy via France, experiencing classical and Renaissance liberal arts and culture along the way. This custom had two major impacts on men's fashion.

One was a passing on of British tailoring techniques to Italy. The climates of England and Italy are quite different, so the British tweeds and flannels of the Grand Tourists needed to be replaced. To do so, they would give their suits to Italian tailors and order new ones of a similar design. It is widely claimed that Italian tailors thus learned suit-making from actual suits, so that in southern Naples in particular a tailoring style that emphasized fittings over patterns developed.

England in turn learned about the vivid colour palettes and decorative details of France and Italy. Influenced by French court fashions, some youths developed preferences for tall wigs, varicoloured jackets, lace cravats, decorated knee britches, and heeled shoes with buckles and ribbons. By the late 1700s they were collectively referred to as 'macaronis'. By this time Anglophiles were already coming to dominate

対する憧憬は高級スポーツカー以上のものがある。馬は貴族の中で最上級の趣味とされてきた。彼らの最高の夢は著名なレースで勝つ競走馬をもつことなのは今も昔も変わらない。その証拠に英国王室も競走馬を所有しているし、1711年にアン王女によって始まったロイヤル・アスコット・レース・ミーティングは、英国王室が主催して現在まで続いている。観客席は幾つかのカテゴリーに別れているが、最上級のロイヤル・エンクロージャーではドレスコードは厳守であり、守らない場合は退場の措置が取られる。男性はモーニングとトップハット、または最上級の正装として軍服の着用が義務づけられている。このドレスコードの厳格さは有名で、皇太子であった頃のウィンザー公がグレーのモーニングを着用したところ、父である国王ジョージ5世に叱責され、お抱えのテーラー「ショルティ」にブラックのモーニングを1日で作らせた逸話さえ残されている。

馬とスポーツに代表される英国貴族のライフスタイルは英国のみならず、ヨーロッパ諸国からも憧憬の対象だった。馬具商であった「エルメス」や「グッチ」が今日までラグジュアリーブランドとして君臨しているのも、こうした乗馬文化が代表するハイソサエティーなイメージの効果がいかに絶大であるかを語っている。

乗馬はイメージばかりでなく、機能面でもメンズファッションに重要な貢献を果たした。乗馬服の影響は今日のスーツのディテールに多く残されている。例えば、乗馬服に由来する仕立ての技法〝ハイアーム〟は馬の手綱を握る際に腕を伸ばしやすいように乗馬服の袖の付け根を高い位置に取りつけることをいう。この技法は「アンダーソン&シェパード」や「エドワード・セクストン」など多くのテーラーで用いられている。前見頃の裾のカーブは馬上で動きやすいようにラウンドにカットしたことに由来し、これはシングル・ブレスティッドのジャケットのスタイルとして定着している。「ハンツマン」など老舗のビスポークハウスでは馬の鞍(くら)の模型があり、そこに跨(またが)った姿勢で採寸する伝統もここに由来している。

英国貴族のファッションやライフスタイルが注目されるにつれ、乗馬服だけでなく、ツイードのスポーツコートといったスポーツ用衣類も重要視されるようになった。

狩猟、乗馬といったスポーツは彼らの生活の中で欠くべからざる要素であり、当時の貴族の重要な義務と言えば、〝ノブレス・オブリージュ noblesse oblige（高貴な義務）〟といった言葉に象徴される戦争であった。メンズファッションの原型であるスーツはひとつは乗馬服、もうひとつは軍服から、こうした背景により大きな

international men's fashion, a trend that was further advanced with the later appearance of the 'dandies', as represented by Beau Brummell, and an increasing interest in sport among nobles.

Even today, the upper crust of Europe seems to love horse racing even more than high-end sports cars. Horses came to be seen as the ultimate hobby for nobles, and—as remains true today—the ultimate dream was to own a horse that won a prestigious race. Even the British Royal Family owned a race track, established in 1711 by Queen Anne, and the Royal Ascot Race Meeting has been a Royalty-sponsored event ever since. There are various levels of viewer seating, but in the most exclusive Royal Enclosure there is a strict dress code; failure to adhere will result in refusal of entry. Men are expected to wear morning coats and top hats or—as the ultimate in formalwear—a military uniform. The Royal Ascot is famous for its enforcement of this dress code; one famous tale is that when he was still a prince the Duke of Windsor showed up in a grey morning suit, resulting in a severe scolding from his father King George V and his personal tailor Frederick Scholte having to create a black one in just one day.

The British nobility's horse- and sport-centred lifestyle and fashion sense spread beyond national borders to become idolised throughout Europe. The continued status of luxury brands like Hermès—which started as a harness maker—and Gucci are good examples of the effects of equine culture's association with high society.

Horse riding has lent not only its image, but also made vital contributions to the functional aspects of men's clothing. There are many details of today's suits that come from riding clothes, an example being the tailoring technique known as the 'high arm' where armholes were made higher to facilitate holding a horse's reins. Many tailors have adopted this style, including Anderson & Sheppard and Edward Sexton. The hems of front panels were cut round to facilitate easier movement on horseback, a style that remains present in single-breasted jackets. Bespoke houses such as Huntsman still keep saddle models in their stores to allow taking measurements of clients on horseback.

As the fashions and lifestyles of British nobility

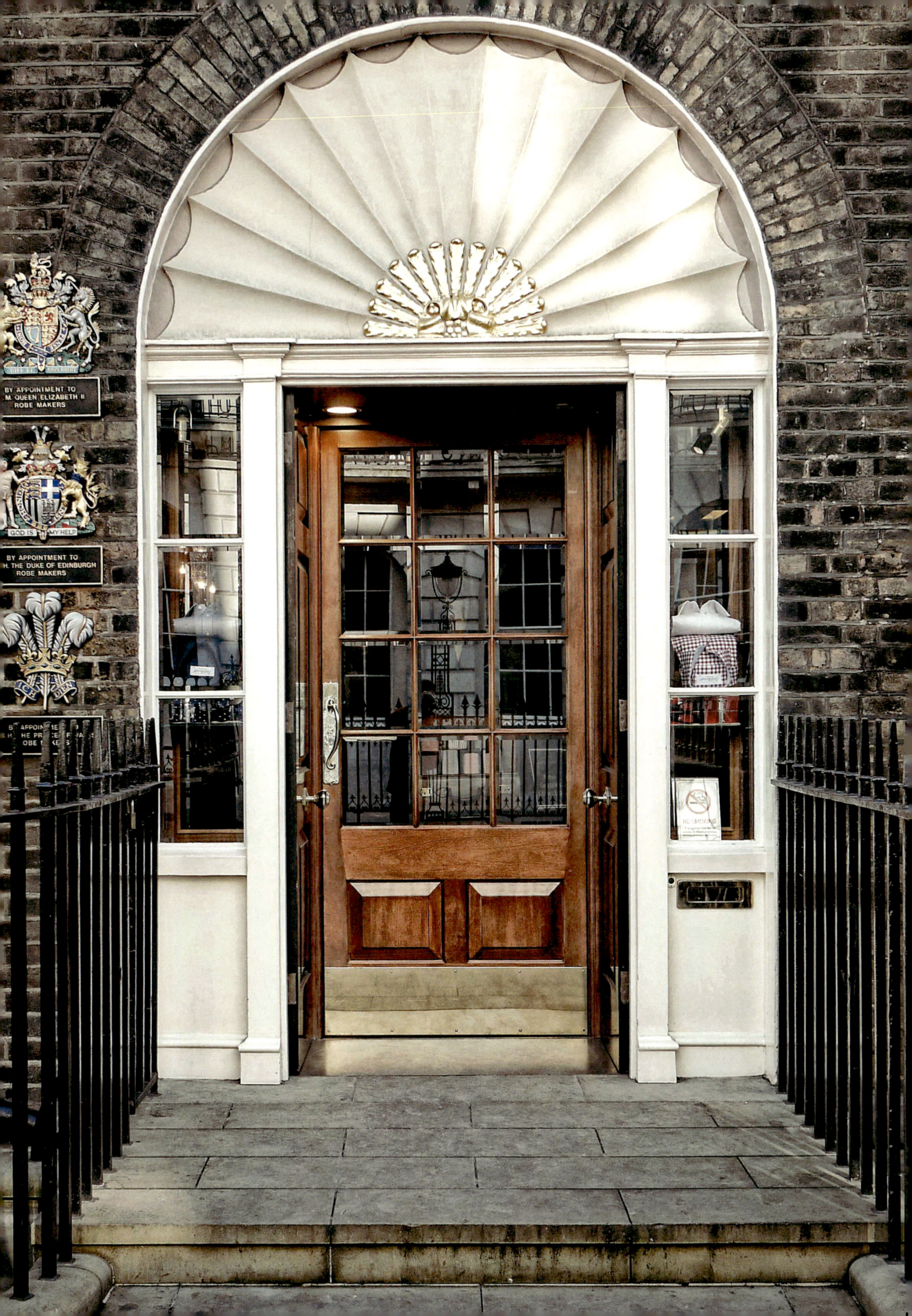

発展を遂げた。

## ダンディズムとジョージ・ボー・ブランメル

　ファッションには時代を牽引するスターが存在する。
　フランス革命から生まれた宮廷文化や貴族文化の否定は服装のカジュアル化、大衆化を促し、その結果、新たな価値観であるダンディズムが生まれた。ダンディズムは社会性や倫理感、人間はどう生きるべきかといった他の思想論とは一線を画し、衣服や身なり、立ち居振る舞いを終始一貫して説き、時代に名を残したという点でも非常にユニークだ。
　享楽好きで知られた国王ジョージ4世（在位1820－30）が皇太子（プリンス・オブ・ウェールズ）であった摂政時代、オックスフォード大学で彼の学友だったジョージ・ブライアン・ブランメル（1778－1840）は、社交界でボー（伊達男）・ブランメルと呼ばれたメンズファッションの先駆者のひとりである。貴族といった特別な出生や肩書きを持たず、生まれ持った洗練されたセンスと

increasingly became a focus of attention, not only riding outfits but also sporting clothes like tweeds and sport coats became popular. Sports such as hunting and riding became central elements of the noble lifestyle, alongside the noblesse oblige of participating in warfare. It is from this that the suit, the archetype of men's fashion, derives from the twin heritages of equestrian outfits and military uniforms.

## Dandyism and George 'Beau' Brummel

As discussed, the French Revolution resulted in a rejection of court and noble cultures, instead promoting a casualisation and popularisation of attire. The result was a new sense of fashion values in the form of dandyism. Unlike ideologies that focused on concepts such as social responsibility, ethics, or how one should live one's life, dandyism is unique in that it emphasised clothing, manners, and deportment.

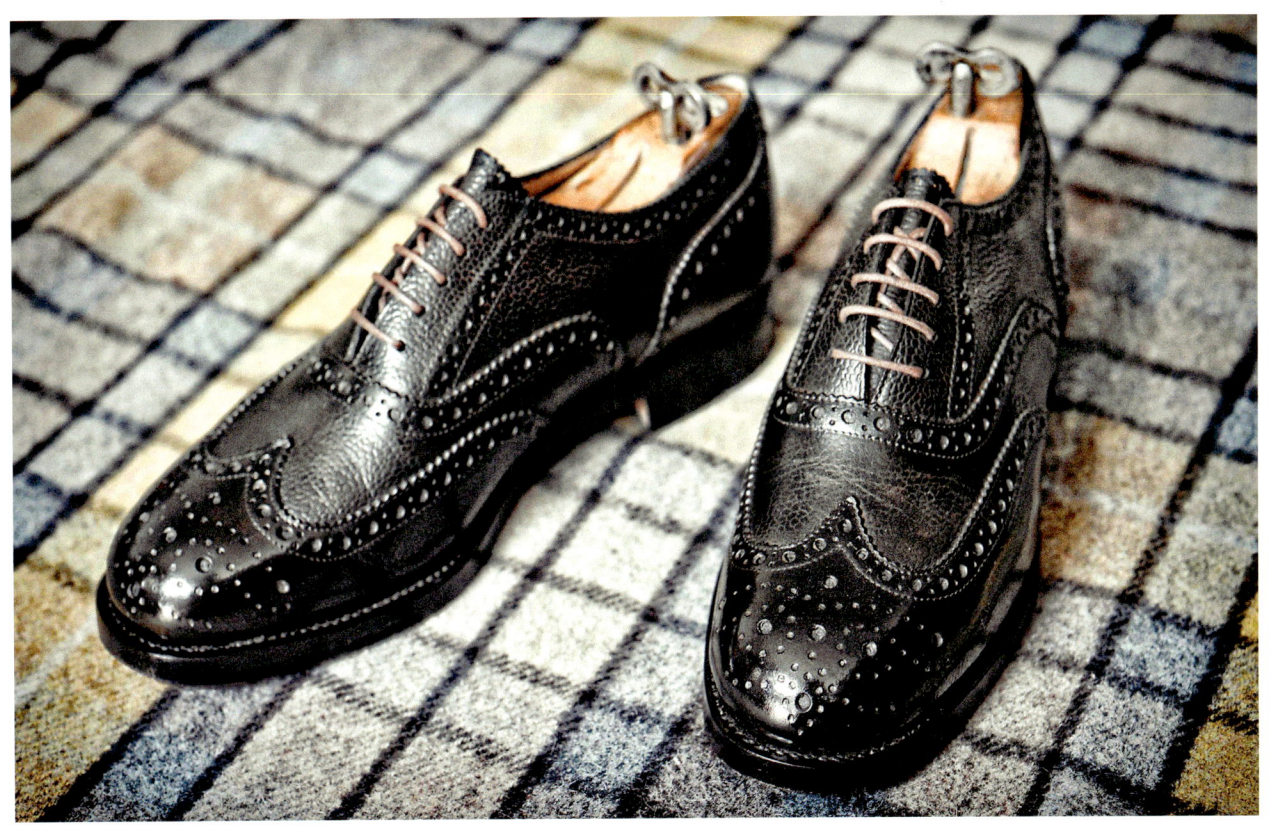

ウィット、優雅な立ち居振る舞いがジョージ4世に認められ、時代のスターとなった。ブランメルはグレーや黒、紺といった控えめな色彩を好み、洗い立てのシャツなど清潔で手入れの行き届いた衣類を身につけ、ネクタイの結び方などディテールで個性を表現した。ネクタイの結び方に腐心するあまり、床いっぱいのネクタイの山を築いたエピソードもある。劣悪な衛生事情の緩和策としてフランス宮廷で流行していた香水を使わず、毎日入浴して髭を剃った。宮廷文化を代表する半ズボンから今日の原型となった黒のトラウザーズを着用したのもブランメルだった。「道で人が振り返るなら、その着こなしは明らかにやり過ぎている」としたブランメルは服装に充分に注意を払うが、一度着用したらあくまで無意識に徹すべきだと説いた。人から自意識過剰と思われたり、自分から目立つ行動をするのは美学に反する。英国男性の服飾の美学の中にある、万事控え目を美しいとする〝アンダーステイトメント understatement〟の精神はこのときに確立されたに違いない。

　それまで宮廷がリードしていた流行はフリルを多用し

During the regency of the notoriously pleasure-seeking King George IV (r. 1820–1830), when he was still known as the Prince of Wales, he became friends with University of Oxford classmate George Bryan 'Beau' Brummell (1778–1840). While he had no status as a noble or position of note, Brummel had a natural refined sensibility and wit that even the Prince Regent could not resist, making him a luminary of the age. Every now and then a star emerges to nudge fashion into a new era, and Beau Brummell was just such a man.

Brummell preferred subdued colours like blacks, greys, and navies, wore only freshly laundered and well-maintained shirts, and expressed his individuality in details like how he tied his ties. He was so fastidious about his ties, in fact, that there are stories of him leaving mountains of failed attempts at getting them just right. He used no perfumes—a vogue that had arisen due to the poor hygiene of the French court—but

たカラフルで華美な服装に、鬘に化粧など、特に男女の差は見られなかった。首相小ピットによる白粉への課税政策が追い風となり、ブランメルの登場とダンディズム以後、メンズファッションは華やかさと新しさを競う女性のファッションとは明らかに異なるものとなった。

当のブランメルの生涯といえば、裕福な家族からの相続財産を衣装と社交に費やし、賭博と遊興に明け暮れた結果、債権者から追われフランスへ逃れ、非業の死を遂げた。しかし、このときに形作られた男の服装に対する美学は今日までジェントルマンの装いにおける規範として受け継がれている。

ところで、"ダンディー"という言葉で注意しなくてはならないのは、もう一人のダンディズムを代表する唯美主義作家オスカー・ワイルド (1854-1900) の存在である。彼はブランメルが推奨した美意識とは正反対の価値観を打ち出した。男性の服飾も華やかな色彩や形態で個性を主張すべきだとして、ベルベットの上着やカラフルなネクタイ、ウェストコートを用いてブランメルの説いた価値観に対抗したのだ。今日、英語圏の人々にとって「ダンディー」という言葉で想像されるのは、オスカー・ワイルドが提唱した華美な服装や奇異な行動で周囲の注目を集めたいと望む男のイメージだとする人が意外に多い。そればかりか「ダンディー」といえば1967年に起こり、男性の服装に鮮やかな色彩を持ち込んだ「ピーコック革命」を想い起こす人も稀ではない。ブランメルの服装哲学は紳士服の規範となったが、それがなぜか現在の英語圏ではダンディズムとして認識されてはいない。反対に「ジェントルマン」は今日でも男の規範とされている。つまり、日本ではダンディーとジェントルマンはほぼ同義語として使われているが、英語圏では同義語ではない。ファッションに関する日本独特のカタカナ英語は便利だが、実は諸刃の剣となる危険性も秘めている。

## スーツはパワー（権力）と結びついている

ヨーロッパのハイソサエティーは英国王室を頂点に築かれ、現在もそのヒエラルキーは変わっていない。時代の変遷につれ、インド、ロシア、中国と新たな国が台頭してきても、英国の首都であるロンドンは金融と政治の力に裏打ちされた権威の象徴であり続けている。

18世紀以後、今日のテーラリングの基礎が確立された時代、英国のテーラー、特にサヴィル・ロウは王侯貴族といった特権階級を顧客に持っていた。彼らには

instead bathed and shaved daily. It is due to Brummell that today we wear trousers rather than the shorts of the French Court.

While Brummell asserted that a gentleman should never 'attract observation in the street by his outward appearance', he also stressed that what one did wear, one should wear well. To behave in a manner that drew attention or made one appear self-conscious was a violation of aesthetics. Herein lies the establishment of British values for the importance of 'understatement' in men's style.

Fashion became highly androgynous under the influence of the French court, featuring wigs, makeup, and frilly, colourful shirts. Aided by a tax on wig powder imposed by Prime Minister Pitt the Younger, men's fashion after Brummell and the rise of dandyism became highly distinct from women's fashion, which remained a competition of novelty and opulence.

In the end, Brummell squandered his inheritance on clothing, social events, gambling, and entertainment, and escaped a violent death at the hands of his creditors only by fleeing to France. Even so, the aesthetics for men's attire that he established remain today as norms for what gentlemen wear.

It is curious that the meaning of 'dandyism' changed over time, likely through its association with author Oscar Wilde (1854-1900). Wilde stood in direct opposition to the aesthetic sense of Brummell, holding that a man's attire should express his character through its palette and form. He wore velvet jackets and colourful ties and waistcoats that refuted Brummell's sense of values in every way.

Today, the word 'dandy' conjures images of this latter type; to most, a dandy is one who affects an ostentatious style and engages in outrageous attention-attracting behaviour in the manner of Wilde. A dandy today is one who actively seeks the attention of others. Some likely even associate dandies with the 'Peacock Revolution' of the 1960s, when colourful men's clothing made a revival. So while Brummell's philosophy of style set the standards for men's clothing today, for whatever reasons it is no longer generally recognised as dandyism, but rather the standard for gentlemen to follow. Indeed, calling one a 'gentleman' is a sign of

当時最高の技術が要求され、これがクラフツマンシップの発展につながった。さらに全世界の４分の１の人口を支配していた大英帝国を支えた大規模な軍隊の受注と世界最大規模の王室の受注、このふたつの膨大な受注はサヴィル・ロウに繁栄をもたらした。

　スーツが象徴するものは資本主義と社会性だ。政治と金融の発展する大都市にテーラリング文化は栄えてきた。ではなぜ、イタリアではナポリでテーラリングが発展してきたのか？　興味深いことに、ヨーロッパの一大財閥である初代ロスチャイルドが銀行家として成功した後、５人の息子に支店を経営させるため選んだ都市が、本店フランクフルトに加え、ロンドン、パリ、ウィーン、ナポリだった。かつて金融におけるイタリアの拠点はナポリにあったのだ。現在の金融の中心はマーケットのあるロンドンのシティとニューヨークのウォール街となった。第二次大戦前にフランクフルト、ウィーン、ナポリのロスチャイルド一族はすべて断絶し、一方、パリとロンドンでは世界の富を掌握した一族として歴史に名を残している。

　19世紀には現代の紳士服の代表であるスーツの原型が、燕尾服などの略式化された形、全部が共布である〝ラウンジスーツ〟として完成した（ラウンジとは「リラックスする」の意味）。ここに上着、ウェストコート、トラウザーズの基本形が完成する。

　19世紀中頃にはネクタイとハイカラーのシャツ、靴（ブーツ）やトップハット、手袋、ステッキといった付属品も重要な服装の一部となった。

　同時に、ネクタイにも変化が表れた。糊付けされた堅いネクタイはスカーフ状のものとなり、現在の結んで下げるネクタイ、フォーリンハンドや、イギリスのアスコット競馬場に由来するアスコットタイが昼間の礼装用として登場した。

　帽子は燕尾服にはトップハット、スーツには山高帽（コークハット、またはボーラーハット）、夏にはボーターハットが登場した。またハンティング用にはハンティング・キャップが用いられた。スーツに加えこの当時から帽子の形態もほとんど変化していない。

## エドワード７世とウィンザー公（エドワード８世）

　20世紀初頭は英国王室のふたりの王、エドワード７世（在位1900－1910）とエドワード８世（在位1936年１月から12月まで11ヵ月、後のウィンザー公）がメンズファッションの中心人物となり、その着こなしに全

praise, while the term 'dandy' is likely to cause insult.

## The relationship between suits and power

　The British Royal Family reached the apex of European high society, and even today that hierarchy remains largely unchanged. While the current era is continually evolving with the increased affluence of places like India, Russia, and China, London remains solidly ensconced as a symbol of financial and political power.

　Since the eighteenth century, the era when the foundations of modern tailoring were established, privileged classes like royalty and the aristocracy have been patronising British tailors—those along Savile Row in particular. Such customers demand the utmost in quality and technique, which led to further improvements in craftsmanship. Continued prosperity was ensured through orders from the extensive British Royal Family and for uniforms for the military forces of the British Empire, which at its peak ruled over one quarter of all persons on the earth.

　The suit is a symbol of capitalism and society, so the culture of tailoring tended to flourish in large cities where politics and finance were most developed. It is therefore interesting to consider that it was Naples that became the centre of Italian tailoring that it did. Interestingly, after succeeding as a banker, the first-generation Rothschild, Izaak Elchanan, entrusted his five sons with management of banks in the five major financial centres of the time, which were Frankfurt, London, Paris, Vienna, and Naples. The Frankfurt, Vienna, and Naples branches of the family died out before World War II, but those in Paris and London left their mark as some of the wealthiest families in history.

　The template for the modern suit arose in the nineteenth century as a simplified form of the tailcoat, and came together in the common three-piece ensemble of jacket, waistcoat, and trousers as the 'lounge suit'. The necktie and high-collared shirt appeared in the mid-nineteenth century, as did accessories like shoes (boots), top hats, gloves, and walking sticks.

　The necktie too has evolved. What began as stiff,

世界の注目が集まった。このふたりの王に共通するのはいずれも遊び好きで社交家のプレイボーイとして知られ、親であり厳格で知られた模範的君主ヴィクトリア女王（在位1837－1901）とジョージ5世（在位1910－1936）に対し、従来の規範を破り、ファッションによって反抗したことだ。王族でありながら革新的であり、やることすべてが新しい洒脱な着こなしとして大衆に受け入れられた。

　エドワード7世は遊説の際に、雨が降っていたことから、裾が汚れないようにトラウザーズの裾を折り返した。これが今も残る男性のトラウザーズのダブル幅の始まりである。また享楽的な生活の代償として、ウェスト周囲がきつくなったため、ウェストコートの一番下のボタンを外したことが流行となり、現在でもウェストコートの一番下のボタンはとめないルールとなって定着している。

　〝ノーフォーク・ジャケット〟（ツイード地でベルトがあり、フロント2箇所とバック1箇所にボックスプリーツがあるのが特徴）も、エドワード7世がサンドリンガム宮殿で狩猟の際、愛用していたジャケットに由来している。英国王室のプライベート・レジデンスであるサンドリンガム宮殿はノーフォーク州にあり、その名前で呼ばれるようになったのだ。

　アメリカ英語で〝タキシード〟、英語で〝ディナージャケット〟を作ったのもエドワード7世である。当時、テールのある燕尾服着用を義務づけられていたが、1860年、サンドリンガム宮殿のディナーパーティーでイブニング・コートのテールをカットしたデザインを「ヘンリー・プール」に注文した。ディナーの後、シガーを楽しむためのスモーキングルームで着用する〝スモーキングジャケット〟にテールがないことから、その発想を得たとされている。このパーティーに出席していたアメリカ人のジェームス・ポッターが、ニューヨークの「タキシード・クラブ」で着用した〝ディナージャケット〟は大きな評判を呼び、こうして〝タキシード〟の名がアメリカで定着した。

　グレンチェックに格子柄（一般的にはブルー）を施したプリンス・オブ・ウェールズ・チェックはエドワード7世が皇太子時代にお気に入りの柄であったことからこの名が付いたものだ。後に彼の孫であるエドワード8世も愛用し、彼が着用したダブルブレスティッドのスーツにベレー帽の写真はファッション史に残る一枚として人々の記憶に残っている。

　エドワード8世、後のウィンザー公は離婚歴のあるア

starched cravats became the softer, scarf-like tie we know today as daytime formalwear, in the form of the modern four-in-hand and British Ascot, which takes its name from the previously discussed racetrack.

The top hats that went with tailcoats became bowlers and summertime boaters, and hunting caps were worn when hunting. The hats developed in those eras remain largely unchanged today.

## Edward VII and the Duke of Windsor (Edward VIII)

In the early twentieth century, two kings—Edward VII (r. 1901-1910) and Edward VIII (r. Jan–Dec 1936)—were the international focus of attention in men's fashion. Unlike their strict parents, the exemplary monarchs Queen Victoria (r. 1837–1901) and King George V (r. 1910–1936), both were known as socialites and playboys, and fashion was one way in which they rebelled against traditional norms. Refreshingly innovative despite being members of the royalty, every novel fashion they adopted rapidly became a new trend among the masses.

As an example, Edward VII was noted for folding up his trouser bottoms to prevent them from becoming soiled in poor weather, making turn-ups fashionable. Edward started leaving the lowermost button of his waistcoat unbuttoned as his hedonistic lifestyle waistline expanded his girth, and this too became the fashion, leading to another fashion trend and present-day rule for dressing. The 'Norfolk jacket', a belted tweed jacket characterised by two box pleats on the front and one on the back, comes from his attire when hunting at Sandringham House, a private residence of the Royal Family located in Norfolk.

Edward VII is also credited as creator of the dinner jacket, or 'tuxedo' as it is called in the United States. In 1860 it was customary to wear tailcoats at formal occasions, but Edward ordered from tailors Henry Poole & Co. an evening coat with drastically shortened tails, reportedly to wear as a smoking jacket while enjoying an after-dinner cigar. New York millionaire James Potter saw this new style while attending a party at Sandringham and imported it to the States. This new

メリカ人シンプソン夫人との結婚が起因となり、わずか11ヵ月で王位を退き、王冠をかけたロマンスとして世界中の関心を集めた。この政治的失脚劇からウィンザー公は頻繁に世界を外遊するようになり、ブリティッシュ・メンズファッションの偉大なアンバサダーの役割を果たした。

ウィンザー公お気に入りのテーラーがサヴィル・ロウの「ショルティ」である。オランダ人のフレデリック・ショルティはミリタリーテーラー「ジョンズ・ベッグ」でヘッドカッターをつとめ、軍服の仕立てを一般のスーツに応用した。ソフトショルダー、軽い構造、肩からウェストにかけての入念なアイロンワークとカット技術、胸元の芯地の多重構造によるドレープカットによる仕立て、〝ロンドンカット〟の先駆者として知られている。

後年、ウィンザー公は「ショルティ」のトラウザーズを好まず、ニューヨークのテーラー「H・ハリス」に作らせていた。メトロポリタン美術館に保管されているディナースーツは、上着は「ショルティ」、トラウザーズは「H・ハリス」製であり、まさに大西洋を挟んで一着のスーツが作られていたことを証明している。

この「ショルティ」の系譜を受け継ぐ「アンダーソン&シェパード」はチャールズ皇太子のテーラーとしてロイヤルワラントを授与され、英国王室が好むスタイルを代表するテーラーとなっている。

さらに、スコットランドのシェットランド諸島にあるフェア島で編まれた伝統的なニットウェア、通称〝フェアアイルニット〟に、プラス・フォーズ（ヴィクトリア朝時代のニッカボッカー型の裾がすぼまった形のトラウザーズ。通常より4インチ長いのでこう呼ばれた）をゴルフウェアだけでなく、日常に着ることを流行させたのもウィンザー公だ。

自伝とされる『A FAMILY ALBUM』でもその半分以上がファッションのことを語っているほど、着こなしに関心の高かったウィンザー公は、現代でもブリティッシュ・ファッションのアイコンであり続けている。

## スポーツとミリタリーが生んだマスターピース

英国王室と同時にオックスフォード大学とケンブリッジ大学も〝スポーツ〟というカテゴリーでメンズファッションに偉大な功績を残した。なかでも〝ブレザー〟と〝オックスフォード・バグス〟はメンズファッションにおいて欠くことのできない重要なアイテムだ。

実は〝ブレザー〟の起源は諸説ある。シングルのブ

fashion made its first major public appearance at the Tuxedo Club's Autumn Ball, thus giving the dinner jacket its American name.

The Prince of Wales check, generally a blue glen plaid, takes its name because it was a favourite pattern of Edward VII when he was the Prince of Wales. Edward VIII too often wore this pattern, and a famous photo of him in a double-breasted suit and beret had a lasting impact on fashion history.

Edward VIII's insistence on marrying American divorcee Wallis Simpson led to his abdicating the throne after just eleven months of rule, a royal romance story that enthralled the world. His 'downfall' allowed him free travel throughout the world, however, and he became an ambassador of British men's fashion to every country he visited.

Scholte of Savile Row was the personal tailor to Edward VIII. Dutchman Fredrick Scholte received his training as a military tailor, a background that he applied to his suits. He is known as the originator of the 'London Cut', a look marked by its soft shoulders, light construction, careful ironwork and cutting from shoulder to waist, and a characteristic drape attained through layered interlining in the chest.

In later years Edward became dissatisfied with the cut of Scholte's trousers, and began having them made by New York's H. Harris. A dinner suit once belonging to him on display at the Metropolitan Museum of Art has labels from Scholte on the jacket and H. Harris on the trousers, showing that the Duke of Windsor did indeed have his suits made on both sides of the Atlantic. Savile Row tailors Anderson & Sheppard have inherited Scholte's heritage and continue to produce styles preferred by the Royal Family, as indicated by their Royal Warrant as tailor to Prince Charles.

Edward also left his mark by popularising Fair Isle knit (a traditional form of multicolour knitting from the Shetland Islands) and plus fours (baggy trousers based on the Victorian knickerbockers, but extending four inches below the knee) not just as golf wear, but as everyday attire.

Over half of Edward's autobiographical A Family Album is dedicated to discussions of fashion. Even today, he remains an icon of British men's style.

レザーは1829年にオックスフォード大学とケンブリッジ大学で行われたボートレースでケンブリッジの学生が燃えるような赤（blazer）の上着を着ていたとする説が有名だ（対するオックスフォードの学生は白地に濃紺の上着を着用していた）。一方でダブルのブレザーは1845年、エリザベス女王拝艦に際して戦艦ブレザー号の乗員が紺のダブルブレスティッドを着用していたとする説もある。胸に錨（いかり）マークや紋章をつけ、ボタンは真鍮（しんちゅう）か黒といったディテールは現在にも残されている。

19世紀末にはボート競技だけでなく、クリケット、ポロでも〝ブレザー〟は着用されるようになり、ユニフォームの意味合いが定着する。1920年頃には〝ブレザー〟はスポーツだけでなく、ファッションとしても着用されるようになった。

1920年代に大流行したフレアー型の幅の広いトラウザーズ〝オックスフォード・バグス〟はオックスフォード大学の学生から生まれた流行である。極端なものでは50cm幅のものまであった。このスタイルを今でも愛する人は多く、「ナッターズ・オブ・サヴィル・ロウ」の系譜を受け継ぐ伝説のテーラー、エドワード・セクストンは彼のグラマラスなスタイルは〝オックスフォード・バグス〟に影響を受けたと語っている。

オックスブリッジ（オックスフォードとケンブリッジ両校を指す言葉）の学生たち、第一次大戦後の裕福なバックグラウンドを持つ彼らのライフスタイルは〝ブライト・ヤングピープル〟として時代の憧憬を集めた。ケンブリッジ卒の写真家セシル・ビートンやオックスフォード卒のイヴリン・ウォーなどはその典型だ。1960年代に日本で若者の憧憬を集めた〝アイビー・スタイル〟はアメリカのアイビー・リーグ8大学のファッションに端を発したが、これも英国のエリート校への憧憬を基にした60年代のアメリカ版といえるだろう。

社会学者のC.W.ミルズはアメリカのハイソサエティーを分析した『パワー・エリート』（1956年）で、ボタンダウンの生みの親「ブルックス・ブラザーズ」が特に宣伝している訳でもないのに、アメリカを代表するブランドとなった理由はエリート階級のスタイルだからだと分析している。しかし、ボタンダウンでえ、英国のポロ競技のシャツがその由来なのである。

ファッションが成立するファクターが固有のイメージに対する憧れである以上、エリート階級がファッションを牽引していく図式は常に普遍のものとなっている。

加えて、19世紀後半から20世紀にかけては〝オーバーコート〟の時代ともいえる。

# Great masterpieces from sport and the military

Alongside the Royal Family, the universities of Oxford and Cambridge too have made significant contributions to sportswear. Blazers and Oxford bags in particular hold a special place in the history of men's fashion.

There are various theories regarding the origin of the word 'blazer'. One popular explanation comes from the 'blazing' red jackets worn by Cambridge students in 1829 at a boat race against rival Oxford (whose students wore navy on white). Another theory is that it comes from the striped double-breasted jackets worn by the crew of HMS Blazer when Queen Elizabeth toured it in 1845. Details like anchor markings and brass buttons remain on such jackets today.

By the end of the nineteenth century, blazers were worn not only in rowing, but also cricket and polo, solidifying their position as sport uniforms. By around 1920 they came to be worn as general fashion items as well.

Oxford bags come from a style of widely flared trousers popular among students at the University of Oxford in the 1920s. Extreme versions reached widths of up to 50 cm. The style is still enjoyed today, and Edward Sexton, the tailor inheriting the legend of Nutters of Savile Row, says that Oxford bags were a major influence on his glamorous styles.

Students of 'Oxbridge' (a portmanteau used to simultaneously indicate Oxford and Cambridge) were admired as the 'bright young things' of post-World War I England, aristocratic socialites the likes of Cambridge graduate Cecil Beaton and Oxford graduate Evelyn Waugh. While fashions credited as the American 'Ivy League' look have been internationally popular since the 1960s, sadly few realise that these styles are generally based on adoration of the clothing worn at elite British universities.

In his analysis of American high society The Power Elite (1956), sociologist C.W. Mills suggests that Brooks Brothers became a representative United States brand despite its lack of extensive advertising because of its association with elite society. However even the button-down shirt, often credited as a Brooks Brothers

1850年代にクリミア戦争で活躍したラグラン卿に由来する〝ラグランコート〟が登場し、1830年代のチェスターフィールド卿に由来する〝チェスターフィールドコート〟、アイルランドに由来し、ウェストベルトがついた〝アルスターコート〟、同時期にスコットランドに由来し、ケープのついた〝インヴァネスコート〟も登場した。

第一次大戦では〝塹壕(トレンチ)〟を意味するギャバジンの防水コート〝トレンチコート〟(原型は〝トロッケンコート〟)が生まれている。「バーバリー」と「アクアスキュータム」の2社が軍の受注を受け、英国軍の活躍と共にその名を世界に轟かせた。他にもメルトン生地に由来する〝ブリティッシュウォーム〟〝グレイトコート〟、英国海軍に由来する〝ダッフルコート〟など、第二次世界大戦にかけて多くのミリタリーを起源とする偉大なオーバーコートが誕生した。

英国ではビスポークのテーラリングの技術が発展したのとは対照的に、アメリカでは19世紀半ばに南北戦争の軍需需要を受け、アメリカ人アイザック・シンガーによって商品化されたミシンの開発と共に、既製服産業が大きく発展していった。

英国ではビスポークを重視したあまり、この後にテーラリング産業が苦境を呈することになるとは予測できなかったに違いない。

## ハリウッドの台頭

20世紀初頭にはハリウッドの映画が一大産業に成長し、大衆の娯楽の中心となると、ハリウッドが生んだスターたちはハイソサエティーの頂点、英国王室のテーラーが立ち並ぶサヴィル・ロウでビスポークのスーツを仕立てた。それまでの王侯貴族に代わり、ハリウッドスターたちのライフスタイルとファッションが流行の最先端となったのである。

フレッド・アステアは「アンダーソン&シェパード」のスーツで、流れるような動きと優雅で華麗なステップを強調した。アルフレッド・ヒッチコックが監督した映画『北北西に進路を取れ』(1959年)でケーリー・グラントは「キルガー・フレンチ&スタンバリー」で撮影用に6着同じスーツを仕立て、サヴィル・ロウが世界に誇る〝ロンドンカット〟の魅力を世界に見せつけた。ゲーリー・クーパー、ダグラス・フェアバンクス・シニアとジュニア、チャーリー・チャップリンなど、当時の名だたるスターたちはこぞってサヴィル・ロウでスーツを作ることをステータスとし、サヴィル・ロウを〝特別な紳士服

innovation, has origins lying in the shirts of British polo. One of the factors behind the establishment of a fashion is the desire to express a unique image, and the elite classes have always provided a universal map for guiding such desires.

The late nineteenth to early twentieth century was the era of the overcoat. The Chesterfield coat originated in the 1830s, and the Raglan coat, named after Crimean War hero the 1st Baron Raglan, made its first appearance in the 1850s. The belted Ulster coat rose to prominence via Ireland, and the caped Inverness coat via Scotland.

A gabardine raincoat supplied by Burberry and Aquascutum was frequently worn by officers in the trenches of World War I, and the fame of the 'trench coat', as it came to be called, spread worldwide alongside the achievements of the British Army. Well-known overcoats such as the British warm and the duffle coat also arose from military and wartime roots.

While England remained a centre of bespoke tailoring techniques, in the mid-1800s the United States developed technologies for mass production, particularly with the advent of Isaac Singer's sewing machine and huge military demand resulting from the American Civil War. It is unfortunate that this focus on bespoke would eventually lead to increased pressure on the tailoring industry.

## Hollywood emerges

Hollywood developed film into a major industry in the early twentieth century, making it the main form of entertainment for the masses. Hollywood stars became the apex of high society, and came to Savile Row to have their suits made by the Royal tailors. The lifestyles and fashions of the Hollywood elite replaced those of the aristocracy as the contemporary vogue.

Fred Astaire's elegant dance steps were accentuated by the flow of his Anderson & Sheppard suit. In Alfred Hitchcock's North by Northwest (1959), Cary Grant's wardrobe included six identical suits from Kilgour, French & Stanbury, introducing the world to Savile Row's 'London Cut'. Many other stars, the likes of Charlie Chaplin, Douglas Fairbanks Sr. and Jr., and

の聖地〟とする伝説を生む結果となった。

　1930年代にはサヴィル・ロウのハウスはアメリカでの受注会トランクショーを始め、アメリカの巨大な市場を背景にしたビスポークの黄金時代が訪れる。これを契機にサヴィル・ロウの主要な市場はアメリカとなり、それは今日でも変わってはいない。

　フェデリコ・フェリーニ監督の『甘い生活』（1960年）のマルチェロ・マストロヤンニのコンチネンタル・ルック、スティーブ・マックイーンの『トーマス・クラウン・アフェア』（1968年）、ラルフ・ローレンが衣装を担当したロバート・レッドフォードの『華麗なるギャツビー』（1974年）、ジョルジオ・アルマーニによるリチャード・ギアの『アメリカン・ジゴロ』（1980年）、007の第一作目『ドクター・ノオ』（1962年）から現在の『スペクター』（2015年）まで、大戦の前後を通じて、ハリウッドはメンズファッションの牽引車であり続けている。

## 第二次世界大戦後のメンズファッションの動向

　第二次世界大戦が終わり、50年代になると、若い世代による新たなメンズファッションの潮流、ストリートが生んだスタイルが台頭してくる。1960年に英国で徴兵制度が廃止されると、史上初の若年層が購買力を持つ時代が到来する。これに伴った若年層向けのトレンドが次々と発信された。フォトグラファー、デザイナー、ミュージシャン、俳優など労働者階級出身の成功した若者によるファッション・トレンドは〝ユースクエイク〟と呼ばれ、新たな若者の時代の到来を世界に印象づけた。

　1966年、「ターンブル＆アッサー」出身のマイケル・フィッシュがロンドンのピカデリーに自身の店をオープン。ヒッピースタイルを取り入れた幅広のキッパータイなど、ここから最新の流行が作りだされた。1960年代始めにはピエール・カルダンの襟無しジャケットと1966年『タイムマガジン』が名付けた〝スウィンギング・ロンドン〟が世界的なブームを巻き起こした。

　1957年に「ジョン・スティーブン」がオープンするとカーナビー・ストリートはファッションの聖地となり、続いて1960年代のロンドンでは〝モッズスタイル〟と奇抜な色彩と過剰な装飾を誇示する〝ピーコックスタイル〟が流行。1960年代の終わりには〝ヒッピースタイル〟が登場、ベトナム戦争が終盤に近づくと〝ヒッピースタイル〟は廃れ、1970年代には〝サイケデリックスタイル〟が登場した。60年代のピエール・カルダンのノーカラー・ジャケットに続き、イヴ・サンローランのサファリ

Gary Cooper made the Savile Row suit a status symbol, and helped define the area as a 'Mecca for Menswear'.

　In the 1930s Savile Row shops began hosting trunk shows in the United States, opening up an enormous new market and initiating a golden age for bespoke tailoring. The primary market for bespoke shifted to America, a trend that continues today. Since then, film has continued as a powerful force for men's fashion, through the continental look of Marcello Mastroianni in Fellini's La Dolce Vita (1960), Steve McQueen in The Thomas Crown Affair (1968), Robert Redford's wardrobe by Ralph Lauren in The Great Gatsby (1974), Richard Gere's Armani suit in American Gigolo (1980), and the suits of James Bond films from Doctor No (1962) through the most recent instalment, Spectre (2015).

## Post-WWII men's fashion trends

　Following World War II, the relatively meandering pace of change that had previously characterised men's fashion trends underwent a turbulent transformation. In the 1950s, post-war youth began developing new 'street' fashions that altered the direction of masculine style. Coinciding with the end of National Service conscription in 1960, British youth attained significant purchasing power for the first time in history, resulting in a series of new youth-oriented styles. Trends originating from successful photographers, designers, musicians, and actors arising from the working class became so predominant that were collectively branded as a 'youthquake', and in 1966 Time coined the phrase 'Swinging London'.

　In the early 1960s Pierre Cardin made a splash with his collarless jacket. In 1966, Michael Fischer left Turnbull & Asser to open his own shop in Piccadilly, from which new trends like the hippie-inspired kipper tie emerged.

　Carnaby Street in London's West End became another fashion centre, epitomised by the 1957 opening of John Stephen's shop, His Clothes. In the 1960s London fashion gave birth to both the classy mod style and the vivid palettes of the peacock style. Hippie styles were predominant in the late 1960s, then abandoned in

スーツに代表されるフランスファッションが注目された。

こうして劇的な変化のなかったメンズファッションは激しい時代のトレンドに左右されるようになった。

1960年代、イタリアの「ブリオーニ」に代表される〝コンチネンタル・ルック〟も全世界的に大流行した。これはよりタイトなシルエットでネクタイも細く、初期の007、『ドクター・ノオ』に登場したショーン・コネリーやザ・ビートルズのスーツが代表例だ。

ビスポーク一辺倒のサヴィル・ロウで既製服の重要性にいち早く気が付いたのはハーディー・エイミスだった。1959年にはメンズウェアチェーン「ヘップワース」で既製服のラインを始めている。

1969年にはトミー・ナッターとエドワード・セクストンが「ナッターズ・オブ・サヴィル・ロウ」をオープン。極端なワイドラペル、異なる柄で縁取りされたジャケットのコンビネーションスーツなど、今までなかった斬新な発想のスーツを世に送り出し、彼らは〝サヴィル・ロウの革命〟と呼ばれた。

イタリアン・パワー

英国の栄光が覆される瞬間は近づきつつあった。戦後のヨーロッパで既製服市場が拡大するにつれ、既製服製造に長けたアメリカとイタリアの隆盛は目覚ましいものとなったのだ。同時に、19世紀に最盛期を誇った英国の服地産業が斜陽となっていくのと対照的に、戦後の経済復興を目指したアメリカのマーシャル・プランにより、イタリア北部ビエラの服地産業は目覚ましい発展を遂げていた。

1950年代の「ダヴェンツァ」や「ブリオーニ」、1960年代には「アルビーニ」らが登場し、70年代から80年代にかけてイタリアの服地の軽量化がこの傾向に拍車をかけた。

80年代にはイタリアン・パワーの激震が世界を襲う。ジョルジオ・アルマーニが世界を席巻し、ブランドブームがやってきたのだ。「アルマーニ」はテーラリングの基本とされるキャンバスや分厚いパッドをなくし、快適さと最先端のファッションをスーツに融合させた。映画『アメリカン・ジゴロ』(1980年)は強烈なイメージを人々に植え付け、それはビスポークのステータスを完全に超えていた。実際、サヴィル・ロウが最も困窮したのは80年代だと多くのテーラーが証言している。富裕層の息子たちは息子に初めてのスーツを馴染みのテーラーで仕立てる伝統より、既製服のグラマラスなイタリ

favour of the psychedelic trends of the early 1970s.

The 1960s were also an era of notable French fashions, like Pierre Cardin's jackets and Yves Saint Laurent's safari suits. Italian designs too enjoyed popularity worldwide, as represented by the continental look of Brioni and suits with tight silhouettes and thin ties, like those of the Beatles and Sean Connery's James Bond in Dr. No.

Hardy Amies was one of the first to realise the importance of Savile Row bespoke to ready-to-wear clothing, and in 1959 partnered with menswear chain Hepworths to create a new line.

In 1969 Tommy Nutter and Edward Sexton teamed up to open Nutters of Savile Row. From there, they revolutionised Savile Row by presenting to the world ultra-wide lapels and the mismatched patterns of their combination suits, innovative looks unlike anything seen before.

## Italian Power

Following World War II, the European market for ready-to-wear attire continued to expand, and this new demand was being fulfilled by the amazing output of countries excelling at mass production like the United States and Italy. The Marshall Plan, originally conceived with the aim of post-War economic recovery, proved disastrous to the British clothing industry that had been so powerful in the nineteenth century, while at the same time promoting amazing development in Italian cities like Biella. The glory of England was in danger of being eclipsed. This trend was further spurred by the emergence of d'Avenza and Brioni in the 1950s, Albini in the 1960s, and the light weight Italian close in the 1970s and 80s.

Italian power shook the world in the 1980s. Giorgio Armani in particular initiated a worldwide fascination with branding. Armani did away with the canvas and thick padding that had been staples of tailoring, thereby creating a fusion of cutting-edge tailoring with comfort. The powerful imagery of American Gigolo in particular proved difficult for traditional bespoke to overcome, and—as many British tailors will tell you—the 1980s were one of the most difficult times Savile Row had ever

アン・ブランドを好んだからだ。

　同時に、1986年にはクラシコイタリア協会がフィレンツェで設立され、イタリアのクラフツマンシップによるメンズファッションが脚光を浴びる時代がやってきた。チェザーレ・アットリーニによるスーツの「キートン」は手仕事の服作りを工場体制にし、画期的な生産体制を持っていた。協会の最盛期には「ブリオーニ」「キートン」「イザイア」「ルイジ ボレッリ」などイタリアを代表する服飾メーカーが在籍し、協会の影響力は多大なものだった。しかし、90年代後半の「ブリオーニ」脱退を端として協会の影響力は減少した。

　それとは対照的に、現在のメンズファッションの一大発信地となっているのが、イタリアのフィレンツェで年に2回開催される世界最大級のメンズファッションの展示会「ピッティ・イマジネ・ウオモ」である。

　イタリアのス・ミズーラ（ビスポーク）のテーラーはミラノとローマの両「カラチェニ」、フィレンツェの「リヴェラーノ＆リヴェラーノ」、ナポリの「ルビナッチ」「アントニオ・パニコ」らが活躍し、特にナポリの手仕事のディテールを多く残したナポリタン・テーラリングは世界中の男たちを今でも魅了している。

　1990年代には、ロンドン勢の巻き返しも起こった。リチャード・ジェームス、オズワルド・ボーテン、ティモシー・エヴェレストら、新たなビスポークの若手の台頭〝ニュー・ビスポーク・ムーブメント〟が注目を集めた。

　イギリスとイタリア、メンズファッションの二大潮流の歴史はこうして繰り返されている。

### ロンドン・コレクション・メンとビスポーク

　サヴィル・ロウといえばビスポーク・スーツの最高峰を意味し、今までこのスーツの聖地はトラディショナルな装いの殿堂ではあっても、ファッションとトレンドとは無縁の存在であったかもしれない。だが、それはあくまで過去の話になろうとしている。

　ここ数年、メンズファッションのトレンドは、カジュアル化から一転した。現代的な要素を加えたモダン・クラシックなスーツがトレンドとなり、スーツにカジュアルにはない格好良さを見出す若い世代が増えている。

　3ピーススーツばかりでなく、ウェストコート（ベスト）にジーンズといった着こなし、さらにスタイリッシュな髭の流行はその顕著な例だ。

　ビスポーク・スーツや靴に代表されるモダン・クラシックなファッションも、他の男の趣味と同様に、手をか

faced. Rather than taking sons to get their first suits at the family tailor, aristocrats headed to retail outlets to pick up a more glamorous Italian brand.

　In 1986 the Classico Italia consortium was established in Florence, announcing a new age of craftsmanship in Italian men's fashion. Cesare Attolini's Kiton brand married hand-sewn technique with factory production, instigating a revolution in manufacturing methods for clothing. At its peak Classico Italia members included prominent names like Brioni, Kiton, Isaia, and Luigi Borrelli, making it a highly influential organisation. Its influence began to wane, however, with the departure of Brioni in the late 1990s. Even so, today one of the most powerful forces in men's fashion is the Pitti Immagine Uomo, which held its 85th showing in 2015.

　Prestigious Italian su misura (bespoke) tailors include Caraceni in Rome and Milan, Liverano & Liverano in Florence, Rubinacci in Naples, and Antonio Panico in Rome and Naples. Neapolitan tailors in particular produce handmade details that are objects of desire for men worldwide.

　London in turn embarked on something of a comeback in the 1990s, when fresh young tailors like Richard James, Ozwald Boateng, and Timothy Everest initiated the 'new bespoke movement'. And thus begins a new chapter in the rivalry between the two fashion powerhouses of England and Italy.

## London Collections Men

　For many, Savile Row represents the ultimate in bespoke attire, but also retains an image of conservative tradition that has been resistant to change and relatively unmoved by the trends of the day. However, that is rapidly becoming a thing of the past.

　For several years now, trends in men's fashion have been withdrawing from previous tendencies toward the casual. More popular today is the 'modern classic' look, a combination of classic styling updated with modern elements that provides the current young generation with a stylishness not possible through a strictly casual look. This does not necessarily mean a return to three-piece suits, though—an example would be combining a waistcoat with jeans and a stylish haircut.

けることに楽しみを見出す趣味の一環、ライフスタイルの一部として捉えられている。仕方なくスーツを着るのではなく、敢えてスーツを選択する。この流行がハイクオリティーなスーツを求める傾向を生んでいる。

こうした背景の中、ビスポーク・スーツを親子代々作ってきた既存の顧客とは異なる、新たな顧客層がビスポークに興味を示すようになった。サヴィル・ロウに加え、ソーホーやメイフェアに多数存在するビスポーク・テーラーの層の厚さも、こうした需要と供給のバランスに叶っている。

さらに、クラシックなスタイルを追い求めるばかりでなく、トレンドに応じたメンズファッションの発信地として、シーズンに応じたコレクションと、それに連動する既製服に力を入れるブランドが増えている。

既製服に早くから進出していた「ギーヴス&ホークス」を筆頭に、カーロ・ブランデッリの「キルガー」、パトリック・グラントの「E.トーツ」、さらに女王陛下のテーラーとしてかつて知られた「ハーディー・エイミス」など、これらサヴィル・ロウのブランドはロンドンで年2回開催されるロンドン・コレクション・メンに、いまや欠かすことのできない存在だ。

これからのロンドンはメンズファッションのトレンドをリードし、誰もがショッピングを楽しめるエキサイティングな場所になっていくかもしれない。だがファッションのトレンドが移り変わっても、サヴィル・ロウやセント・ジェームズ地区に象徴される〝ビスポーク〟のスタイルと文化が世界中の〝男の装い〟のゴールであることに変わりはない。

Like many other men's pastimes, modern classic fashion finds enjoyment in appreciating the effort required to attain one's goal. It is a part of one's lifestyle, one that shows you wear suits not because you have to but because you choose to, and therefore select one of high quality.

Against this backdrop, the bespoke suit is now becoming a product that is no longer based on established relationships with generations of specific families, but instead open to entirely new strata of customers with an interest in fine clothing. To fulfil this demand, bespoke tailors are now going beyond the boundaries of Savile Row into places like Soho and Mayfair. Another result is that Savile Row has become a destination not only for those seeking classic styles, but also men's fashion reflecting the latest trends and seasonal collections.

There are several brands taking advantage of this by creating ready-to-wear lines. One of the first was Gieves & Hawkes, who were soon followed by Carlo Brandelli's Kilgour, Patrick Grant's E. Tautz & Sons, and Hardy Amies, tailor to Her Majesty the Queen. Such notable Savile Row brands gather twice per year for the London Collections Men event, which has become a fixture in the men's fashion scene. Stores like those of Gieves & Hawkes and Hardy Amies have furthermore undergone renovations that have transformed them into modern shops that would have been unimaginable from their Georgian origins.

Savile Row is also welcoming an ever-increasing number of new stores selling ready-to-wear goods, such as the long anticipated Gaziano & Girling, nearby Anderson & Sheppard's Haberdashery, and Drake's for a wide selection of ties, accessories, and clothing.

We can thus look forward to London not only leading future trends in men's fashion, but also becoming an exciting shopping destination for a wider audience. Even so, regardless of how trends and fashions change over the coming years we can rest assured that Savile Row and the St. James's district will remain what they have been for centuries, a centre of bespoke style and culture with a single goal—dressing men well.

## Classic Masterpieces　物が語るスタイルがある

### BARBOUR INTERNATIONAL JACKET

バブアー インターナショナル・ジャケット

ミリタリーに系譜を持つアイテムには多くの名品が存在している。なかでもロイヤルワラントを3つ保持する老舗、「バブアー」社のインターナショナル・ジャケットは現在もタイムレスな魅力を放っている。

「バブアー」社はイングランド北東部サウスシールズでジョン・バブアーによって1894年に創業された。北海の過酷な環境で働く漁師や港湾労働者のために、開発されたオイルドクロスが、その120年以上に及ぶ歴史の始まりである。

第二次世界対戦において活躍した潜水艦HMSに由来し、"ウースラ・スーツ"と呼ばれたスーツのジャケット部分は、「バブアー」の"モーターサイクル・ジャケット"とほぼディテールが同じものだ。実はこのジャケット自体、「バブアー」のモーターサイクル・ジャケットを元に考案、開発されている。

「バブアー」に依頼して作製されたプロトタイプの"ウースラ・スーツ"は、海軍少佐ジョージ・フィリップスが着用し、1939年に撮影された画像が残されている。

事の発端は、部下である潜水艦長レイキンが着用していた「バブアー」のモーターサイクリングスーツだっ

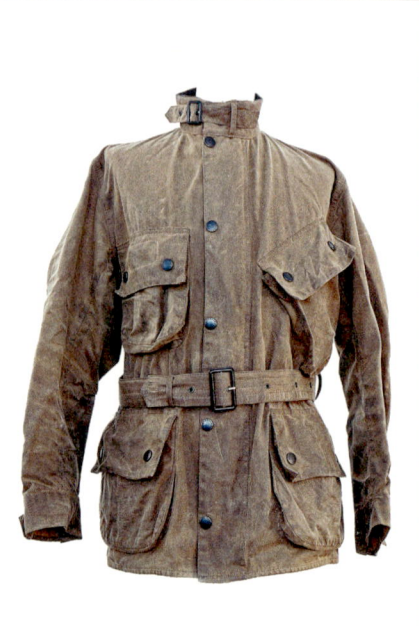

Barbour
International Jacket
2007-2008

There are many masterpieces of fashion that have their roots in military styles. One with a particular timeless fashion is the International Jacket from Barbour, an established clothing store and recipient of three Royal Warrants.

The details on Barbour's motorcycle jacket are nearly identical to the jacket part of the Ursula suit, named after the WWII submarine HMS Ursula. That is perhaps not unexpected, since the suit was created with that motorcycle jacket as a model. Lieutenant Commander George Phillips, commanding officer of HMS Ursula, commissioned Barbour to create a prototype of the

た。このワンピース・スーツは1930年代からの同社の代表的商品であり、多くのレーサーが愛用していた。スティーブ・マックイーンが1964年の6デイズ・トライアル・サーキットで着用したことでも広く知られている。

　当時の海軍の支給品に不満を覚えていたフィリップスは、レイキンに「バブアー」のスーツを着用させ、消火用のホースで水をかける実験を行った。結果は独自のオイルド・コットン・ワックスによる優れた防水効果が功を奏し、レイキンは衣類を濡らすことなく任務を終えたのだった。この結果に気を良くしたフィリップスは「バブアー」社に上下が別れたツーピースの〝ウースラ・スーツ〟を注文する。このスーツの実用性は高く評価され、1940年から1941年にかけて、すべての英国海軍の支給品となった。

　真鍮の前開きのジッパーには同じ真鍮のボタンを採用し、ヘルメットの着用を妨げずに首回りの防寒の役目を果たすスタンドアップ・カラー、斜めに取り付けられた左ポケットは運転中にもポケットの中のものが取り出しやすいよう、右利きのドライバーのために設計されたものだ。防寒のためのライナーも用意されている。

　写真のジャケットはイギリス人士官によって、アフガニスタンの戦闘地域ヘルマンド地方で2007年から2008年にかけて現地で実際に着用されたものである。このジャケットのかなりの酷使に耐えたであろう佇まいには、まさに〝ヘビーデューティー〟という言葉が相応しい。

　ファッションにおける〝ヘビーデューティー〟という言葉は「丈夫な、酷使に耐える」といった意味合いを持つ。同時に純粋な言葉の意味として「重大な責務」の意味もこの言葉は持っている。ミリタリークローズにはこのふたつの意味を兼ね備えた機能こそが必須とされているのではないだろうか。

　時代を経ても色褪せない「バブアー」の魅力は、他のミリタリーアイテムと同じ、男にとって重大な責務を完遂できる服、そのことに尽きるのだと思われる。

Dissatisfied with the waterproofing of Navy-issued kits of the time, Commander Phillips had Lieutenant Lakin wear the suit while being sprayed with a fire hose. The oiled and waxed cotton did its job, and Lakin emerged dry. Impressed, Phillips ordered a two-piece version, which became the Ursula suit. Its utility was widely praised, and from 1940 through 1941 it became standard issue for all Royal Navy Submarine Service personnel.

The suit featured a front zipper and buttons made of brass, a raised collar designed to keep the neck warm without interfering with helmets, and a diagonal left-side pocket designed to allow easy access by right-handed wearers while driving.

The jacket shown in a private purchase and used by a British officer from 2007–2008 in combat zones in Afghanistan's Helmand province. As can be seen from its appearance, this jacket is the very essence of 'heavy duty'.

In a fashion sense, 'heavy duty' implies 'sturdy' and 'able to withstand harsh treatment', but in a literal sense the phrase suggests an 'important responsibility'. Both are vital aspects of military clothing, and both are surely factors behind the attractiveness of Barbour's products, which like other military items have played important roles in men's style throughout the ages.

## Classic Masterpieces  物が語るスタイルがある

### BRITISH WARM OVERCOAT　ブリティッシュウォーム・オーバーコート

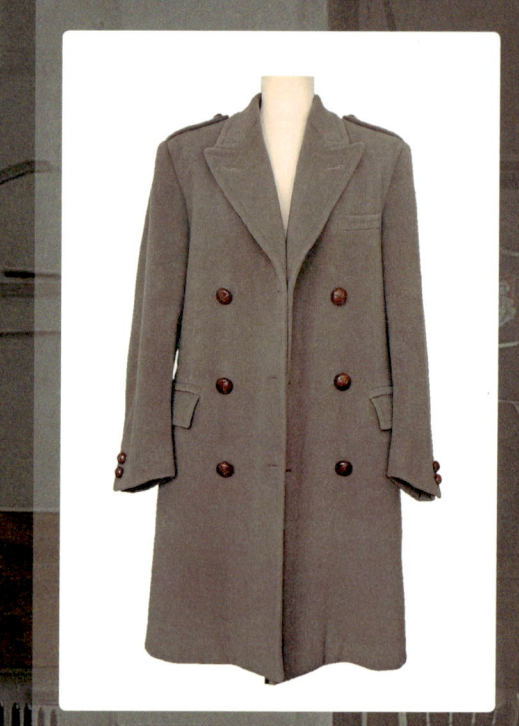

Bespoke
British Warm
Overcoat

メンズファッションのアイコンにはミリタリーを起源とするものが非常に多い。"ブリティッシュウォーム・オーバーコート"もそのひとつだ。

第一次大戦中に英国陸軍の士官用として生まれたこのコートは、分厚いメルトンクロスが使用されており、色は通常モーブ（鼠色）がかったグレーとされている。

しばしばコート用の生地の代名詞ともされるメルトンは、イギリス中部のレスターシャーの町、メルトン・モーブレーにその名が由来する。しっかりと緊密に織られたウール生地は、誕生した19世紀当時には、驚異的な厚さと重さを誇り、少なくとも34オンス（952g）はあったという。暖房設備の乏しかった当時、英国の厳寒の気候から人々を守り、丈夫で保温効果に優れたメルトンクロスはオーバーコートの生地の代名詞となった。

一方、スコットランド人のジョン・クロンビーがアバディーンに自らのミル（紡績工場）を設立したのが1805年。19世紀後半になると「クロンビー」社は製造した生地の販売だけでなく、"ロシアンコート"やロシアの王室用にデザインした"カバートコート"で成功を納め、ヨーロッパ、アメリカ、ロシアへも同社の製品は輸出された。

Many icons of men's fashion have their origins in the military, among them the trench coat, the duffle coat, and the British warm. The last of these was originally developed as an officer's overcoat during WWI, and it was worn even by King George VI and Winston Churchill. It is fabricated from thick Melton cloth, usually in a taupe-tinged grey.

Melton is often considered synonymous with coat fabric, and originates from the town of Melton Mowbray in central England's Leicestershire. It is a wool fabric woven at high density, and when it was first developed in the nineteenth century was famed for its outstanding thickness, a minimum of 34 ounces. Heating was poor at the time, despite England's harsh climate, making Melton cloth a superb fabric for overcoats.

In 1805, Scotsman John Crombie established a mill in his hometown of Aberdeen. By the latter half of the nineteenth century the Crombie mill was selling not only fabrics, but also 'Russian coats' and 'covert coats'

第一次世界大戦が始まると、「クロンビー」社は英国陸軍との契約を結ぶことに成功する。対戦の開始された1914年から戦時生産をはじめ、同社の作製するオーバーコートはイギリス軍の士官用コートの10％のシェアを占めるようになる。〝ブリティッシュウォーム〟が認識されるにつれて、厚手のメルトン生地はしばしばクロンビー・フリースとも呼ばれるようになった。
　〝ブリティッシュウォーム〟のオリジナルの士官用コートは、ダブルブレスティッドにレザー・フットボールの6つボタン、ウェスト部分を絞り込み、ピークドラペル、ふたつのフラップポケット、ひとつの胸ポケット、シングルのバックベント、ふたつのカフボタン、バックベルト、そしてエポレット（肩章）が付いている。
　当初はジョッパー型のパンツとフィールドブーツと共に着用されるために考案されたため、丈は膝までの長さに作られていた。さらに国王ジョージ6世が着用している〝ブリティッシュウォーム〟には、左ポケットの上に小さなオープニングが認められる。これは軍刀を携帯するためのものだった。
　1930年代には生地は比較的軽く薄くなり、戦後には他のミリタリーコート同様に市民権を得ていった。士官用のコートとして、軍服を得意とするテーラーでもクロンビー・クロスを用いてビスポークの〝ブリティッシュウォーム・オーバーコート〟が多数作られている。現在では、軍刀用のオープニングは完全に姿を消し、バックベルトやエポレットがないものなどさまざまなバリエーションが存在している。
　イギリス首相ウィンストン・チャーチルや国王ジョージ6世に着用された〝ブリティッシュウォーム〟には、かつての軍服や現代の男の戦闘服であるスーツと同様、機能を第一義として作られ、削ぎ落とされた美意識がある。国家の命運を背負って戦ったチャーチルの不敵な面構えには〝ブリティッシュウォーム〟が良く似合う。自らを装い誇示するための服ではなく、武骨なまでに任務を遂行するための服。それが〝ブリティッシュウォーム・オーバーコート〟が現在のメンズファッションにおいて、ある種の男たちを惹きつける理由だろう。

designed for the Russian tsar. They were exporting their goods to Europe, the United States, and Russia. Soviet leader Mikhail Gorbachev was seen wearing a Crombie coat when he visited the West in the mid-1980s. Crombie thus established itself as manufacturer of overcoats popular throughout Europe.

　Crombie landed a contract with the Royal Army at the start of WWI. Production began in 1914, the first year of the war, and they attained a 10% share of the greatcoats worn by British officers. As its popularity spread, this thick Melton fabric also became known as 'Crombie fleece'.

　The original British warm officer's coat was waisted and double-breasted, with six regimental buttons, peaked lapels, two flap pockets, a single breast pocket, a single back vent, two cuff buttons, a belted back, and epaulettes. On the British warm worn by King George VI, you can see a small opening above the left pocket to accommodate wearing a sword.

In the 1930s the fabric was made thinner and lighter, and as in the case of military coat became popularized with the general public. Tailors with a military tradition have made many British warms for use as officer's overcoats. Today the sword slit has of course disappeared, and you will find many other variations, such as wool-cashmere blends, coats without back belts or epaulettes, and those lengthened to below the knee.

　As with the military uniforms of old and business suits today, the British warm has an aesthetic of being crafted and honed for function. It is well suited to the fearless figure of Churchill, bravely fighting for the fate of his country. It is clothing for knuckling down and doing one's duty, not for showy display. This appeal is likely what has maintained the British warm's status in men's style for over a century.

# Classic Masterpieces 物が語るスタイルがある

## OXFORD SHOES オックスフォード・シューズ

メンズシューズの中でオックスフォードほど汎用性が高い靴は他にないのではないだろうか。切り替えの無いホールカットの靴に比べややフォーマル度は劣るものの、服装が全体にカジュアル化してきている現在では、オックスフォードのキャップ・トウのストレートチップは、ビジネスから冠婚葬祭までフォーマルな場で通用する信頼性を持つデザインだ。

オックスフォードの靴の起源は17世紀まで遡る。当時、一般的に普及していたのは長靴（ブーツ）であり、この時代に創業したイギリスの老舗の靴屋の多くが「ブートメイカー」と名乗っていることは、靴が普及する以前、その歴史がブーツから始まったことを表している。

1640年頃、主流であったブーツに反抗して、敢えて丈の短い、現代型の靴を履きだしたのがオックスフォード大学の学生だった。短靴着用時のフィット感を高めるため、足の甲の部分を紐で結ぶ形が考案された。「甲を紐で結ぶ」のが定義とされた初期のオックスフォードは、日本では紐を通す革の部分が外側に付けられていることから、外羽根式と呼ばれるダービーであったという説もあり、その真偽は定かでない。

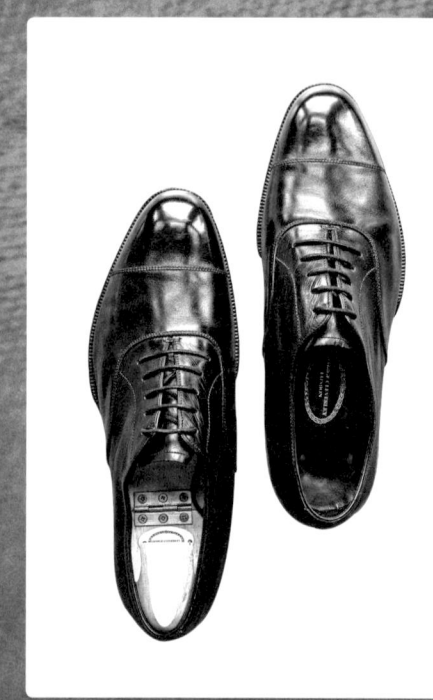

George Cleverley
Bespoke
Black Oxfords

There is no other men's shoe as versatile as the Oxford, a fundamental part of any man's wardrobe. While not quite as formal as a wholecut, given the more casual trends of today's fashion, a cap-toe, straight-chip Oxford is a reliable design acceptable to situations from business to wedding ceremonies.

The Oxford's roots stretch back to the seventeenth century, a time when boots were standard footwear. Indeed, many British shoemakers established in this era called themselves 'bootmakers', an indication of the origins of modern-day shoes.

Around 1640, students at the University of Oxford bucked this trend by wearing much shorter footwear, very similar to the shoes we wear today. To improve the fit of such a low cut, laces were used to tighten the uppers. The first such laced shoes in Japan are reported to have had an open lacing system, making them Derbies instead of Oxfords, but this remains uncertain. What we call Oxfords today have a closed lacing

現在はオックスフォードといえばバルモラルとも呼ばれる内羽根式のことを指す。バルモラルはブーツに対して多用され、その由来はヴィクトリア女王の夫君アルバート公が1853年に英国王室の居城のひとつ、スコットランドのバルモラル城で考案したことからこの名がある。

当初は学生の反抗のイメージの象徴であったオックスフォードが、フォーマルなイメージを持つようになったのは、第一次世界大戦以後だろう。この時代、特にイギリスのメンズファッションで注目を集めていたのが、第64代首相を務めたアンソニー・イーデンだった。

1897年イーデン準男爵家に生まれ、イートン・カレッジ、オックスフォード大学のクライスト・チャーチで東洋言語学を学び、仏語、独語、ペルシャ語など多くの語学に精通していた。常に内閣と外務省の間では反目があったにも関わらず、チャーチルの内閣において高い信頼を得た政治家だった。

貴族出身のエリート、「役者のようだ」と当時イギリス人の間で形容された容姿の相乗効果もあり、彼が着用したホンブルグ帽は「アンソニー・イーデン・(ハット)」として、外交官や官僚の間で多大な人気を博した。第二次大戦後の1945年、チャーチルの後を継いで首相となったアトリーは「イーデンのようなホンブルグを購入したい」との希望で、老舗の帽子店「ジェームス・ロック」を訪れ、ホンブルグを購入した逸話も残されている。このことからも、イーデンのファッション・アイコンとしてのイメージは強烈なものだったことが窺われる。

政治家としてのキャリアを語るとき、首相としての判断がスエズ危機とポンド下落を招き、大英帝国の終焉を世界に告げたとする意見は免れないだろう。政治生命に終止符を打った致命的な判断力の欠如とは別に、内閣の誰もが讃えたイーデンの資質は「誠実さ」の一言に尽きる。首相就任時には健康を害していたこともあり、感情的で精神的な脆弱さを抱えていたが、全生涯を通してイギリス人が尊重するフェアネスを持つ「清廉の士」であったという評価は変わることがなかった。イーデンは公式の場ではストレートチップのオックスフォードを愛用していた。メンズウェアがファッションではなく個々のスタイルの表現だとすれば、オックスフォードの靴のキャラクターは、イーデンの生まれ持っていたこの資質を体現していたに違いない。

system. These shoes are also called Balmorals, a term first used to distinguish them from boots and deriving from Balmoral Castle in Scotland.

The shoes were originally a symbol of university student rebellion, but took on a more formal image during World Wars I and II. Particularly attracting attention to men's fashion in this era was Anthony Eden, who served as the 64th-generation prime minister.

He was born in 1897 into the family of a baronet, and attended Eton College and Christ Church, Oxford, where he studied Oriental languages. He was fluent in French, German, and Persian, and said to have understood Russian and Arabic. Despite his constant feuding between the Cabinet and the Ministry of Foreign Affairs, particularly in the Cabinet of Winston Churchill, he was considered a highly reliable politician. Perhaps aided by his noble status and being labeled as 'dressing like an actor' by the British public, the Homburg hat he wore became known as an 'Anthony Eden' and was highly popular among British diplomats and bureaucrats.

Talk of Eden's political career inevitably leads to discussion of his role as Prime Minister in the Suez Crisis, devaluation of the Pound Sterling, and other factors bringing about the demise of the British Empire, but, setting aside these examples of poor decision-making that ended his political career, he was nonetheless praised by everyone in the Cabinet for his sincerity. By the end of his term he was in poor health, leaving him emotionally and psychologically vulnerable, but even so he was known throughout his life as being a paragon of integrity, always adhering to the British respect for fairness.

In public, Eden was commonly seen in a pair of straight-chip Oxfords. Considering that not as an example of menswear fashion, but rather as an expression of personal style, the character of Oxford shoes are the perfect example of the qualities that Eden personified.

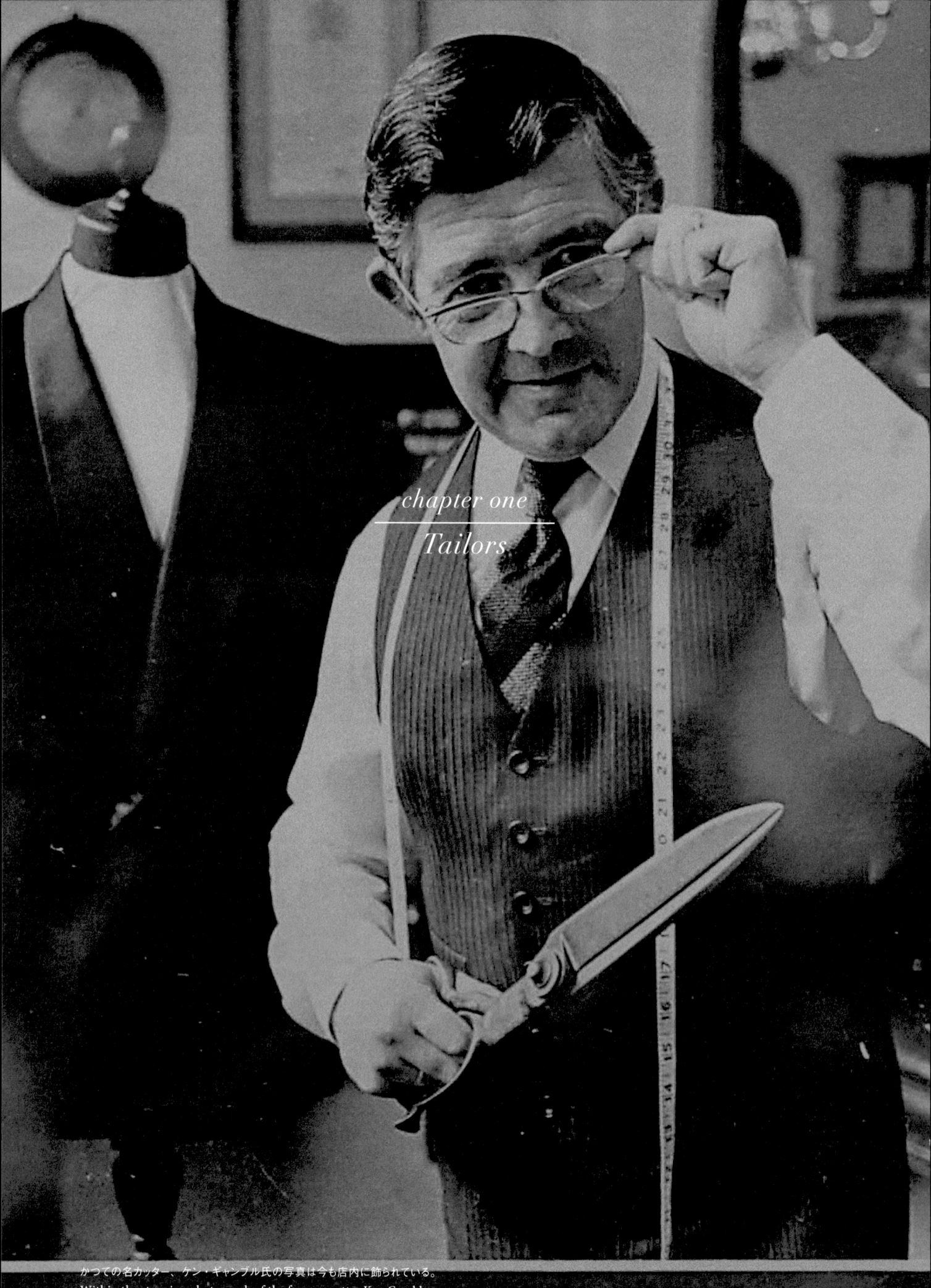

*chapter one*
―――
*Tailors*

かつての名カッター、ケン・ギャンブル氏の写真は今も店内に飾られている。
Within the store is a photograph of the famous cutter Ken Gamble.

# Henry Poole

ヘンリー・プール

15 Savile Row, London, W1S 3PJ
TEL +44 (0)20 7734 5985
www.henrypoole.com

　創業1806年、紳士服の聖地サヴィル・ロウに設立された最初のテーラー「ヘンリー・プール」。20世紀初頭には世界最大のテーラーとなり、1858年のナポレオン3世から授与されたロイヤルワラントを筆頭に、英国王室、日本の天皇家も含め、世界各国の王室から40ものロイヤルワラントを授与されている。

　1846年から同社に保管されている台帳にはウィンストン・チャーチルや白洲次郎の名もある。さらにアメリカと日本では「タキシード」と呼ばれているディナー・ジャケットを作りだしたのも「ヘンリー・プール」だ。

　このようにサヴィル・ロウで最も伝統あるテーラー「ヘンリー・プール」を牽引するのが7代目当主のサイモン・カンディ氏である。

　イタリアの靴ブランド「フェラガモ」やイギリスのミル「テーラー＆ロッジ」等で経験を積んだ後、1989年に「ヘンリー・プール」に入社した。

　父である6代目当主アンガス・カンディ氏から受け継いだ経営哲学を、彼はこのように語っている。

　「『ヘンリー・プール』を経営していくことは、たとえて

　Founded in 1806, Henry Poole was the first tailor on Savile Row. In the early twentieth century they were the largest tailor in the world. They hold over forty Royal Warrants from around the world, starting with an 1858 warrant from Napoleon III and extending to the British Royal Family and the Japanese Imperial Family. Their client register stretches back to 1846, and includes names like Winston Churchill and Japanese politician Jiro Shirasu. It was Henry Poole that first created the dinner jacket, better known as the 'tuxedo' in the United States and Japan.

　Today, this oldest of tailoring traditions on Savile Row is carried on by its seventh-generation Simon Cundey, who joined the company in 1989 after developing his career at Italian shoemaker Ferragamo and British mill Taylor & Lodge.

　He described to me his management philosophy, inherited from sixth-generation operator Angus Cundey: 'Managing an operation like Henry Poole is

Henry Poole ヘンリー・プール 35

シニアカッター、フィリップ・パーカー氏（右）から技術と伝統を受け継ぐ、アレックス・クック氏（左）。
Alex Cooke (left) is the inheritor of the techniques and traditions of Senior Cutter Phillip Parker (right).

言えば、大きな船を操るようなものだ。ひとつの方向に向かって、我々全員が櫓を漕いでいる。『ヘンリー・プールとは何か』を全員が理解し、スーツ作りの哲学が正しく継承できていれば、船は真っすぐに進む。これができていなければ、船はどこかへ行ってしまう。シンプルだが、これが我々がサヴィル・ロウで今まで生き残ってこられた理由だと思う。そして顧客の要求に正しく応えることができれば、それは顧客からの感謝と信頼につながる。テーラーとしての仕事の喜びはそこにあることを、父から学んだ。それはどんなに時代が変わっても変わることはない」

　カンディ氏ら経営者とともに、このハウスの名声を支えてきたのは店の顔となるカッターである。カッターはサイズを採寸し、顧客の体型に合わせ、型紙を作り、生地を裁断する。その後、裁縫職人が生地とキャンバスをアイロンの熱でまげ、糸で縫い付ける。多くの職人の手を経て、ひとつのスーツが完成されるが、基本となる良い型紙なくして良いスーツを作ることはできない。

　名店に名カッターあり。

akin to piloting a large ship. We're all pulling at the oars, trying to head in a specific direction. If everyone here understands what Henry Poole is all about, if we've properly passed on our philosophy of suit-making, then the ship will maintain a true bearing. If we fail at that, however, we will stray off course. It's a simple way of looking at things, but I believe this is what has kept Henry Poole on Savile Row for so many years. When we are able to respond to our customer's needs, we are rewarded with their appreciation and their trust. As my father taught me, that is the joy in being a tailor. No matter how the times change, that will remain the same.'

Together Simon Cundey and Henry Poole's other directors have maintained its prestige as the point-of-contact between shop and customer. The cutters take measurements, create patterns that best fit the customer's body, and cut the cloth. Sewing craftsmen will then use heat from an iron to bend the cloth

"ヘンリー・プール・ハウス・チェック"は、11/12オンスのラムズウールを使用。軽く、現代に合わせた仕様となっている。
The Henry Poole House Check uses an 11/12 oz. lambswool for a light, contemporary fit.

「ヘンリー・プール」の伝統を継承してきたシニアカッターのフィリップ・パーカー氏は、この道50年を超えるキャリアを持つ。

「私が『サリバン&ウーリー』に入社したのは1963年のクリスマスで、1980年に『ヘンリー・プール』に入社した。父は銀行家だったが、私は試験の成績が良くなくて、父にどうするかと訊かれたとき、テーラーになりたいと答えたんだ。なぜ、そんなふうに答えたのか、そのときは自分でも疑問に思った。後からわかったのは、母方の家系にプリマス（イングランド南西部の港町）でテーラーをしていたウィリアム・H・サッチウィルという者がいた事実だ。驚くべきことに、1860年代のその店の広告にはかつて『ヘンリー・プール』で働いたテーラーと記されていたんだ。私が『ヘンリー・プール』で働くようになったのは、こうした祖先からの縁があったからだろう」とにこやかに笑う。

まずコートメーカー（サヴィル・ロウではジャケットを正式名称であるコートと呼ぶ伝統が守られている）の見習いとして4年間修行を積み、それから店に出ることを

and canvas, and sew everything together. Creating a suit requires the input of many craftsmen, but it is impossible to create a good suit without a good pattern serving as its basis.

In other words, a good bespoke tailoring business needs good cutters.

Philip Parker, Senior Cutter and inheritor to the traditions of Henry Poole, has spent fifty years developing his career.

'I joined Sullivan & Wooley at Christmas in 1963 and Henry Poole & Co in September 1980', he says. 'My father was a banker, but I didn't do so well on my exams. When he asked me what I wanted to do with my life, I said I wanted to be a tailor. I wasn't sure why I said that at the time, but later I learned that a relative on my mother's side, William H. Satchwill, was a tailor in Plymouth [a port town in southwest England]. Interestingly enough, an advertisement for his store from the 1860s mentions that he used to be a tailor here

7代目当主サイモン・カンディ氏と新たな試みとして復刻されたオリジナル〝ヘンリー・プール・ハウス・チェック〞。
Seventh-generation operator Simon Cundey, with a new project: the restored original Henry Poole House Check.

許されて、カットを学んだ。その後、「ヘンリー・プール」のディレクターとして、ドイツ、アメリカのトランクショーに行き、90年代にマネージングディレクターとなった。

「ここにいる者の中には私より技術的には優れている者がいるかもしれないが、私はここで最も経験を持つ者の一人だ。経験を金で買うことはできない。それは多くの歳月を積み重ねることでのみ、身に付くものだ」

人をリラックスさせる独特の柔和な語り口は彼の重ねて来た経験をそのまま物語っている。

ここでのカッター修行は、まず4年かけて縫製も含めたスーツの仕立てを学ぶ。その後、生地の裁断（ストライキング）を学んで、アンダーカッター（ストライカー）になる。それからトラウザーズ（パンツ）のカッターとなり、ウェストコート（ベスト）、コート（ジャケット）のカッターへと難易度に合わせ進んでいく。4年の経験を経て、初めて顧客の前に立つことが許されるようになるという。

だが、誰もが名カッターになれるわけではない。良いカッターになるにはどうすればよいのだろう？

「まずスーツの構造を学び、作り方を理解する必要がある。次に採寸したサイズから型紙をおこす技法を学ぶ。ビスポークのスーツ作りは個人的な一対一の信頼関係で、その信頼の築き方は一朝一夕に学ぶことはできない。あたかも自分が外交官であるかのように、人々の気持ちをそらさずに話をすること、顧客の求めていることがなにかを知ることが重要だ。すべては経験がものをいう世界なんだ」

世界でも最も有名なテーラリングハウスのひとつ、「ヘンリー・プール」で働きたいという希望者は後を絶たない。ここで働くのに求められる資質とは何か。

「若い人たちは資格やどんな学校を卒業したかを語りたがる。しかし、私が知りたいのはその人自身の資質であり、あなたはどんな人なのかということだ。毎朝定時に出社し、電話に応対し、人々から常に学び、我々のメンバーになりたいという意欲を見せられるのか。それだけだ。常に研修生を受け入れているが、彼らはやがて会社の一部となる。訓練を受けて、我々の服作りを体得したものが『ヘンリー・プール』のスーツを作る、そのことに意義がある。そうでなければ、『ヘンリー・プール』のスーツも他のテーラーのスーツも同じになってしまう。トレーニングの重要性はここにある。修行する中で最も大事なことは毎日が学びであり、テーラーにとって学ぶことを止めることはないということだ」

フィリップ・パーカー氏に師事し、現在は7代目当主

at Henry Poole.' Parker smiles. 'I suppose it was my ancestor who led me to my position here.'

Parker started with a four-year apprenticeship as a coat maker (keeping in mind that Savile Row adheres to the tradition of calling suit jackets 'coats'). He was then allowed to work in the shop, where he learned cutting. Following that he served as a Henry Poole director, attending trunk shows in Germany and the United States, and became Managing Director in the 1990s.

Parker's extensive experience is evident in his relaxing, mellow speech. 'There are people working here with more technical expertise than I', he says, 'but I have the most experience. You can't buy experience with money; it's something that can only be obtained through the passage of time.'

During his apprenticeship, Parker spent his first four years learning how to tailor coats. After that he learned fabric cutting (striking), and became an undercutter. He then became a trousers cutter, and proceeded up the ranks in difficulty to waistcoats (vests) and coats. He was first allowed to present himself to customers after four years of experience.

Knowing that not just anyone can become a famous cutter, I ask him what the secret is.

'First and foremost is learning the structure of a suit, and understanding how they are made. Then you learn the techniques for creating a pattern from measurements. Fashioning a bespoke suit involves a one-to-one personal relationship based on trust, and how to build that trust isn't something you can learn in a day. It's almost like you're a diplomat; you need to learn to speak in a way that doesn't put customers off, and it's important to be able to grasp what it is they're after. You can only learn that through experience.'

As one of the most famous tailoring houses in the world, there is no end to the number of people wanting to work at Henry Poole. I asked what they look for regarding qualifications.

'Young applicants want to talk about the qualifications they have and where they went to school. But what I really want to know is what kind of person they are, what qualities they have. I want to know if they can arrive on time every morning, whether they can speak on the telephone, and if they are always learning from

最後のリヴァリー専門のテーラーであることに自負を持つキース・リヴェット氏。
Keith Levett is proud to be the last tailor specialising in livery.

であるサイモン・カンディ氏とジョイント・マネージング
ディレクターに就任したシニアカッターのアレックス・クック氏は、カッターの研修生であるストライカーとして入社し、以来、17年になる。

　服作りへの道を志したのは、幼少期の経験によるものだという。最初はファッションデザインに興味が芽生え、そこからテーラリングとパターン・カッティングを学ぶことになったのは自然な流れだった。この時期に婦人服の仕立てを学んだが、それはパターン・カッティングやフィッティングに問題があったとき、問題を解決する助けとなっていると語る。

「私が引いた型紙はスーツを形作る重要な要素のひとつだが、大半の工程は生地とキャンバスをアイロンの熱でまげ、糸で縫い付けることであり、これを担当するコートメーカーの腕にかかっている。カッターとテーラー（裁縫職人）はお互いが共同作業で、どちらが欠けてもスーツ作りは成り立たない。ひとつの工程だけがスーツを作っている訳ではなく、すべてが重要だ」

　彼が「ヘンリー・プール」において、学んだ最も重

those around them. I also want to see a strong desire to be a part of our team. That's all. We are always open to new trainees, and they become part of our company. There's a certain significance to receiving our training, and to learning how to fashion a Henry Poole suit. Otherwise we would be just like all the other tailors. That's the importance of training, the most important part of which is learning new things every day. As a tailor, one can never stop learning.'

Seventh generation family head Simon Cundey serving along with him as Managing Director is Joint Managing Director Alex Cooke, who started at Henry Poole seventeen years ago as a trainee striker.

He says he wanted to be involved in making clothes from early childhood. He started out interested in fashion design, which naturally led to learning tailoring and pattern-cutting. He first learned tailoring of women's clothing, something which he says is helpful when trying to work out problems related to pattern

要なことはなんなのだろう。

「ここには究極のハウススタイルというものはない。その人を引き立てる身体にフィットした服を作る、純粋な意味でのビスポーク・テーラーだ。顧客を型にはめるというより、個々の持っているプロポーションを重視し、そこからベストのバランスをみつける。ウェスト・ボタンの位置、ジャケットの長さは適切か。より自然に見える美しいショルダー・ラインを作るには肩パッドは必要なのか。胸のドレープは強調すべきか。ウェストラインは隠すべきか。顧客の体型によっても考慮すべき点はたくさんある。最も重要な点は全体のフォーム（形）が顧客にフィットしているかどうかなんだ。トレーニングした場合、本人にやる気があれば、技術は比較的短期間で習得することができる。学ぶのに時間がかかるのは、顧客への対応の仕方だ。顧客の要望をくみ取り、いかに彼らが満足のいくスーツを完成させるか。フィリップからは技量ばかりでなく、カッターとして何をすべきか、どう振る舞うべきかを学んだ。ここには4人のシニアカッターがいるが、敢えてヘッドカッターという言葉は使わ

cutting and fittings today.

'The patterns I create are one important element in forming a suit, but the greater part of the process is in bending the cloth and canvas with an iron and sewing it all together, which is the job of the coat maker in charge. Cutters and tailors work together, and you can't make a suit without the cooperation of both. There's no single step that produces the suit, it's all important.'

I asked him what was the most important thing he learned at Henry Poole.

'We do not hold a specific house style. We're a pure bespoke tailor, in the sense that we just make clothes that fit the man. Rather than try to fit our customers into a particular form, we pay attention to the proportions of each individual and find the best balance from that. There are many aspects of the customer's body that we need to consider: Where to place waist buttons. How long the jacket should be. Whether shoulder pads are needed to form a more

ない。ヘッドカッターという言葉は他のカッターより自分の方が優れていると示唆しているような響きがあるように感じる。自分自身ではヘッドカッターだというつもりはない。ここではシニアカッターといえば、誰もが『ヘンリー・プール』のスーツを作るのに相応しい技量を備えているということなんだ」

こうした「ヘンリー・プール」の伝統を継承しているのはアレックス・クック氏ばかりではない。シニアカッターのフィリップ・パーカー氏に「我々は彼のような卓越した才能を得て、実に幸運だ」と言わしめたテーラーがいる。それが「ヘンリー・プール」でロイヤルワラントを授与されているリヴァリー部門専門のテーラー、キース・リヴェット氏だ。

リヴァリーとは各国の大使が公式行事で着用するアンバサダーコートや、エリザベス女王のスタッフのコートなど、主に式典用に着用する礼服を意味している。

貴族が使用人にサヴィル・ロウ製の礼服を着用させることは、富とステータスの象徴だった。そのため、かつてサヴィル・ロウには多くのリヴァリー・テーラーが存在していたが、リヴァリーに対する需要の減少から、今は「ヘンリー・プール」を含め、わずか数社が手掛けるのみとなっている。

「私はサヴィル・ロウに残る最後のリヴァリー・テーラーだ。このことは私にとって非常な名誉でもある。さらに、リヴァリーを手掛けるテーラーは他にもあるが、数百年前と同じ材料、同じ手法で製作しているのはここだけだ」と、情熱を込めてリヴェット氏は語る。

リヴァリーが作られた数百年前と同じ部材、同じ手法で作製するには膨大なコストと手間がかかる。それにも拘わらず、「ヘンリー・プール」が、頑なにその手法を守り抜くのには理由があるという。

数百年前から変化していない式典用礼服は、長い歴史を経て受け継がれたデザインと技術の粋を集めたハンドワークに意味がある。そのディテールを変えることは、礼服の意味そのものを変えてしまうに等しいというのがその理由だ。

「どの礼服にも異なる難しさがある。繊細で高価なゴールドレースを重ねて礼服の形を作る、それには高い技術と忍耐強さが必要とされる」

6代目当主アンガス・カンディ氏による入社試験のインタビューで、ミリタリーとリヴァリーに対する群を抜く知識が認められ、25年前に「ヘンリー・プール」に入社した。テーラーの家系に生まれ、幼い頃より祖母から裁縫を習った。彼の中では縫うことができるのは当たり

naturally attractive shoulder line. Whether drape across the chest should be emphasised. Whether the waistline should be hidden. But most important of all is whether the overall form fits the customer. Given a motivated learner, with some training the techniques behind all this can be learned in a relatively short time. What takes longer to learn is how to deal with the customer. How to take in the customer's requests, and from that create a suit that he will be happy with. Philip is not only technically skilled, he has also learned how to behave as a cutter, what he should be doing. We have four senior cutters here, but we intentionally don't use the term "head cutter". Calling someone the head cutter gives the impression that they are somehow superior to the others. I certainly have no intention of being a head cutter. Instead we have senior cutters, and anyone we call that has what it takes to create a Henry Poole suit.' It is not only Cooke who carries on the traditions of Henry Poole. Another is Keith Levett, master tailor in Henry Poole's Livery department, which holds the current Royal Warrant. Speaking of Senior Cutter Phillip Parker, he says, 'We are fortunate to have been able to have from such an exceptional talent.'

'Livery' refers to uniforms used primarily for ceremonial occasions, such as those worn by ambassadors during official events or the uniforms worn by Queen Elizabeth's staff on ceremonial occasions.

Having servants wear uniforms tailored on Savile Row was a way for nobles to show their wealth and status. There were therefore many livery tailors in the area at one time, but today there is less demand for their wares. Henry Poole is one of the few remaining tailors who fashions it.

'I'm the last livery tailor on Savile Row', says Levett. 'I consider that quite an honour. There are other tailors who create livery, but we're the only house that still uses the same materials and methods that were used centuries ago.'

Of course, those materials and methods do not come low cost. Even so, there's a reason why Henry Poole stubbornly sticks to them. Ceremonial garb that remains unchanging over centuries represents designs and techniques passed down over equally long times.

前のことだったが、その非凡な才能に気が付いたのは、フィリップ・パーカーのもとで修行を積むようになってからのことだ。

「フィリップは素晴らしい教師で、彼からスーツの仕立てを学び、次にカッティングルームでカットを習得した。だが自分自身ではビスポークのテーラリングをリヴァリーほど楽しむことはなかった。それで式典用礼服を専門に担当するテーラーになったんだ」

最後のリヴァリー専門のテーラーは1960年代に既に亡くなっているため、「ヘンリー・プール」に保管されている膨大なアーカイブから、リヴァリー独特の生地、構造、カットに至るまでを独学で学んだ。

25年後の今、リヴェット氏は「ヘンリー・プール」のディレクターの肩書きを持つ。

「ヘンリー・プール」で働くということは、英国の歴史の一端を担っていることと同じだと彼は語る。1876年、2代目の「ヘンリー・プール」が逝去の際、彼の死を悼むプリンス・オブ・ウェールズ（後のエドワード7世）からの手紙がここには遺されている。「ヘンリー・プール」の最も貴重とされるアーカイブのうちのひとつだ。いかに「ヘンリー・プール」が王室に愛されたテーラーであったかを、この手紙が物語っている。

リヴェット氏は「ヘンリー・プール」の未来、そしてこのテーラリングビジネスの将来には希望があるという。消え行くかと思われたこの職業に、若い世代が興味を抱くようになったからだ。現在は数多くの履歴書が世界中から届く。彼は長い歴史と伝統によって作られたビスポーク・スーツが過去の形骸でなく、真の価値を見出されるようになったことを心から喜んでいる。

メンズファッションの源流であるスーツの歴史は、そのまま「ヘンリー・プール」の歴史と重なっている。その台帳は大英帝国の隆盛の歴史と共にあり、顧客は親から子どもへ、何世代にもわたる。タイムレス・エレガンスを象徴するサヴィル・ロウのビスポーク・スーツ。ここ「ヘンリー・プール」では技術の継承と共に、その精神も受け継がれている。

Changing the details would be tantamount to changing the meaning behind them.

'There's a different kind of difficulty behind each uniform. Creating clothing from delicate and expensive gold lace requires a very high level of technique and patience.'

When Angus Cundey underwent his employment interview twenty-five years ago, he demonstrated an exceptional knowledge of military uniforms and livery. He was born into a tailoring family and learned sewing from his grandmother, so to him knowing how to sew seemed only natural. His extraordinary talent was only uncovered while studying under Philip Parker. 'Philip was an excellent teacher. I learned cutting under him in the cutting room. But I never really enjoyed bespoke tailoring in the way that I love ceremonial dress. That's how I ended up specialising in it.'

The last tailor specialising in livery had closed shop in the 1960s, so he learned everything about livery's unique fabrics, structures, and cuts on his own, through study of Henry Poole's extensive archives. Twenty-five years later, Levett is now a Director.

He tells me that working at Henry Poole means being part of England's history. When second-generation operator Henry Poole passed on in 1876, the Prince of Wales (later Edward VII) sent the family a letter of sympathy, which today is considered one of the most precious artefacts in the store's archives, a symbol of the Royal Family's affection for its tailor.

Levett expresses hope for the future of Henry Poole, and the tailoring business in general. Once expected to fade away as a profession, he says that the younger generation is now expressing more interest in tailoring. Every day they receive resumes from around the world. He is overjoyed to see the long history and tradition of the bespoke suit rediscovered for its true value, rather than being relegated to a relic of the past.

The history of the suit is the foundation of men's fashion, which has developed hand-in-hand with Henry Poole. Their client ledger traces the history of the rise of the British Empire, and their suits have been worn by parents and children over generations. The Savile Row bespoke suit symbolises timeless elegance, the spirit of which is being carried through time by Henry Poole.

*chapter one*
---
*Tailors*

# Gieves & Hawkes

ギーヴス&ホークス

1 Savile Row, London, W1S 3JR
TEL +44 (0)207 432 6403
www.gievesandhawkes.com

聖地サヴィル・ロウを代表する名門「ギーヴス&ホークス」。「サヴィル・ロウ1番地」というアドレスが象徴しているように、18世紀にはキャベンディッシュ公爵の邸宅としてジョージ・〝ボー〟・ブランメルが招かれ、19世紀には王立地理学会であった威風堂々たる建築とその規模、服飾専門家によって管理されている膨大なミリタリー・アーカイブ、ロイヤルワラントを含めた歴史的背景など、すべての意味においてサヴィル・ロウにある他のハウスとは一線を画す存在だ。

その歴史は創業1785年海軍のテーラー「ギーヴス」社と、創業1771年の軍用帽子と陸軍のテーラーであった「ホークス」社に始まる。1974年に「ギーヴス」社が「ホークス」社を買収したことにより、現在の「ギーヴス&ホークス」社が誕生した。同社はマイケル・ジャクソンなどのセレブリティーから、世界各国の王室、政治家に至るまで幅広い顧客層を持つことでも知られている。こうして長年にわたり築かれたブリティッシュ・テーラリングの美学は、今、新たなステージを迎えようとしている。

Gieves & Hawkes represent the spirit of Savile Row.

As its street address suggests, 1 Savile Row is a majestic, imposing building that was the eighteenth-century residence of Lord George Cavendish and one-time home of the original dandy, George 'Beau' Brummell. In the nineteenth century it was the headquarters of the Royal Geographical Society, and even today retains a rich historical heritage through its extensive archive of military uniforms and royal warrants. In all aspects, Gieves & Hawkes' flagship store stands apart from the other houses on Savile Row.

Its history begins with Gieves & Co., founded in 1785 as a Royal Navy tailor, and Hawkes & Co., founded in 1771 as a tailor and hatter to the Royal Army. Their present form took shape in 1974, when the two merged to become Gieves & Hawkes. They are known for their exclusive yet broad-based clientele from around the world. From royalty, politicians and business people to celebrities like Michael Jackson. As always, they are

「ギーヴス&ホークス」のビスポーク部門を率いるヘッドカッター、ダヴィデ・トウブ氏。
Davide Taub, head cutter in Gieves & Hawkes bespoke division.

1833年の記録が残されたウェリントン公爵の注文台帳も遺されている。
A ledger from 1833, listing an order from the Duke of Wellington.

「『ギーヴス&ホークス』を知り尽くした男」、現チェアマンを務めるマーク・ヘンダーソン氏には、そんな形容がまさに相応しい。

「ダンヒル」のヘッド・オブ・マーケティングを経て、1996年に入社して以来、同社のマネージングディレクター、チェアマンを歴任。老舗の伝統を背負ったテーラーリングハウスを、現在のトータルなメンズウェア・ブランドに作りあげた張本人といっても過言ではない。

2002年に「ギーヴス&ホークス」が香港の「ウィンタイ・プロパティー（現在のUSIホールディングスLtd.）」の所有となったときから、彼の目標は明確だった。それはU.K.と中国、ビスポークとライセンシー、両方の市場を拡大し、「ギーヴス&ホークス」をインターナショナルなメンズウェア・ブランドにすることである。

「ラグジュアリー・ブランドのビジネスを展開するためには一定の市場規模が必要となる。それ以下では利益を生み出すビジネスとして成立しないからだ。『ギーヴス&ホークス』は中国と英国、種類の異なる製品に対してそれぞれの市場を持つことでこの規模を達成でき

bringing the venerable traditions of the British tailoring aesthetic into new times.

Current chairman Mark Henderson is called 'the man who knows everything about Gieves & Hawkes', and he lives up to that claim. He joined the company in 1996 after serving as head of marketing at Dunhill, and was Gieves & Hawkes' marketing director before becoming chairman. It was he who transformed Gieves & Hawkes from an historical tailoring house into the worldwide menswear brand that it is today.

Since its acquisition in 2002 by Hong Kong's Wing Tai Properties (currently USI Holdings, Ltd.), Henderson has maintained a clear goal: expanding Gieves & Hawkes' bespoke and licensee markets in both the U.K. and China to build the company into an international brand. 'Expanding business as a luxury brand requires a certain market scale', he says. 'Below that, it is difficult to produce profit. We can attain this scale by maintaining different product lines in the

ミリタリー・テーラーとしての偉大な過去の栄光を物語るアーカイブ・ルーム。
The Archive Room contains remembrances of Gieves & Hawkes' glorious past as a military tailor.

る。現在、中国ではライセンシービジネスとして100店舗以上を展開している。対して、今回英国では大規模な投資を行い、既製服からビスポークまでを揃えたトータル・ブランドとしてまったく新たなブランディングを開始した。ここに来れば、新生したラグジュアリーな『ギーヴス&ホークス』の全貌がわかるだろう」

2012年、世界最大のコンシューマー・プロダクトのサプライヤーのひとつ、香港の「リー&フン」社の傘下である「トリニティーLtd.」の所有となり、この経営戦略はより明確になったようだ。

「当社の既製服の歴史は1926年にまで遡る。ビスポークと既製服、その両方の製造の歴史を我々は持っている。今回は今までの『ギーヴス&ホークス』のコレクションに、よりインターナショナルで現代的なテイストが加わった。ロンドン・コレクション・メンズも盛況となり、ますますロンドンはメンズファッションにとって重要な市場となる。同時に我々のチャンスも充分にある」

「コンテンポラリー&ラグジュアリー」な路線を打ち出す一方で、「ギーヴス&ホークス」のブランドとしての真

U.K. and China. We currently have over one-hundred licensee stores in China, and in the U.K. we have made significant investments toward a totally new branding as a producer of a wide range of menswear, from bespoke to ready-to-wear clothing. We are being reborn as a luxury brand.'

In 2012, Gieves & Hawkes came under ownership of Trinity, Ltd., a subsidiary of Hong Kong's Li & Fung, one of the world's largest supplier of consumer products. This has made their management strategy all the more clear.

Regarding future developments, Henderson says, 'We've added a more international, modern touch to our line-up. Our Men's London Collection has been particularly successful, emphasizing London's importance as an important centre of men's fashion. This creates even more opportunities for us.'

When asked about the value of Gieves & Hawkes' brand in its dual pursuit of contemporary and luxury,

王室の護衛兵 "オナラブル・コープス・オブ・ジェントルメン・アット・アームズ"の軍服により、エリザベス女王2世よりロイヤルワラントを授与されている。
Gieves & Hawkes received a royal warrant from Queen Elizabeth II to supply uniforms for Her Majesty's Honourable Corps of Gentlemen-at-arms, the bodyguards for the British Monarch.

グローバルなメンズウェア・ブランドの視野を持つ「ギーヴス&ホークス」会長マーク・ヘンダーソン氏。
Chairman Mark Henderson brings to Gieves & Hawkes a global perspective of menswear.

価はどこにあるのか？　その問いにヘンダーソン氏はこう答えている。

「我々のブランドとしての真価はビスポークにあり、長年にわたり、この地に継承されてきた伝統にある」

この言葉が示す通り、現存するすべてのロイヤルワラント3つを持ち、専門のヒストリアン（歴史家）によって管理されているアーカイブ・ルームには、1797年に初めてロイヤルワラントが授与された記録もある。200年を超える王室からの受注は、現在の王室の護衛兵の軍服まで継続されている。

この栄光を支えるのはビスポークのクラフツマンシップ、そしてその鍵となるのが高い技術力の継承だという。

現在はあらゆる商品に「ビスポーク」という言葉が氾濫している。この事態に対抗し、サヴィル・ロウで作られるビスポークの技術的価値を証明するため、2004年に「ヘンリー・プール」、「アンダーソン&シェパード」、「ディージ&スキナー」といった老舗のハウスと共に、「ギーヴス&ホークス」を加えた5店舗で「サヴィル・ロウ・ビスポーク・アソシエーション（SRBA）」を設立した。

SRBAへの加入には厳密な規定を設けている。カッターによる直接採寸と個別の型紙の作成、2ピースのスーツに対して最低50時間以上の手作業によって作られることなど、〝ビスポーク〟のスーツの定義、基準を示した。さらに加入したテーラーが互いに協力し合い、大学からの研修生制度やゴールデン・シアーズ賞などのコンテストを設け、この業界で働く職人の若返りをも図っている。

「サヴィル・ロウは特別な場所だ。世界で最も地価の高いロンドンのメイフェアの中心に、100人を超える熟練の職人たちが集まり、最高級のスーツを仕立てている。それは我々が持つヘリテージそのものであり、何より重要なのは伝統を継承していく人材にほかならない」

そしてブランドの真髄であるビスポーク部門を率いるヘッドカッターがダヴィデ・トウブ氏だ。

彼がこの日着用していたのは、ダブル・ブレスティッドの3ボタン、ブラック・シルクのスーツだった。構築的でシャープなショルダーラインとロープド・スリーブヘッド、ダブル・フロントダーツの入ったスーツは、絞り込んだウェストとバックラインが見事にフィットしている。このスーツにはシルク100%の素材が持つラグジュアリー感と、ミリタリーを思わせる男の服の威厳があり、同時に抑制のきいたエレガンスがある（48ページ写真）。

「顧客ひとりひとりに合わせるのがビスポーク。ハウスによって得意なスタイルは存在するが、決まったハウスス

Henderson replied, 'The core value of our brand remains unchanged: Men's bespoke fashion, in a sense, developed here on Savile Row.'

Indeed, even today Gieves & Hawkes' retains three Royal Warrants, and the company's Archive Room—curated by a full-time historian—retains records of the first, issued in 1797, establishing a two-hundred-year history of supplying the Royal Court. This accomplishment is due to the craftsmanship of the company's bespoke clothing, the key to which is its tradition of technical accomplishment.

'Savile Row is a special place', says Henderson, 'Located in Mayfair, the most exclusive district in London, it is the workplace of over one hundred experienced craftsmen, who produce the finest suits in the world. Savile Row is our heritage, and we are entrusted with carrying on its traditions.'

When we spoke, Davide Taub, head cutter in Gieves & Hawkes bespoke division was wearing a button-three double-breasted suit in black silk. It featured a sculptural sharp shoulder line, roped sleeve heads, and double front darts, providing a remarkably fitting waist and back line. It had a controlled sense of elegance through the combination of its 100% silk material and the austerity of an almost military cut.

Taub continues: 'Bespoke means fitting to each individual customer. Each house has particular styles that it exceeds at, but none are defined by those styles. More important to the tailor's job is understanding the customer. We have customers from around the world, and we would not try to force British styling on clients who are not from the U.K. The vital thing is that the suit brings out the customer's individuality. There's no point in trying to make a Japanese businessman look like an Mediterranean playboy. The silhouette we pursue is that which reflects the beauty of the wearer, this is the goal toward which our techniques aim.'

The suit that Taub wears clearly reflects Gieves & Hawkes' bespoke philosophy. It is none other than the result of his broad and varied career experience, which began with London's established military tailor, Kashket & Partners. Following that, he learned cutting techniques at Savile Row tailor Maurice Sedwell. His innate talent was recognized at an early age, starting

タイルというのは特にない。それよりテーラーの仕事は顧客を理解することだと考えている。ここには世界中から顧客がやってくるが、イギリス人ではない彼らをブリティッシュスタイルにしようとは思わない。もっと重要なことはその人の個性がそのスーツに生かされているか。着用したときに快適であり、機能的なのか。ポケットは正しい位置にあるか。良くフィットしているか。日本人のビジネスマンが地中海のプレイボーイに見えるのでは意味がない。各自の個性を反映させた美しさこそ、我々が目指すシルエットであり、そのために我々の技術があると考えている」

そう語るトウブ氏のスーツには現在の「ギーヴス&ホークス」のビスポーク哲学が鮮明に反映されている。それは彼のこれまでのさまざまなキャリアによって築き上げられたものにほかならない。

トウブ氏はロンドンの老舗ミリタリー・テーラー「カシュケット&パートナーズ」でそのキャリアを開始。次にサヴィル・ロウのテーラー「モーリス・セドウェル」でカッターの技術を学んだ。その天賦の才能は早い段階

with his winning the Merchant Taylor's Golden Shear Competition for Best Menswear. He was furthermore assistant cutter under Edward Sexton, legendary right-hand-man to Tommy Nutter, and later returned to Maurice Sedwell as head cutter.

Both are tailors that pursue comfort and strong style, which shows in his suits today. While retaining the structural finish that is the hallmark of English tailoring and the military taste derived from Gieves & Hawkes extensive tradition, he adds to his creations a soft comfort.

'My suits today are the result of my past experience', he says. 'At Kashket I learned how to sew military uniforms quickly, but precisely, which is a fundamental of tailoring. At Maurice Sedwell I learned Savile Row tailoring, cutting in particular. Edward Sexton is of course a legend, best known for his colourful history, but of course he is more than all that. He has a very academic approach to tailoring, and under him I

で認められ、若手テーラーの登竜門、マーチャント・テーラーズ・ゴールデン・シアーズ賞においてベストメンズウェア賞を受賞。さらに、トミー・ナッターの右腕として知られた伝説のテーラー「エドワード・セクストン」でアシスタント・カッターとして働き、復帰した「モーリス・セドウェル」ではヘッドカッターを務めた。

イングリッシュ・テーラリングらしい構築的な仕立てや「ギーヴス＆ホークス」の膨大なアーカイブに由来したミリタリー・テイスト、加えて、見た目からは想像できない柔らかな着心地が備わっている。

「今までのすべての経験が今のスーツに生かされている。『カシュケット』では軍服をいかに正確に早く縫いあげるのか、テーラリングの仕立ての基本を学んだ。『モーリス・セドウェル』ではサヴィル・ロウの仕立て、特にカッティングを学んだ。それからエドワード・セクストン、彼は偉大なる伝説であり、過去の華やかな歴史が取り上げられることが多いが、もちろんそれ以上の存在だ。彼のアカデミックな仕立てへのアプローチも含め、どうしたら向上できるのか、常に努力を続けるその

learned how to make continual effort toward bettering my skills. It would be foolish to be completely satisfied with the suits I produce. For me, the perfect suit doesn't exist, but of course it is what we strive for. If we aren't aware of imperfections then we cannot continually improve on our craft. A bespoke suit is the unification of our creativity and our skill. Savile Row's history goes back over two hundred years, and the bespoke suit is at the pinnacle of human-crafted goods. We take a flat, piece of cloth which we mould and sculpt, to create a three-dimensional form that envelops the human body. Sexton taught me that in both cutting and tailoring, the most important aspect is integrity.'

'Integrity' implies a sense of completeness. A sense of virtue, rectitude, and honesty. Even as Taub describes his passion for tailoring, his narrative is humble, reminiscent of the sincere attitude of the craftsmen of yesteryear.

Taub says that as head cutter, he must demonstrate

姿勢を学んだ。自分の作ったスーツに完全に満足してしまったら、それは愚かだと思う。実際、私にとって完璧なスーツなど存在しない。どのスーツも異なり、すべてのスーツが難しい。ビスポークは我々の創造性と技術力の統合によって作られている。200年の歴史を超えるサヴィル・ロウで、人の手から作られる最高峰のクラフトがビスポーク・スーツだ。平面の生地から、三次元の人間の身体を包み込む立体を作りあげる。カッティングにおいても、仕立てにおいても重要なものはインテグリティーだと彼から学んだ」

〝インテグリティー（integrity）〟。その言葉が意味するのは完全無欠、高潔、清廉、誠実だ。自らのテーラリングにかける情熱を語る、その語り口は謙虚であり、昔ながらの職人の真摯な姿勢を彷彿とさせる。

加えてヘッドカッターであるトウブ氏に求められるのは、個人の技術の研鑽ばかりではない。ビスポーク部門で働く全員を統率し、最上級のスーツを作る、その士気をチーム全員に浸透させることだという。

「それにはスーツ作りに明確なヴィジョンを示し、顧客、生地商、職人、スーツの仕立てに関わるすべての人々に敬意を持って仕事することが不可欠だ」

サヴィル・ロウで働くことはテーラーにとって特別な意味があるという。この小さな通りに最高峰のテーラーが集い、世界中から超富裕層がやってくる。そのブランド価値はまさに唯一無二だ。しかし、トウブ氏が語るのは最高級のラベルとしての価値だけではない。

「サヴィル・ロウでは誰もが知り合いなんだ。ランチで会ったときにも、今作っているスーツについて話し合う。我々は競争もしているが、むしろ、ここで技術と情熱、伝統を共有している。サヴィル・ロウで作ることに意味がある。私が目指すのはこの伝統を継承し、技術を向上させ、現代的な自分の美学を加えることだ」

他のテーラーとは一線を画す巨大な規模を持つ「ギーヴス＆ホークス」。だが、地下のワークルームでビスポーク・スーツが作られる伝統は、他のテーラーとなんら変わりがない。240年を超えるテーラリングの歴史は、サヴィル・ロウ1番地で今も継承されている。

19世紀はイギリスの世紀、20世紀はアメリカの世紀とするなら、21世紀は間違いなく中国の世紀となることだろう。多くのラグジュアリー・ブランドが付加価値としてビスポークによるクラフツマンシップを打ち出している今、こうした彼らキーパーソンたちは、金で購うことのできない神聖な歴史を持つ「ギーヴス＆ホークス」というブランドに、どんな進化をもたらすのだろうか。

not only a devotion to his individual skill, but also leadership in directing the entire bespoke division staff, giving his team the motivation to continue producing some of the finest suits in the world.

'To do so, you need to demonstrate a clear vision for suit-making', Taub says. 'It is vital that we perform our job with the utmost respect for the customer, the fabric manufacturers, the craftsmen—everyone associated with tailoring.'

He tells us that working on Savile Row has a special meaning for tailors. The best tailors in the world ply their trade along this short street, and attract some of the wealthiest clienteles. Savile Row's brand value is second to none. However, what Taub describes is not only the value of an exclusive label.

"Everyone here knows each other. When we run into each other at lunch, we talk about the suits we're working on. We're competitors, yes, but at the same time we share a tradition of skill and passion. There's meaning behind what we do on Savile Row. My goal is to maintain that tradition, while improving my own skill and adding my own contemporary aesthetic."

What sets Gieves & Hawkes apart from other tailors is its enormous scale; however, they share the same tradition of crafting in their basement workroom, which is a tradition that has lived on for over 240 years at 1 Savile Row.

The nineteenth century belonged to England, and the twentieth to the United States. The twenty-first century will no doubt be China's. Today many luxury brands aim at added value through the craftsmanship of bespoke service, and we look forward to how the key persons of the upcoming age will alter the sacred history of Gieves & Hawkes; something unobtainable at any price.

**KENTON TRIMMINGS**
WHOLESALE TAILORS' TRIMMING MERCHANTS
5 MOZART STREET, LONDON W10 4LA

*chapter one*
―――――
*Tailors*

# Chittleborough & Morgan

チトルバラ&モーガン

12 Savile Row, London, W1S 3PQ
TEL:+44 (0)20 7437 6850
www.chittleboroughandmorgan.co.uk/

トミー・ナッター直筆のエルトン・ジョンのステージ衣装のデザイン画からは彼のクリエイティビティーが伝わる。
Tommy Nutter's creativity is evident in these designs for stage costumes for Elton John.

　ロイ・チトルバラとジョー・モーガン、ふたりのカッターによって創業されたのが、サヴィル・ロウ12番地に位置するテーラー「チトルバラ＆モーガン」だ。

　70年代の伝説となったサヴィル・ロウの革命児、ザ・ビートルズが「アビー・ロード」のアルバムジャケットで着用したスーツや、ミック・ジャガーが自らの結婚式で着用したホワイトスーツ、これら時代に名を残すスーツを生んだのがトミー・ナッターによるテーラー「ナッターズ・オブ・サヴィル・ロウ」である。

　「チトルバラ＆モーガン」はこの「ナッターズ」の系譜を引く、サヴィル・ロウに現存する唯一のテーラーとしても知られている。

　現在、同社を率いるディレクターにしてヘッドカッターのジョー・モーガン氏は、1970年、20歳のときに「ナッターズ」を経営していたデザイナーのトミー・ナッターとヘッドカッターのエドワード・セクストン、ふたりのアシスタント・カッターとして入社した。

　「私は本当に幸運だったと思う。ここに入る前はグレーのウーステッドのコンサバティブなスーツを着て、細いネ

You will find Chittleborough & Morgan' founded by legendary cutters Roy Chittleborough and Joseph Morgan' at 12 Savile Row.

Savile Row was famous in the 1970s for the 'rebel' tailor Tommy Nutter, owner of Nutters of Savile Row and designer of such iconic suits as those worn by the Beatles on the cover of their Abbey Road album and the white suit worn by Mick Jagger at his wedding ceremony.

Today, Chittleborough & Morgan is known as the only tailor on Savile Row that can trace a direct linkage to Nutters. Joe Morgan serves as Director and Head Cutter, and along with Edward Sexton was Assistant Cutter to Tommy Nutter from the time he joined Nutters in 1970, when he was twenty years old.

Morgan vividly remembers those days.

'I have truly been so fortunate. Before coming here I wore conservative grey worsted suits and stiff-collared shirts with thin ties, as most tailors did at the time.

エルトン・ジョンの名がある注文台帳。ダブル・スーツにはオックスフォード・バグスなど興味深いディテールが記されている。
An order ledger featuring Elton John's name. Interesting details are shown, such as Oxford bags for a double-breasted suit.

クタイに固いカラーのシャツを着ていたんだ。当時はほとんどのテーラーがそんな風だった。ところがここに来て、すべてが変わった。『ナッターズ』のスーツはスタイリッシュで、流行の先端を行っていた。店には毎日のようにポール・マッカートニーやジョン・レノンが遊びに来て、実にエキサイティングな時代だった」

当時を思い出す、モーガン氏の語り口は鮮明だ。「『ナッターズ』が成功したのは、トミーのデザインが誰も作ったことのないスタイルでありながら、サヴィル・ロウの他のテーラーと同じ、超一流のクオリティーを持っていたからだ。彼が登場する以前には、そんなことが出来たテーラーは誰もいなかった」

紳士服の聖地「サヴィル・ロウ」に革命を起こした反逆児トミー・ナッターと「ナッターズ・オブ・サヴィル・ロウ」はどんなテーラーであったのか。

1969年2月14日のバレンタイン・デー、ついに革命の幕は上がった。

場所は19世紀から「紳士服の聖地」と謳われたテーラリングの伝統を誇るロンドンのサヴィル・ロウ。その

Working with Tommy changed all that. Nutters suits were stylish, the very forefront of fashion. People like Paul McCartney and John Lennon would visit us all the time, so it was a truly exciting era.'

Speaking of Nutters' success, he says, 'It was because Tommy's designs were styles that had never been done before, but still retained the same utmost quality of other Savile Row tailors. Before he appeared on the scene, nobody had ever achieved that.'

To understand just how revolutionary Tommy Nutter and his store were, we have to go back to its beginning, on St. Valentine's Day of 1969.

Known as the Mecca of menswear since the nineteenth century, Savile Row had been characterised by its stately Georgian architecture and thick, closed curtains. But a new store at 35 Savile Row—the first truly new tailor to appear there in 120 years—proudly sported a large glass show window. That window was filled with suits featuring exaggeratedly wide lapels,

Chittleborough & Morgan　チトルバラ&モーガン　65

日、オープンした新しいテーラーには、モデルのトゥイギーから貴族のモンタギュー卿まで、当時の名だたるセレブリティーが集まり、サヴィル・ロウ35番地は史上空前の喧噪に包まれた。

デザイナーのトミー・ナッターとカッターのエドワード・セクストン率いる「ナッターズ・オブ・サヴィル・ロウ」は、ジョージアン様式の建物が建ち並び、分厚いカーテンに閉ざされたサヴィル・ロウで、初めて全面ガラスのショーウィンドウを設け、120年ぶりにサヴィル・ロウに登場した新たなテーラーだった。

その大きなウィンドウに飾られたのは、極端なワイドラペル、幅広く男性的なショルダーライン、対照的にぎりぎりまで絞り込んだハイウェスト、1920年代の〝オックスフォード・バグス〟に由来する幅の広いフレア・トラウザーズのスーツだった。

スウィンギング・シックスティーズで沸き返ったロンドンのストリート・カルチャーを、旧態依然としたサヴィル・ロウに持ち込んだ、それこそがまさに革命だった。

この仕掛人こそ「ナッターズ」の出資者、「アップル・

broad and masculine shoulder lines balanced by high waists as narrow as they could possibly be, and flared trousers inspired by 1920s 'Oxford bags'.

Through Nutters, Tommy Nutter and his assistant Edward Sexton had brought the reborn street culture of 'swinging Sixties' London to traditional and outdated Savile Row. The result was a crowd unlike anything seen before, from supermodel Twiggy to nobility like the Montagues.

Backing the store were Peter Brown, Managing Director of the legendary Apple Corps, and other Beatles relations. Apple Corps itself was located just across the street, so Nutters became a glamorous mingling spot for figures in the music industry.

Tommy Nutter was a salesman at Donaldson, Williams & Ward in nearby Burlington Arcade when he met cutter Edward Sexton, an encounter that culminated in this revolution. Against a backdrop of 1970s glamour, the combination of Nutter's charisma

Chittleborough & Morgan　チトルバラ&モーガン　67

トラウザーズのウェスト部分の弧を大きく描くカーブはアイロンワークの高い技術によって生み出される。
The large curves in the waist of these trousers are the result of excellent iron-work techniques.

コーポレーション」のマネージングディレクター、ピーター・ブラウンと関係者たちである。サヴィル・ロウ3番地のもうひとつの音楽業界における伝説、「アップル」の向かいにあった「ナッターズ」は、業界の人間が出入りする華やかな社交場と化した。

サヴィル・ロウにほど近いバーリントン・アーケードにあったテーラー「ドナルドソン、ウィリアムス&ワード」のセールスマンであったトミー・ナッターと、そこでカッターをしていたエドワード・セクストンとの出会いが、この革命を生み出したのだ。

ナッターのカリスマ的なデザイン力、加えて、セクストンの卓越した技術は、最先端のファッションと音楽が結びついたグラマラスな70年代に、サヴィル・ロウ発の新たなメンズファッションの潮流を創りあげることとなる。

多くの人々の記憶に残る1969年のジョン・レノンの結婚式、1971年のミック・ジャガーの結婚式のホワイトの3ピースも共にナッターのものだ。その顧客はザ・ビートルズ、ミック・ジャガー、エルトン・ジョンなど音楽業界の錚々たる顔ぶれが並んでいた。

ところが、ナッターの栄光は長くは続かなかった。1976年、ナッターはビスポークに飽き足らず、自身のブランドネームで既製服を販売するため、「ナッターズ・オブ・サヴィル・ロウ」を離れ、1977年に「キルガー」へ移ってしまう。

「これが悲劇の始まりとなってしまった。トミーは既製品ではビスポークほど自分のアイデアをうまく表現できなかったからだ。このことが結果的に彼を追いつめたのだと思う」とモーガン氏は語る。

1988年には再びサヴィル・ロウで自身の店をオープンするが、わずかその4年後の1992年、惜しくもHIVにより49歳の若さで死去した。

一方で、1981年にはエドワード・セクストンが「ナッターズ」を去り、サヴィル・ロウ37番地に自身の店、「エドワード・セクストン」をオープンする。

名門「キルガー、フレンチ&スタンバリー」に師事し、将来を嘱望されたセクストンにとって、「ナッター」の名に留まることに飽き足らなくなったのは自然な成り行きだった。セクストンはその後サヴィル・ロウから移転し、現在もナイツブリッジで営業を続けている。

伝説は幕を閉じ、誰もがサヴィル・ロウを去った。だが、モーガン氏は今も変わらず、この地で「ナッターズ」の美学を守り続けている。

デザイナーのトム・フォードがサヴィル・ロウにオマージュを捧げているのは有名だが、特に影響を受けたのは

and design skill with Sexton's exceptional technique fused high fashion and the music scene into a new departure for Savile Row fashion.

In 1969 they crafted the memorable suit John Lennon wore at his wedding ceremony, and in 1971 did the same for Mick Jagger. Other eminent clients from the music world included the other Beatles and Elton John. However, Nutters' fame did not last long. Seemingly tired of the bespoke world, in 1976 Tommy abandoned Nutters to use his name for ready-to-wear branding, and in 1977 joined Kilgour, French and Stanbury.

'That was the beginning of tragedy', Morgan recalls. 'Tommy just wasn't able to express himself through ready-made clothing the way he could with bespoke. I think that's what drove him away, in the end.'

Nutter returned to Savile Row with his own shop in 1988, but sadly died due to complications from AIDS just four years later at the too-young age of 49.

Famous designers such as John Galliano and Timothy Everest had worked at Nutters in the late 1980s, so it is difficult to gauge the extent of Tommy Nutter's influence on men's fashion. Designer Tom Ford is famous for his homages to Savile Row, and says that Tommy Nutter was a particular influence. Morgan asserts that indeed, one can find many similarities between Tom Ford's ready-made clothing and Nutters' lines and details.

Given Edward Sexton's training at prestigious Kilgour, French and Stanbury and everyone's expectations regarding his future, it is perhaps no surprise that he left Nutters in 1981 to open his own store, at 37 Savile Row. He later left for Knightsbridge, where he remains today, thus drawing the curtain on two Savile Row legends.

I asked Morgan what it was like working with a British fashion superstar like Tommy Nutter.

'In a word, he had overwhelming charisma. Not only did he dress people in stylish suits, he also made them fall in love with him. He was great fun to work with, and I don't think that the revolution that was Nutters would have been possible without such a charming character.'

Nutters' clients were not limited to the music world, but rather extended to personalities such as Formula

Chittleborough & Morgan　チトルバラ&モーガン　71

絞り込んだウェスト、広がったスカートのアワーグラス（砂時計）シェイプ、シルエットで驚くほどの華やかさが表現されている。
A tight waist and wide, hourglass skirt present a remarkably graceful silhouette.

「トミー・ナッター」だと語っている。事実、モーガン氏もトム・フォードの既製品はナッターズのラインやディテールに非常に近いと述べている。

　1980年代後半にはナッターの下で働いたジョン・ガリアーノやティモシー・エヴェレストなどのデザイナーを生み出し、トミー・ナッターが後のメンズファッションに与えた影響は計り知れない。

　では、ブリティッシュ・ファッションにおけるスーパースター、トミー・ナッター自身は、果たしてどんな人物だったのだろうか？
「トミーには強烈な魅力があったよ。スーツをスタイリッシュに着こなすだけでなく、会った誰もが彼を好きになった。一緒に働くのは楽しかったし、トミーの愛すべきキャラクターなくしては、『ナッターズ』の革命もなかっただろう」とモーガン氏は語る。

　顧客はロックミュージック業界だけにとどまらず、F1運営組織CEOバーニー・エクレストン、作曲家アンドリュー・ロイド・ウェバー、そして女王陛下のテーラー、ハーディー・エイミス卿まで、実に多彩で豪華だった。

One Group CEO Bernie Ecclestone, composer Andrew Lloyd Webber, and the Queen's courtier Sir Hardy Amies.

Today, Joe Morgan is the inheritor of these styles that drew such acclaim.

'The suits I make are based on Tommy's, onto which I've added my own personal touch.'

Morgan's technique has been finely polished over his long career as a cutter. He furthermore embodies the character of the British gentleman in his polite manner and dealings with customers. Above all else, even his dark-coloured suits have a graceful silhouette that brings out an unmatched beauty.

Morgan prefers soft Italian fabrics with twisted warp and single-weft yarns like those of Loro Piana and Carlos Barbera, which help bring out elegant lines. A silhouette that dramatically tucks from the back to the waist is an inheritance from Nutter, further refined by Morgan. The beauty of the back line when such a suit is

繊細なミラネーゼ・ボタンホールがスーツのディテールに手仕事の美しさを加えている。
Delicate Milanese buttonholes add beautiful details to this suit's handwork.

こうして多くの人々を魅了した彼のスタイルをモーガン氏は受け継いだ。

「私が作るスーツはトミーが創ったスタイルをもとに、私自身の経験を生かして作りあげたものだ」

長年の経験によって磨かれたモーガン氏のカッターとしての技術に加え、英国紳士の〝ジェントルマンネス″を体現する穏やかな態度と接客、そして何より、スーツのシルエットの流麗な美しさ、ダークカラーでもこれほど色気のあるスーツは他に類をみないだろう。

ロロ・ピアーナやカルロス・バルベラなど、モーガン氏好みの経糸双糸緯糸単糸、柔らかなイタリアン・ファブリックの素材使いがエレガントなラインをより引き立てている。背中からウェストにかけて、吸い付くように大胆に絞り込んだシルエットは、ナッターから受け継ぎ、モーガン氏が進化させたもの。着用時のバックラインの美しさは特筆に値する。

「フィッティングは最低3回、多ければ多いほど完璧なものができる」

モーガン氏の完璧主義を反映した言葉だ。

worn deserves special mention.

Morgan is a stickler for perfection: 'We require at least three fittings, the more the better.'

None of the suits in his store are so boring as to be applied to mere business etiquette; they are designed to dress a man as glamorously as possible. They retain the very aesthetic that Tommy Nutter brought to Savile Row.

The unique taste represented by Chittleborough & Morgan is reflected in their client list. As an example, Rolling Stones' drummer Charlie Watts has been a customer since the 1970s; his stylish yet discrete fashions are a perfect fit for Morgan's suits.

'He's a very difficult case', Morgan says with a laugh, 'but the kind that gives a tailor a great deal of satisfaction. He has many ideas, always knows exactly what he wants, and will accept nothing else.'

Many other celebrities too support this small Savile Row store, no doubt because of Morgan's reputation for

ここでは単なるビジネス上の儀礼としての退屈なスーツは存在しない。限りなくグラマラスな男が装うためのスーツ。これこそがトミー・ナッターがサヴィル・ロウに持ち込んだ美学である。

このスーツの他にはないテイストの素晴らしさは、長年の顧客のロイヤリティーにも表れている。例えば、ローリング・ストーンズのチャーリー・ワッツ氏は1970年代から現在に至るまでの50年近い顧客である。チャーリー・ワッツ氏のスタイリッシュでディスクリートなテイストは、そのままモーガン氏の作るスーツと、本人の持つ抑制したエレガンスに重なる。

「彼は本当に難しい、そしてテーラーとしてはやり甲斐のある顧客だ。さまざまなアイデアがあり、自分の欲しいものが常にとても明確で、それ以外は一切受け付けないから」とモーガン氏は笑った。

チャーリー・ワッツのみならず、世界のセレブリティーがこの小さなサヴィル・ロウ・テーラーを支持している。その理由は寸分の妥協を許さず、自分たちの最上のクオリティーのビスポークを提供する、彼らの姿勢と技術を高く評価しているからに違いない。

モーガン氏がナッターから受け継いだのはカッティング・ラインの美しさばかりではない。

「トミーは華やかな色彩感覚や大胆な遊び心を、保守的なサヴィル・ロウのテーラリングに持ち込んだんだ」

そんなナッターの持ち味がよく出ているのが「コンビネーション・スーツ」だろう。これはジャケットはプレーン、ウェストコートはグレンチェック、トラウザーズはストライプなど、パターンのそれぞれ異なる服地を使い、スーツに仕立てたもの。当時の価格は台帳によれば180ポンド、現在の「チトルバラ&モーガン」の価格は6000ポンドだが、いまだに他とは違うスーツを求める顧客に根強い人気があるという。

さらに、ジャケットのラペルを身頃とは違う柄で縁取りしたり、ベルベットやデニムをスーツに使用するなど、斬新な素材使いでもユニークな才能を発揮した。

現在のモーガン氏はナッターのエッセンスを生かしつつ、現代にフィットするスタイルの提案をしている。例えばウェストコートはビジネスにもカジュアルにも着用できる、非常に汎用性の高いアイテムだ。単体で着ることを前提に、バック部分も前身頃と同じ服地で作っている。ここにラペルを付けたり、ミラネーゼ・ボタンホールをあしらうことで華やかさも加わる。ポケットがついているので携帯や財布も入るし、ジーンズにも合わせることができる便利なアイテムだという。

refusing to compromise in sizing and their ability to deliver the highest quality of bespoke clothing.

It is not only the beauty of his cutting lines that Morgan inherited from Nutter.

'Tommy brought a chic colour sense and a bold playfulness to the conservatism of Savile Row.'

This Nutter flair shows well in the 'combination suit', which combines patterns like a plain jacket, glen check waistcoat, and striped trousers into a single suit. Further examples of the uniqueness of this approach include differing patterns on jacket lapels and the body, or the innovative use of materials such as velvet and denim.

Ledgers show that such a suit cost £180 in the 1970s, but today a Chittleborough & Morgan suit costs £6,000. Even so, they have retained a strong base of customers who demand something a little different in a suit.

Today Morgan retains Nutters' essence while proposing styles that better fit contemporary tastes. For example, waistcoats are an extremely versatile item that can be used in both business and casual wear. Morgan creates waistcoats with the presumption that they might be worn alone, so fronts and backs use the same material. He increases their flamboyance by adding lapels and details like Milanese buttonholes. They have pockets that are convenient for carrying cell phones or wallets, and are flexible enough to be worn with jeans. Morgan says ideas such as this come from his younger customers.

'I believe it quite important that tailors create clothing suited to their younger customers, lest they fall behind the times.'

Michael Brown works as Morgan's assistant cutter, and at thirty years old as an occasional model. I asked him why he chose Chittleborough & Morgan.

'I actually studied computer science at university, but I was also interested in fashion and had worked at Paul Smith. My ideal for clothing is something that fits my body, is well tailored, and that will last a long time. Searching for the highest quality suit leads one to Savile Row, which in turn led me here. To me, bespoke tailoring doesn't just mean high quality, it also requires style. I find it regrettable that people looking for style pay high prices for ready-to-wear goods, while we

こうした発想は若い顧客との付き合いから生まれている。

「時代遅れにならず、若い人たちに受け入れられるものを作ることは、いつの時代でもテーラーにとってとても重要なことだと考えている」

そんなモーガン氏のもとでアシスタント・カッターとして働くのがマイケル・ブラウン氏だ（63ページ写真）。時にモデルも務める、現在30歳の彼は、なぜ「チトルバラ＆モーガン」を選んだのか。

「大学でコンピューター・サイエンスを学んだが、同時にファッションにも興味があって、『ポール・スミス』で働いたこともある。理想とするのは身体にフィットしていて、仕立てが良く、長く着られる服。最上のクオリティーのスーツを求めた結果、サヴィル・ロウ、そしてここに辿り着いたんだ。自分にとってはビスポークのスーツ作りが最上級であるだけではなく、スタイリッシュであることも大事だ。人々はスタイルを求めてブランドの高価な既製服を買うが、それは残念なことだね。反対に、ここには最上の仕立てとスタイル、その両方がある。何より、ジョーは品質に対して、一切妥協しない。常に自分たちが提供できる最上のものを作ろうとしている。働くのにこれ以上の環境はないだろう？」

ブラウン氏はナッターから受け継いだ華やかな哲学はもちろんのこと、日々、モーガン氏から顧客への接し方など多くのものを学んでいるという。ビスポークでは顧客ひとりひとり、全員異なる。彼らとどう信頼関係を築くかによって、スーツの仕上がりも変わってくる。それは経験によって培われるというのはサヴィル・ロウで働く、誰もが口にする言葉だ。

またビスポーク業界同士のつながりもここでは重要だ。昨年、サヴィル・ロウに待望のストアをオープンした同じビスポークの靴ブランド「ガジアーノ＆ガーリング」。当時、サヴィル・ロウでスペースを探していた彼らに場所を提供するなど、モーガン氏の温厚で温かな人柄は、特に定評がある。

1970年代、黄金時代を築いたトミー・ナッターのカリスマ性とグラマラスな仕立ての哲学は、ジョー・モーガン、そしてマイケル・ブラウンへと世代を超え、ここサヴィル・ロウで生き続けている。

can provide both style and excellent tailoring. Most important is that we never compromise the quality. We are always striving to create the best clothing we can. I can't think of a better environment to be working in.'

While Brown of course inherited his philosophy of chic from Nutter, he continues learning through Morgan's daily atitude with customers. Bespoke means different things to different people. The relationship of trust that they create with their customers has a direct effect on the quality of their suits. As anyone on Savile Row will tell you, this is a skill that is fostered through experience.

In addition, a relationship within the bespoke community is important. When bespoke shoemakers Gaziano & Girling were searching for space on Savile Row before they opened their highly anticipated store, Morgan proved his reputation for having a warm, welcoming personality by renting them space.

The charisma and glamorous tailoring of Tommy Nutter created a golden age for Savile Row in the 1970s, but his legacy continues to thrive in a new generation, as represented by Joe Morgan and Michael Brown.

ディレクターにしてヘッドカッターのジョー・モーガン氏。
Director and head cutter, Joe Morgan.

*chapter one*
―――――――
*Tailors*

ESPOKE TAILORS

# Thom
# Sweeney

トム・スウィーニー

1-2 Weighhouse Street,
Mayfair, London, W1K 5LR
TEL:+44(0)20 7629 6220
www.thomsweeney.co.uk

クラシックでコンサバティブ、構築的な仕立てのミリタリーを彷彿とさせるスーツ。未だにそれがブリティッシュ・テーラリングのすべてだと思っているならば、それは「トム・スウィーニー」を知らない人だろう。

　長いテーラリングの歴史を誇るロンドンにはサヴィル・ロウ以外にも多くのテーラーが存在している。中でも最先端のモダン・ブリティッシュを標榜する若手が「トム・スウィーニー」だ。

　新時代のテーラーを実感させる店内には、ディスプレイのように配置された無数の顧客の型紙、低く流れるモダンジャズ、ウィスキーのデキャンタボトル、「モダン・ジェントルメンの隠れ家」を意識した店内には、彼らの美学が反映されている。

　1990年代、新たなブリティッシュ・テーラリングの潮流を作りあげたテーラー、ニュー・ビスポークムーヴメントの旗手「ティモシー・エヴェレスト」の元で知り合ったトム・ウィデット氏とルーク・スウィーニー氏。その後、ふたりが独立して始めたビスポーク・テーラーの名は、まさにふたりの名前を組み合わせたもの。この名が示

　If your image of British tailoring is classic, conservative constructions evocative of a military uniform, then you clearly do not know Thom Sweeney.

　Of course, there are many London tailors with long histories outside of Savile Row. Among them, Thom Sweeney is one of the strongest advocates for 'modern British' styling.

　The store is the epitome of a new era in tailoring. Within, you will find the patterns of countless customers arranged as if on display, modern jazz playing softly in the background, and a whiskey decanter. It is a picture of the owners' aesthetic for the perfect 'modern gentleman's getaway'.

　Thom Whiddett and Luke Sweeney met in the 1990s under Timothy Everest, forefront of the 'New Bespoke Movement' of British tailoring, and the bespoke tailor that they established bears a combination of their names. As the name suggests, they share the responsibilities of both tailoring and store management.

モダン・ブリティッシュを代表するテーラー、トム・ウィデット氏（左）とルーク・スウィーニー氏（右）。
Representatives of the modern British tailor, Thom Whiddett (left) and Luke Sweeney (right).

Thom Sweeney　トム・スウィーニー

す通り、現在はテーラリングと経営、両方の分野をふたりで分担している。

「自分たちはラッキーだった。その頃はデザイナーといえばファッショナブルで若者が憧れるビジネスだったが、ビスポーク・テーラーは依然として古くさいイメージで、誰もやりたがる者はいなかった。反対に、自分にとってテーラーはいつもクールでカッコイイ、子どもの頃から憧れの職業だったんだ」とふたりは語る。

はじめは一部屋、口コミのみで始めたビジネスは、今ではビスポーク専門のウェイハウス・ストリート店に加え、メイド・トゥ・メジャー（パターン・オーダー）と既製服を扱うブルトン・ストリート店、ロンドンはメイフェアの中心に2店舗を構えるまでに成長した。

彼らのように成功した若手テーラーが登場したことも一因となって、ロンドンではテーラーを目指す若者が増加傾向にある。かつて肉体労働のイメージが強かったシェフという職業が、メディアに登場したセレブリティ・シェフの影響で、一躍、若者の憧れの職業となった。これと同じ現象がテーラー業界にも起きている。

'I was really lucky', Sweeney tells me. 'At the time, being called a "designer" was a fashionable thing for a young man to be, but bespoke tailoring had this old-fashioned air about it that kept everyone away. I had always thought of tailoring as very cool, though. I'd wanted to be a tailor since I was a child.'

They started their business from a single room, advertising via word-of-mouth, but today they have not only their shop on Weighhouse Street, but have furthermore opened additional stores on Bruton Place and in Mayfair to sell their ready-to-wear and made-to-order lines.

Thanks to the success of young tailors like Thom Sweeney, there has been an increasing number of youths hoping to become London tailors. It was not long ago that being a chef had a strong image of hard physical labour, but the appearance of celebrity chefs in the mass media transformed it into a desirable profession. A similar phenomenon is underway in the

その顧客層は弁護士からミュージシャンまで、年齢層は20代から80代までと実に幅広い。ここで注文できるビスポークの価格は2ピースで2195ポンドからと、サヴィル・ロウの平均価格に比べ、リーズナブルだ。サヴィル・ロウだけでなく、彼らのようなテーラーの選択肢があることも、ロンドンのビスポーク業界の魅力といえる。フィッティングは通常2回。初めの1着には合わせるシャツによってドレスアップもダウンもできる、クラシック・ネイビーの3ピース・スーツを薦めることが多い。予算に余裕があれば、同じバンチの色違いでグレーを作っておくといいとアドバイス。ネイビーとグレー、それぞれジャケットとウェストコートにトラウザーズの色違いを合わせることで、フォーマル感がありながら、外しの遊び心のあるコーディネートも可能になる。

彼らのクール・アイコンは映画『トーマス・クラウン・アフェアー』のスティーブ・マックイーンや、『007』のジェームズ・ボンドを演じるショーン・コネリーなど、スーツによる装いの美学を極めた男たちだ。

アイコンである60年代から70年代のスターを彷彿とさせるスタイリッシュな3ピースが彼らの基本のスタイル。時に古臭くなりがちなウェストコートだが、Vゾーンが映えるように、どんな形にしろ、開口部を大きめに取ることで新鮮に着こなせるという。

それまで古臭いと思われていた3ピース・スーツのイメージを覆したのは、英国を代表するモデル、デヴィッド・ガンディが着用した「トム・スウィーニー」によるダブル・ブレスティッドの3ピース・スーツだった。ラウンドシェイプで開きの広いウェストコートが印象的なスーツには、スタイリッシュでモダン、それでいてクラシックな男の装いの持つタイムレスな魅力に溢れていた。

「仕立て自体はキャンバスを重視したブリティッシュ・テーラリングだが、サヴィル・ロウでイメージされるミリタリールックではなく、キャンバスやパッドはごく薄いものを使用している。従来より軽く、快適な着心地だ」

全体のラインはスリムでシェイプされ、着丈は通常よりわずかに短い。高いアームホールに細めのスリーブ、特徴的な肩のラインのロープド・スリーブヘッドも従来よりすっきりとしたショルダーラインになっている。

クラシックなブリティッシュ・テーラリングに、洒脱なイタリアン・テイストを加えたスタイリッシュなビスポーク。それが彼らのハウススタイルだ。

サヴィル・ロウのテーラーによっては仕立て映えのする張り感が特徴のブリティッシュ・クロスを好むところも多いが、「特にブリティッシュ・クロスに固執することはな

world of tailoring.

One of the attractions of the London bespoke scene is that there are options beyond Savile Row like Thom Sweeney, whose customers range from lawyers to musicians, from youths in their twenties to seniors in their eighties. A bespoke two-piece suit costs £2,195, which is quite reasonable considering Savile Row prices.

As a first suit, they recommend a classic three-piece navy that can be used to dress up or down, depending on the shirt worn. If you have the budget, they advise buying a grey suit in the same pattern; combining colour variations of jacket, waistcoat, and trousers makes for a playful coordination that retains a feeling of formality.

Whiddett and Sweeney's 'icons of cool' include Steve McQueen in The Thomas Crown Affair and Sean Connery's James Bond, men whose aesthetic is defined by the suits they wear. Accordingly, their fundamental style is a sophisticated three-piece suit that evokes images of film stars of the 1960s and 70s. While waistcoats are generally considered démodé today, they manage a fresh look by creating a wider opening that emphasises the wearer's chest.

Similarly, top British model David Gandy's wearing of a Thom Sweeney three-piece suit went a long way toward dusting off its dated image. The suit's round shape and broadly open waistcoat is stylish and modern, yet retains a timeless classicism.

'British tailoring heavily emphasises use of canvas, but we are not after the military look of Savile Row—we prefer use of very thin canvas and padding that makes suits lighter and more comfortable.'

A Thom Sweeney suit has slim lines and a slightly shorter length than usual. Higher armholes, thinner sleeves, and roped sleeveheads provide a characteristic neat shoulder line. Their house style could be called a mashup between classic British tailoring and an unconventional Italian taste.

Many Savile Row tailors prefer to use British fabrics that provide a certain tension to their designs, but as Whiddett tells me, 'We are not fixated on British cloth. It is the suit that should define the best fabrics to use. I suppose if I have a favorite it would be fresco. It's a good fabric to travel in, well suited to hot climates.

# BESPOKE TAILORS

**THOM SWEENEY**
LONDON

WWW.THOMSWEENEY.CO.UK

1-2

THOM SWEENEY
LONDON

BESPOKE TAILORS

い。選ぶ生地はスーツの目的によって変わるのが普通だ。強いて言えば好きな服地はフレスコ。旅行や、どんな気候にも対応できる。グレーやネイビーのバリエーションも豊富だ。もっとカジュアルなスーツにはホップサックやウィンターツイードもお薦めだ。単純に気候だけを考えるなら、理想的な組み合わせは冬にはブリティッシュ・クロス、夏用はイタリアン・クロスだと思う」

ロンドンには多くのビスポーク・テーラーがあるが、どうやって自分にぴったりのテーラーを選ぶべきか？

「今はインスタグラムやブログもあるし、周囲の評判も参考に、リサーチすること。さらに自分のワードローブと語り合うことだ。そこからどう自分のワードローブを構築するのか。テーラーはヘアドレッサーみたいなもので、自分の感性と合うところを見つけるのが大事だ。重要なのは、テーラーとして何事に対してもフレキシビリティーなセンスを持っていることだ」

ヘアドレッサーを選ぶようにテーラーを選ぶ新世代。彼らが作る新鮮なモダン・クラシック、それが「トム・スウィーニー」のビスポーク・スーツだ。

It also comes in a wide variety of gray and navy. For more casual suits I also recommend hopsack or winter tweed. If you want to think simply in terms of weather, I suppose the ideal would be a British fabric in winter and an Italian one in summer.'

I asked how one should choose from among the many bespoke tailors in London to find the one best for you.
'Today we have Instagram and blogs, to see what others are saying. You should also have a dialogue with your wardrobe, to confirm what kind of suit you like, what styles you prefer. Then you think about how you're going to construct your wardrobe. A tailor is sort of like a hairdresser, in that it's important to find one that fits your sensibility. Also important is that the tailor has a flexible approach to the work.'

It is truly a new era when one chooses a tailor in the way they choose a hairdresser. The modern classicism of a Thom Sweeney bespoke suit is a herald of that age.

*chapter two*
―――――――――
*Shoemakers*

マスター・ビスポーク・シューメーカー、ジョージ・クレヴァリー氏（右）と顧客である俳優テレンス・スタンプ氏。ふたりの表情から互いの信頼関係が伝わる。
Master bespoke shoemaker George Cleverley (right) with actor Terence Stamp, a customer. Their expressions show their mutual trust.

# George Cleverley

ジョージ・クレヴァリー

13 The Royal Arcade, 28 Old Bond Street, London, W1S 4SL
Tel +44 (0)20 7493 0443
www.gjcleverley.co.uk

アンソニー・クレヴァリーのラスト（木型）には顧客台帳の筆頭に記載のあるバロン・ド・レデの名がある。
The customer list for Anthony Cleverley's lasts includes the Baron de Redé.

　ロンドン、メイフェアの喧噪の中心にありながら、ヴィクトリアン時代の意匠を色濃く残すロイヤル・アーケード。その静寂の中に佇む名店、ビスポーク業界で「ジョージ・クレヴァリー」の名を知らぬ者はいない。加えて、その顧客リストの豪華さは驚嘆に値するだろう。「アンダーソン&シェパード」や「ハンツマン」、「リチャード・アンダーソン」といった名だたるサヴィル・ロウのテーラリングハウス、ロスチャイルド一族に加え貴族や政財界の大物、テレンス・スタンプやチャーリー・ワッツ、ジョージ・クルーニーやコリン・ファースといった現代のセレブリティーに至るまで、彼らの作る靴は世界中のハイソサエティーの足下を飾り続けている。
　「ジョージ・クレヴァリー」を有名にしたのは、ビスポークの最高峰とされる伝統的製法とクオリティーに加え、質実剛健な英国靴のイメージを覆す、洗練とエレガンスを象徴した独自のデザインだ。
　スクエアトウの中でも特徴的な鑿（英語で「チゼル」）の形をしたチゼルトウは、男性的な端正さと華やかさを備え、ハンドメイドの技術だからこそ作り得る英国ビス

Located in the heart of the hustle and bustle of London's Mayfair district, the Royal Arcade is a resplendent example of Victorian design. Within its relative serenity you will find George Cleverley, a name known by all in the bespoke world. Their client list well reflects their reputation, including major tailoring houses of Savile Row like Anderson & Sheppard and Huntsman, nobility like the Rothschilds, movers and shakers in global finance, and modern-day celebrities like Terence Stamp, Charlie Watts, George Clooney and Colin Firth. For many years now, their shoes have decorated the feet of high society.

George Cleverley became famous through the quality of their shoes and traditional manufacturing methods that represent the height of bespoke fashion. Added to that, their unique designs represent a refined elegance that revolutionised the Spartan image of British shoes. They are best known for the masculine neatness and opulence of their chisel-toed shoe, whose

ビスポークを物語るピッチドヒール、深くくびれたウェスト、スリークな全体のライン、アンソニー・クレヴァリーの理想が反映されたサンプルシューズ。
A sample of Anthony Cleverley's ideal bespoke shoes—a pitched heel, deep-cut waist, and sleek lines.

ポークの美学を体現している。このチゼルトウで一躍名を馳せたのが創業者のジョージ・クレヴァリーである。

　1898年、ジョージ・クレヴァリーはロンドンの靴作りの家系に生まれた。第一次世界大戦従軍後の1920年、当時、メイフェアのクリフォード・ストリートにあったニコラウス・トゥーシェック経営の靴店、1853年創業の「N. トゥーシェック」で修行を積む。クレヴァリーが在籍した38年間で、チゼルトウによるスリークなデザインとシューレースなしで履くことのできるサイドエラスティック、革のつなぎ目をなくすためダミーのブローグを設けたブラインドブローグといった画期的なデザインを次々と打ち出し、店の名声は揺るぎないものとなった。

　1958年、60歳のクレヴァリーは独立して自らの店「ジョージ・クレヴァリー」を同じくメイフェアのコーク・ストリートで創業する。彼の卓越した才能のゆえか、在籍時代のトゥーシェック夫人との確執ゆえか、顧客は次第にクレヴァリーに移り、1970年に「トゥーシェック」は「ジョン・ロブ」によって買収。百年を超える歴史の幕を閉じることとなった。

manufacturing techniques embody the British bespoke aesthetic.

It was founder George Cleverley who brought this chisel-toe look to such prominence. Cleverley was born into a London shoemaking family in 1898. In 1920, following his involvement in World War I, he continued his training at N. Tuczek, founded in 1853 by Nikolaus Tuczek. During his thirty-eight-year employment there, he launched one groundbreaking design after another, including the sleek design of his chiseled toe, side elastics that allow shoes without laces, and 'blind brogues' that hide leather stitching through use of a dummy brogue. These achievements brought unwavering fame to the store.

In 1958, at sixty years old, Cleverley opened his own store on Cork Street, the same Mayfair road as Tuczek. Whether a result of his exceptional talent or the discord between himself and Mrs. Tuczek, customers migrated to George Cleverley, to the point where Tuczek was

伝説の担い手、マスター・シューメーカーのジョン・カーネラ氏（左）とCEOのジョージ・グラスゴー・シニア氏。
Bearers of the legend, master shoemaker John Carnera (left) and CEO George Glasgow Sr. (right).

1991年、ジョージ・クレヴァリーが92歳で亡くなると、彼の薫陶を受けたジョージ・グラスゴー・シニア氏とマスター・シューメーカーのジョン・カネーラ氏により、1993年に復活したのが現在のジョージ・クレヴァリーだ。カネーラ氏はクレヴァリーを継承した経緯をこう語っている。
「クレヴァリー氏が独立する前だが、『トゥーシェック』の職人に靴作りを学んでいた。よくショーウィンドウの『トゥーシェック』の靴を眺めたものだ。彼は私にこう言った。『これが世界最高の靴だ』。彼は正しかった。その完成されたシェイプや靴に宿るイマジネーション、それは他の靴とはまったく異なる次元のものだった。だから私にとって『クレヴァリー』を受け継ぐことは至極真っ当な選択だった」
　その2年後に、彼の甥であり、これも名職人とされたアンソニー・クレヴァリーが亡くなると、彼の家族の依頼により、商標権やアーカイブなどを1994年に取得した。その中には彼の60年に及ぶすべての顧客の名が記された台帳とサンプルカタログも含まれていた。

acquired by John Lobb in 1970, ending a century of shoemaking history.

George Cleverley died in 1991 at the age of ninety-two years old, leaving his store in the care of pupils George Glasgow Sr. and master shoemaker John Carnera, who reopened the store in its present incarnation in 1993.

Speaking of his inheritance of Cleverley's legacy, Carnera says, 'Before going independent, George learned shoemaking at Tuczek. I often stood in front of Tuczek, looking at the shoes in their store window. He once told me, "These are the best shoes in the world". And he was right. The perfection of their shape, the imagination in their form… They were on a completely different dimension from other shoes. That's what justified my taking over at Cleverley.'

Following the death of George Cleverley's nephew and fellow craftsman Anthony Cleverley, at the family's request Carnera and Glasgow acquired Cleverley's trademark and archives in 1994. Included was the client

アンソニー・クレヴァリーのサンプル台帳に掲載された茶のピッグスキンのペニー・ローファー、その実物のビスポーク・シューズからは精緻な職人技が伝わる。「ジョージは卓越した靴職人で、現在に続くクレヴァリーの名声を築いた。ジョージとは反対に、甥のアンソニー・クレヴァリーは靴自体の美しさにこだわるアーティスト志向の強い職人だった。皮肉なことに、これはアンソニーの脚に障害があったことと関係しているだろう。顧客も限られた紹介のある者しか受け付けなかったし、とにかくふたりはあらゆる意味で気が合わなかったんだな」と、ジョージ・グラスゴー・シニア氏は豪快に笑った。

だが、アンソニーの極端なまでに理想の靴の美学を追求した靴は、ファンが絶えず、同店に残る顧客リストには貴族階級を中心に各界の名士が名を連ねている。

カネーラ氏は「アンソニーのラストを見ると、彼の理想としていた靴作りがよく理解できる。極端に幅の狭いチゼルトウ、甲も薄く、ウェストは絞られ、ヒールも小さいが、全体のラインはこの上なくエレガントだ。今まで見た中で最高のスタイルだろう」と語る。

彼の言葉を裏付けるように、アンソニー・クレヴァリーが残したラスト（木型）は、より鋭角で流麗なラインを持っている。〝究極の靴〟を徹底的に追求した彼の哲学が鮮明に表現されている。同時に、何人の顧客が果たしてこのデザインに合う優美な足を持っていたのか。そう思わせるほど、その木型のラインは繊細で美しい。

「もちろん、彼らの時代と現代とは顧客のニーズも異なる。彼らのプライオリティーはいかに美しい靴を作りあげるか。しばしば、顧客がそれを履くということを忘れていたかのようだ。我々の哲学はもっと現実的だ。今の顧客は特にフィット感、それから見た目の美しさ、その両方を求めているからね。面白い話がある。ジョージ・クレヴァリーを受け継いだとき、最初の顧客は既に何十足も作っている上得意だったが、彼のリクエストは『自分の足に合う靴を作ってくれ』だった！ ジョージ・クレヴァリーには強い個性があり、アンソニーはさらにすごかった。とにかく顧客と話さなかった。もちろん、現代に生きる我々は顧客のリクエストによく耳を傾けているよ」とカネーラ氏は笑った。その証拠に、現在のクレヴァリーでは顧客の要望に合わせ、チゼルトウ、スクエアトウ、その中間のサスピシャス・スクエアトウと、スクエアトウのパターンだけでも豊富な選択肢がある。

採寸した数値から木型を作るラストメーカー、木型から型をおこすパターンメーカー、革を裁断するクリッカー、靴のアッパー部分を作るクローザー、ソールも含め

list and sample catalogues developed over sixty years in business.

Included in Anthony Cleverley's samples listing is a brown pigskin penny loafer, and the actual product displays the exquisite craftsmanship of bespoke shoes. As George Glasgow Sr. recalls, 'George was an exceptional shoemaker, and Cleverley's continued fame is a result of that. His nephew Anthony, on the other hand, was more of something like an artist who was dedicated to the beauty of the shoes themselves. Ironically, I believe that is related to the fact that Anthony was handicapped. He only accepted a select clientele brought to him through introductions.' Glasgow laughs, saying, 'In any case, the two were of a very different sort.'

Even so, there is no limit to the number of fans of Anthony's pursuit of the ultimate shoe aesthetic, as shown by the shop's client list, which contains famous names that form the core of the rich and famous.

'If you look at Anthony's lasts', Carnera says, 'you can see the kind of shoemaking that was his ideal—a chiseled toe with as little width as possible, a thin instep, a tight waist, a small heel. Above all else, supreme elegance in the overall lines. They're the most stylish shoes I've ever seen.'

Indeed, the lasts that Anthony Cleverley left behind show sharper, more elegant lines than what we see today, a clear representation of his philosophy regarding 'the ultimate shoe'. The delicate lines of these wooden models raise the question of how many clients have equally elegant feet to match.

Carnera laughs when I raise this point.

'Of course, clients' needs have changed between his time and ours. Anthony's top priority was just making the most beautiful shoes he could, to the point where at times he seems to have forgotten that people actually had to wear the things. Now we follow a more realistic philosophy. Today's customers want a good fit, not just an attractive look. An interesting story: Our first order after we took over George Cleverley was from a long-time and high-profile customer who already had dozens of pairs of our shoes, and his request this time was "Please make me some shoes that actually fit my feet!" George Cleverley had a strong individuality, but

102

たボトム部分をつくるボトムメーカー、仕上げを担当するフィニッシャー、これらの職人の手から生み出されるのがハンドメイドのビスポーク・シューズだ。

アッパーとボトム部分をつなぐ最も重要な部分、ウェルトを縫い付ける際にはわずか1インチ（2.5cm）に18スティッチを施すといった高度な職人技が「ジョージ・クレヴァリー」の栄光を支えている。

さらに厳選された最高級のレザー、特にクレヴァリーとロシアン・レインディア（トナカイ）・レザーの関係は伝説とさえなっている。1973年、イングランド南岸プリマス湾で、1786年に沈没したデンマークの帆船から帝政ロシアで製造されたトナカイの革が発見された。帝政ロシア独自の伝統製法は独特の赤褐色を帯びた燻したカラーと匂い、そして表面の鉄のローラーによる格子模様が特徴であり、200年の風月を経た重厚な風合いは他に類を見ない。クレヴァリーではこの革を修復、保管することを許されたプリマスの業者と契約を結んでいる。レザーの中でも希少性が高いロシアン・レインディアのなめし革を使用した靴も、老舗クレヴァリーを代表するスタイルのひとつといえるだろう。

この店の2階にあるワークルームで1週間に製作できるのはわずか10足ほど。採寸後の仮縫いは通常1回から2回、最初の注文から約1年を経てビスポーク・シューズが完成する。この靴作りの伝統を継承するにあたり、カネーラ氏が重要としていることは何か。

「理想のイメージを具現化して靴を作りあげる、これには天賦の才能もある。私にはその才能があったと思う。しかし、それよりもっと大切なことがある。完成された靴のイメージを木型として完成させるラストメーカー、それを具現化するボトムメーカー、双方のコンビネーションが不可欠だ。ビスポーク・シューズはひとりで作ることはできない。優秀なラストメーカーとボトムメーカー、さらに靴作りに関わるチームが最も重要だと考えている」

加えて、ジョージ・グラスゴー氏はこう語っている。「私がこのビジネスに加わった1960年代、ビスポーク・シューズはずっと安価だった。今は3000ポンドを超えるが、昔より多くの注文を世界中から得るようになった。初めて日本とビジネスを開始したとき、英国の靴メーカーは恐らく『チャーチ』を除いて、日本にひとつも無かっただろう。今とは隔世の感がある。いつの時代も変わらずに、私が最も重要と考えるのは仕事に対する献身的な態度だ。ビスポークはすべて人の手から生まれる。集中力と情熱が要求される。それには心の中に問題や不安があってはならない。ガールフレンドやボーイ

Anthony even more so. He never spoke with customers, you know. Of course, these days we try to do a better job of listening to our clients.'

A pair of bespoke shoes is the result of many processes, each performed by a craftsman: The last maker, who converts numeric measurements into a wooden model. The pattern maker, who develops patterns from the last. The clicker, who cuts the leather. The closer, who creates the upper part of the shoe, and the bottom maker, who produces the bottom portion and sole.

Part of George Cleverley's fame was his ability to place eighteen stitches per inch when sewing the welt, the most important structure binding the top and bottom of the shoe.

Cleverley was also known for his select, highest quality leathers, Russian reindeer in particular. In 1973, a shipment of Russian reindeer leather was recovered from a Danish boat that had sunk in England's Plymouth Sound in 1786. This leather was produced by traditional methods unique to Russia, giving it a distinctive reddish brown color and smoky fragrance, and a characteristic latticework pattern from pressing with iron rollers. It had a distinct, stately texture resulting from two centuries of aging that had been previously unseen. Cleverley contracted with the Plymouth operator charged with the restoration and preservation of this leather, resulting in shoes using this ultra-rare Russian reindeer becoming a representative style of George Cleverley.

The workroom on the first floor of the shop only has a capacity for ten pairs of shoes per week. After measurements are taken basting is normally performed once or twice, and it can take around a year from the time of ordering for a pair of bespoke shoes to be completed.

I asked Carnera what he considers most important in carrying on this traditional form of shoemaking.

'Developing a shoe that embodies an ideal, that's where genius lies. I believe I had that kind of talent. But there's something even more important—the combination of the last maker's ability to transform the image of the completed shoe into a wooden model, and the sole maker, who must realise that image. These

フレンド、家族、子どものこと、何か心配事があれば、それは必ず靴作りに反映される。すべてが順調であれば、素晴らしい靴が生まれる。良い靴は素晴らしい職人から生まれる。違う者が作れば、デザインやフィット感も違ってくるだろう。だからこそ、我々はいつも同じ人々、チームが『クレヴァリー』の靴を作ることが重要だと思っている。チームがハッピーであれば、顧客もハッピーだ。こうして『ジョージ・クレヴァリー』を経営していること、私は自分がとても幸運だと思うし、これ以上の幸福はない」。トレードマークの満面の笑みをたたえ、グラスゴー氏は最後の言葉を結んだ。

　最上級を知り尽くした者は、なぜ、「ジョージ・クレヴァリー」を選ぶのか。それはクレヴァリーのビスポーク・シューズを見れば一目瞭然だ。歴史によって育まれ、完成されたスタイルの美学は永遠に色褪せることはない。この事実がその理由を物語っている。

are absolutely vital. A pair of bespoke shoes is not the product of an individual. You need an exceptional last maker and sole maker, not to mention the rest of the team involved in the process.'

George Glasgow adds: 'When we first started doing business in Japan, it's quite a different situation today. But I believe that what hasn't changed is the importance of devotion to one's work. Bespoke is a product of human hands. It demands concentration and passion, and doesn't allow room for problems or anxiety. When everything goes well, the result is a wonderful pair of shoes. Good shoes come from exceptional craftsmen, and the design and fit will differ from person to person. That's why we at Cleverley consider it so important that the same people, the same team, always make our shoes.'

サイドエラスティック・デザインを持つアンソニー・クレヴァリーのサンプルシューズ。
Examples of side-elastic shoes by Anthony Cleverley.

*chapter two*
―――――
*Shoemakers*

# John Lobb

ジョン・ロブ

9 St.James's Street, London SW1A 1EF
Tel: + 44 (0)20 7930 3664
www.johnlobbltd.co.uk

1930年代に作られたフルブローグのオックスフォード・シューズ。
Full-brogue Oxfords from the 1930s.

　英国が世界に誇るビスポークのクラフツマンシップ、歴史と伝統を継承した名門シューメーカー、セント・ジェームズに位置する「ジョン・ロブ」こそ、まさにその名に相応しい。

　現在も創業者一族によって経営され、英国のビスポーク・シューメーカーの中で、唯一ロイヤルワラントを授与されている。さらに既製靴は製造せず、ビスポークの靴作りに徹しているのも「ジョン・ロブ」のみだ。

　創業者ジョン・ロブは1829年イングランド南西部コーンウォール地方の農夫の息子として生まれた。足が不自由であったためコーンウォールで靴作りを学び、ロンドンで靴職人の仕事を探すが、大都会ロンドンで彼を雇う者はいなかった。失意の中、既に移住していた兄を頼って、ゴールドラッシュに沸くオーストラリアに渡る。ジョン・ロブは靴作りとビジネス、双方に類い稀な才覚を備えていたに違いない。1849年にシドニーでブートメーカーを創業すると、金鉱で働く労働者にブーツを販売し、ここで一躍成功を収めた。その成功をもとに、1866年、ロンドンにブートメーカーを開店した。

The U.K. is home to world-class bespoke craftsmanship, as evidenced by the history and prestige of St. James shoemaker John Lobb. Still managed by its founding family, they are the only British bespoke shoemakers to have received Royal Warrants. They are also the only shoemakers fully devoted to bespoke products, offering no ready-to-wear shoes.

Founder John Lobb had a rare natural talent for both shoemaking and business. He was born in 1829 to a farming family in southwest England's country of Cornwall. Due to a physical handicap he studied shoemaking in Cornwall, then moved to London to seek work. Finding no employment there, he followed his older brother to Australia, which at the time was in the midst of a gold rush. In 1849 he founded a company to supply boots to prospectors, his first step toward fame. His success led to establishment as a London boot maker in 1866. The quality of his work garnered high praise, eventually leading to an award at The

# LOBB

INC. CHAS MOYKOPF   F.H. BUHL   CRAIG & DAVIS   JOSEPH BOX

# LOBB

LONDON ESTABLISHED 1849

彼の靴作りは既に高い評価を得ており、万国博覧会で賞を受賞、後にロイヤルワラントを授与される。こうしてプリンス・オブ・ウェールズ（後のエドワード7世）のブートメーカーとして王室とのコネクションを築きあげたのが、今日の「ジョン・ロブ」の歴史の始まりとなった。エドワード7世の死後、息子であるジョージ5世も顧客となるなど、現在のプリンス・オブ・ウェールズ（チャールズ皇太子）とエジンバラ公フィリップ殿下からのロイヤルワラント授与に至るまで、英国王室と最も縁の深いシューメーカーだ。

創業者の初代ジョン・ロブが亡くなると、孫の2代目ウィリアム・ハンター・ロブの時代に最盛期を迎え、ロンドンに2店舗、さらに1901年にパリ店をオープン。大量生産の既製靴が普及する以前、20世紀初頭は大英帝国の経済の隆盛と付随してロンドンのビスポーク・テーラーとブートメーカーにとっても最盛期であった。

彼の死後、ウィリアムの未亡人ベッツィーによって経営は引き継がれた。その後はベッツィーの息子エリック・ロブが3代目の後継者となったが、既に大量生産の既製靴は戦後の市場を席巻し始めていた。1976年にパリ店を閉鎖、この時にフランスのラグジュアリーブランド「エルメス」がパリの店舗と「ジョン・ロブ」の商標権を獲得した。エルメスは「ジョン・ロブ」のブランド名で高級既製靴の販売を開始し、加えて既製靴製造のためノーザンプトンにあった旧「エドワード・グリーン」のファクトリーも買収。現在も「ジョン・ロブ（パリ）」の既製靴はそこで製造されている。

こうして現在では、英国製の既製靴をメインに販売する「ジョン・ロブ（パリ）」と、完全なビスポークである「ジョン・ロブ（ロンドン）」、ふたつの「ジョン・ロブ」がメーカーとして存在している。オリジナルの「ジョン・ロブ（ロンドン）」は、現在も創業者一族である4代目ジョン・ハンター・ロブ氏、さらに5代目のジョナサン・ロブ氏によりロンドンで経営が続けられている。

かつて詩人バイロン卿の住居であったセント・ジェームズ9番地にある本店は、ウッドパネルが重厚な輝きを湛（たた）えるインテリアと共に、店内に鎮座する背の高いキャビネットが圧倒的な存在感を示し、中には年代物のサンプルシューズが整然と並んでいる。壁には100年にわたる王室からの礼状の数々が飾られ、すべてが渾然一体となって、ここに流れた時間と幾多の物語を訪問者に告げている。

この日案内してくれたディレクターのジョン・ホワイト氏は兵役終了後、1956年に「ジョン・ロブ」に入社し

Great Exhibition and receipt of a Royal Warrant. This allowed him to become the official boot-maker for the Prince of Wales (later Edward VII), the start of John Lobb's prestigious history. After Edward VII's death his son George V too became a customer, cementing John Lobb's long connection with the British Royal Family, including additional Royal Warrants from the current H.R.H. the Prince of Wales (Prince Charles) and H.R.H. the Duke of Edinburgh, Prince Philip.

Following founder John Lobb's death, the shop entered a golden age under grandchild William Hunter Lobb. They opened a second London shop, and in 1901 a store in Paris. The early twentieth century, a time before mass-produced, ready-to-wear products became widespread, was a good time for all bespoke tailors and shoemakers.

Following William's death, his widow Betsy took over management of the shop. By the time her son Eric Lobb took over, the post-war market was already flooded with ready-made goods. The Paris store closed in 1976, with Parisian luxury brand Hermes acquiring the Paris store and the John Lobb trademark. Hermes began sales of high-end ready-to-wear shoes under the John Lobb brand, and furthermore purchased the previous Edward Green factory in Northampton for increased production. Even today, they manufacture shoes there under the 'John Lobb (Paris)' brand.

So today there are two 'John Lobb' brands, John Lobb (Paris), which mainly produces British-made ready-to-wear shoes, and John Lobb (London), which specialise in bespoke shoemaking. The original John Lobb (London) is still run by the family, namely fourth-generation John Hunter Lobb and fifth-generation Jonathan Lobb.

The flagship store, located at poet Lord Byron's former residence at 9 St. James's Street, features wood panelling with a stately sheen, and the store is dominated by tall, imposing cabinets filled with an orderly array of generations of shoe samples. The walls are decorated with letters of compliment from the Royal Families spanning a century, a testament to the time and clients that have passed through the premises.

My guide was Managing Director John White, who joined John Lobb in 1956, following his military service.

た。3代目エリック・ロブはホワイト氏の父の友人であり、彼の名付け親を務めたと語った。現在の会長、4代目のジョン・ハンター・ロブ氏が入社したのは1959年。ハンター一族と共に現在の「ジョン・ロブ」を築き上げて来た。こうした意味でも「ジョン・ロブ」は真のファミリービジネスといえるだろう。

グランドフロアー（地上階）ではラストメーカーが木材をブロックから削り出し、丹念に足型の模型であるラスト（木型）に仕上げている様子が見える。ラストには耐久性があり、成形もしやすい、主にビーチ（ブナ材）を使用している。

7人のラストメーカーは採寸するフィッターの役も兼ねており、同時にフィッティングに対する全責任を負っている。ここでは一度担当したら、できる限り同じシューメーカーが顧客を担当する。すべてがハンドメイドだから、同じ数値を基にしても担当するシューメーカーにより靴の作りは微妙に異なるというのがその理由だ。

ホワイト氏が「マップ・オブ・ザ・フット（足の地図）」と呼ぶ採寸表には、基本4箇所の採寸場所に加え、骨の形状など足の特徴が書き込まれる。「左右同じ形の足を持つ人はほとんどいない。特に25歳を超えると、人間の足は生活習慣によってその違いが顕著に表れるようになる。例えば、プロのサッカー選手は通常は利き足が短く、その脚の方が強くなるといった風に」

加齢によって顧客の体型が変化するに従い、足の形も変化している。極端に足の形が変わらない限り、新しい木型を作ることはせず、足が大きくなった場合はレザーを継ぎ足し、小さくなった場合は削って対応する。

ここで働くのは木型を作る前述のラストメーカーに加え、木型から型紙を起こすパターンメーカー、型紙から革を裁断するクリッカー、裁断された革を縫製し、飾りを付けたり、靴のアッパー部分（底を除くすべての部分）を作るクローザー、縫製されたアッパーをつり込み、ウェルト（靴の甲革と底側の縫い目の間にいれる細革）、レザーソールをつけるボトムメーカー、靴のインソール（中敷）を敷くソッカー、最後に革の磨き仕上げをするポリッシャー、これら総勢約30人の職人で年間約600足のビスポーク・シューズを作りあげる。ほとんどがインハウスで働く職人であり、一人前の職人となるには最低でも10年はかかるという。

「ビスポークの靴職人というのは自分の半生をかけて学ぶ仕事だ。すぐに学べる単純な仕事ではない。毎日、異なるスタイルを学び、それぞれの顧客の異なる問題を解決する。すべてに時間がかかる」。その短い言葉には

He tells me that third generation owner Eric Lobb was a friend of his father, and furthermore White's godfather. The current Chairman, fourth generation John Hunter Lobb, joined the company in 1959. The Hunter family has built John Lobb to its current prominence, making it a family business in the true sense of the word.

On the ground floor I see craftsmen carving lasts from a block of wood, carefully forming them into modelled feet. The seven last makers also serve as fitters, charged with taking measurements and all other fitting tasks. Whenever possible, the same shoemakers continue to serve the same customers. This is because everything being handmade means different craftsmen will produce slightly different products, even when working from the same numeric values.

White shows me a sizing chart labelled 'Map of the Foot', which depicts the four basic points of measurement along with features related to bone structure. 'Very few people have identically structured left and right feet', he tells me. 'Especially after age twenty-five, differences in our feet resulting from lifestyle habits become prominent. For example, the dominant leg of a professional football player will normally be shorter and stronger than the other.'

Clients' body shapes change with age, their feet included. Even so, except in cases of extreme change the same lasts are used, with increases in foot size accommodated through the addition of more leather, or trimming should feet become smaller.

In addition to the last maker are the pattern cutter, who creates patterns from lasts, the clicker, who cuts leather according to the pattern, the closer, who sews together the individual pieces and adds ornamentation to create the upper portion of the shoe, the maker, who adds welts (thin pieces of leather inserted into the seam combining the sole and upper) and attaches the leather sole, the socker, who adds the insole, and the polisher, who gives the shoe its final polish. In all, a total of thirty craftsmen produce around six hundred pairs of bespoke shoes per year. Almost all craftsmen work in-house, and ten years' experience is considered the minimum to truly develop one's craft.

White describes the importance of experience in this trade: 'It takes half one's life to become a bespoke

ヴィンテージのルームシューズはかつて3つのワラントと支店を持っていた時代を彷彿とさせる。
These vintage room shoes are reminiscent of the era of three Royal Warrants and branch stores.

ホワイト氏の長年の経験が滲んでいる。

　アッパー部分に使う革はヨーロッパ各地からの厳選した最上級の材料を使用している。細工もしやすく、カラーバリエーションが多いカーフレザーに始まり、鹿革、オストリッチやクロコダイル、希少なものでは象革もあるという。

　本店のグランドフロアーから想像できないほど広い地下のワークルームには「ジョン・ロブ」の歴史が蓄積されている。その中には1930年以後の採寸台帳もある。1899年から1920年の台帳はロンドンのミュージアムに保管されている。過去の顧客といえば、オスカー・ワイルドとその恋人アルフレッド・ダグラス卿、実業家アンドリュー・カーネギーやアリストール・オナシス、政治家ハロルド・マクミラン、作家ジョージ・バーナード・ショー、スコット・F・フィッツジェラルド、俳優ローレンス・オリヴィエ、フレッド・アステア、ピーター・オトゥールなど、彼ら名士やセレブリティーにとってロンドンの「ジョン・ロブ」でビスポークの靴をオーダーすることはステータスであったのだ。

shoemaker. This is not a simple job that one can just pick up. We must learn new styles every day, and find how to adapt them to the various problems our customers experience.'

John Lobb's underground workroom, the expanse of which is difficult to imagine from seeing the ground floor, has accumulated much of the store's history, including sizing ledgers since 1930 (those from 1899 through the 1920s are housed in a museum in London). They show that having a pair of bespoke shoes from John Lobb on one's feet has long been a de rigueur status symbol for establishing one's credibility as a dignitary or celebrity; past customers include Oscar Wilde and his lover Lord Alfred Douglas, industrialists Andrew Carnegie and Aristotle Onassis, politician Harold Macmillan, writers George Bernard Show and F. Scott Fitzgerald, and actors such as Lawrence Olivier, Fred Astaire, and Peter O'Toole.

The flagship store is also famous for its basement

この本店でもうひとつ有名なものが、地下の倉庫の天井までうずたかく積み上げられた木型だろう。その数は2万足とも言われている。第二次世界大戦中、ドイツ軍によるロンドン大空襲でセント・ジェームズの店舗は爆撃の被害にあったが、3代目のエリックはすべての木型と顧客台帳を本店から移動させていたため、その難を逃れた。今は木型は増える一方のため、15年間注文がない顧客には手紙で廃棄する旨を伝えるようにしているそうだ。その後3ヵ月待って、返事が何もないようだと木型は処分される。

　「ジョン・ロブ」で最初にビスポーク・シューズを作る場合は約3200ポンドから、納期は採寸してから約8ヵ月、木型があれば約4ヵ月となる。こうして最上級の皮革とクラフツマンシップから作られたビスポーク・シューズは、実際のところ、どれくらい保つものなのだろうか。

　「その質問に答えるのは実に難しい。どれくらいの頻度で履いて、なおかつどれくらい歩くのか、歩き方、その人の体重、革の種類、手入れの仕方によっても異なる。長く保たせるためには、履いた後は必ずシューツリーに入れて保管すること、定期的に磨くこと、濡れた後は時間をかけて乾かすことが重要だ。最近修理した靴は40年前のものだが、もっと古いものもある。中にはアッパーは同じでソールとヒールをすべて交換するといった修理もある。上質な素材と高度なクラフツマンシップで作られた製品は作る時にも時間がかかるが、それだけ長く使うことができる」と、ホワイト氏は自信を持って語った。

　「初めに木型ありき（The last shall be first）」

　創業者ジョン・ロブは自らの靴作りの哲学をこう語った。創業者の意志を受け継ぎ、快適であることを優先した「ジョン・ロブ」の靴には、これが「ジョン・ロブ」であると顧客に訴えかける饒舌なディテールも、顕著なハウススタイルも存在していない。だが、キャップトウのシンプルなオックスフォードにせよ、フルブローグの装飾的なギリーにせよ、その靴が持つ普遍的でクラシックなスタイルには幾多の年月が育んできた風格が漂っている。

　ロンドンの老舗ビスポーク・シューメーカーの作る靴は単にハンドメイドだから高価というわけではない。激しい競争の結果、磨き抜かれた最高の技術、世界から厳選された最高素材、長年の歴史によって培われたハウススタイル、英国ビスポーク・シューズの歴史、そのすべての結晶がロンドンのビスポーク・シューズなのである。「ジョン・ロブ」はその象徴ともいえる名店である。

warehouse, in which some 20,000 lasts are stacked to the ceiling. The St. James store was destroyed in German air raids during The Blitz, but third-generation owner Eric Lobb averted disaster by having had the lasts and client ledgers moved to a safer location. The number of lasts continues to increase, so the company has been notifying customers who have not placed an order for fifteen years that their lasts will be disposed of unless they reply within three months.

A pair of bespoke John Lobb shoes starts at around £3,200. Delivery requires around eight months from initial measurements, or four months from an existing cast. I asked White how long a pair of bespoke shoes should last, given the excellent materials and craftsmanship involved.

'That's a difficult question to answer. It depends on many factors, such as how often the shoes are worn, how much they are walked in, how the wearer walks and his weight, the type of leather, and how the shoes are cared for. To make a pair of shoes last, one must always store them on a shoetree after they are worn, periodically polish them, and carefully dry them after they've got wet. I recently repaired a forty-year old pair of shoes, and I've seen older ones. Some customers completely replace the sole and heel, retaining only the upper. It is a time-consuming process to create shoes with superior materials and craftsmanship, but the result is a shoe that can be worn for a long time.'

Founder John Lobb expressed his philosophy of shoemaking as 'the last shall be first'. The current owners carry on his tradition of shoes that are above all else comfortable. There is no expressive detail or particular house style that marks a pair of shoes as being from John Lobb. But whether they are simple cap-toed Oxfords or decorative full brogue ghillies, they will exude a timeless, universal classic style that has been nurtured over many years.

Being handmade is not the only thing that makes a pair of shoes from an established London bespoke shoemaker so expensive. They are also the culmination of outstanding techniques polished through harsh competition, use the best materials available throughout the world, and feature styling developed over long histories. And John Lobb is the perfect example.

1990年代に作られた鹿革のダービー・シューズ。
Deerskin Derby shoes from the 1990s.

*chapter two*
---
*Shoemakers*

# Foster & Son

フォスター＆サン
83 Jermyn Street, London SW1Y 6JD
Tel: + 44 (0)20 7930 5385
www.foster.co.uk

創業1840年、2015年に175周年を迎えたロンドン最古のビスポーク・シューメーカー「フォスター＆サン」。

　1966年に現在の場所、ジャーミンストリート83番地に移転し、以来、同じ場所で営業を続けている。ジャーミンストリートに面し、ショーウィンドウのある落ち着いた佇まいを見せる1階の店舗、木型や革の裁断が行われる工房は店の2階にあり、ラストメーカーをはじめ、数人の職人が今日も働いている。

　「フォスター＆サン」のハウススタイルをそのまま象徴するかのように、華美な装飾は何もない。だが、プロポーションのバランスの取れた美しさ、控え目でありながらクオリティーの高さを感じさせる皮革の上質な輝き、ビスポークであることを告げるウェストラインをはじめとした全体の滑らかなシルエット、ひとつひとつ丁寧に作られたことが如実に伝わるその靴は、200年変わらぬというロンドンの「ウェスト・エンド・スタイル」の靴作りを正統に受け継いでいる。

　1999年には創業1750年、ライディングブーツとミリタリーブーツで知られた老舗「ヘンリー・マックスウェ

Founded in 1840, London's oldest bespoke shoemaker Foster & Son recently celebrated their 175th anniversary in 2015.

They relocated to 83 Jermyn Street in 1966, and have continued doing business there since. The show window expresses the calm demeanour of the ground-floor showroom, and last making and sewing take place in the upstairs workshop. When I visited, a last maker and several other craftsmen were hard at work.

　There are no ostentatious decorations in the store, a reflection of Foster & Sons' house style. Beauty is instead attained through balanced proportions, the subdued yet distinctive glow of high-quality leather, and the sleek silhouette of a waistline that can only be achieved through bespoke shoemaking. These are shoes that were clearly created one at a time, using traditional "West End-style" techniques that have remained largely unchanged for two centuries.

　In 1999 they took control of Henry Maxwell, a maker

ル」を傘下におさめた。その結果、現在は「フォスター＆サン」と「ヘンリー・マックスウェル」、両方のブランドの取り扱いがある。

　チャーリー・チャップリン、クラーク・ゲーブル、ポール・ニューマンなど多くの有名顧客を持つ同店だが、その名声を長年にわたり支えてきたのはラストメーカー、テリー・ムーア氏の存在である。彼の経歴は、そのまま、ロンドンの戦後のビスポークシューズの歴史といっても過言ではない。

　ムーア氏は1950年に伝説の名店「ピール＆Co.」に入社。同時に靴専門学校、ロンドン北部ハックニーに位置する「コードウェイナーズ・テクニカル・カレッジ」に週1回通いながら、靴作りを学んだ。

　「ピール＆Co.」は1565年、英国北東部ダーラムで創業。1765年に英国中部ダービーへと移り、1791年にはロンドンに進出した。一時は200人の従業員を抱えた最大のシューメーカーであり、かつての顧客にはウィンザー公の名もある。

　1965年に「ピール＆Co.」は閉店するが、この際、

of riding and military boots that was founded in 1750. As a result, today they carry both the Foster & Son and Henry Maxwell brands.

　The store's client list has long included famous names like Charlie Chaplin, Clark Gable, and Paul McCartney, thanks in part to exceptional last makers like Terry Moore. It is no exaggeration to say that his career exactly traces the history of bespoke shoes in post-WWII London.

　Moore joined the legendary Peal & Co. in 1950, where he learned shoemaking while attending weekly classes at Cordwainers Technical College in northern London's Hackney district. Peal & Co. was founded in 1565 in Durham, then relocated to Derby in 1765 before finally moving to London in 1791. At one time they had over two hundred employees, making them the largest shoemaker in the world, and customers the likes of the Duke of Windsor. Peal & Co. closed shop in 1965, but Moore took over the company's archives and techniques

ムーア氏は同店のアーカイブと技術を引き継ぎ、「フォスター＆サン」に加わった。

「踵はフィットする感覚が最も重要であり、靴の美しさはトウに集約される」と、手のひらで踵を包み込むような仕草と、トウのデリケートなデザインを再現するような手つきで語るムーア氏の脳裏には、理想の美しい靴が鮮明に刻まれているようだった。

気鋭の職人であったムーア氏は現在に続く「フォスター＆サン」のハウススタイルを作りあげた。特に、1966年に彼が開発したとされるパティーナ、画期的なアンティーク仕上げの染色技法は同店のアーカイブ、セミ・ブローグのオックスフォード「チャブス」にも見ることができる。現在はこのアンティーク仕上げと呼ばれる技法を用いるビスポーク・シューメーカーも多いが、その先駆者とされるのがムーア氏なのである。

さらにムーア氏が「ピール＆Co.」から「フォスター＆サン」にもたらしたものに、現在でも使用されているブーツと狐のロゴマークがある。1953年に「ピール＆Co.」が「バートレー＆サン」を買収した際、同社のロゴマー

and added them to Foster & Son.

Moore has a clear sense of his ideal shoe in mind. He cups a heel in his hand and gestures to describe the delicate design of a shoe's toe. 'A shoe's focus of beauty is at its toe', he says, 'but the heel is the most important factor behind attaining a good fit.'

As a determined, passionate craftsman, it was Moore who built up Foster & Son's current house style. Particularly noteworthy is the patina he developed in 1966, a breakthrough staining technique that results in an antique finish, used by many other bespoke shoemakers today. This finish can be seen in their 'Chaves' semi-brogue Oxford.

From Peal & Co., Moore also brought to Foster & Son its boot-and-fox logo, which Peal & Co. acquired along with Bartley & Son in 1953. Brooks Brothers purchased rights to these trademarks when Peal & Co. closed in 1965, explaining why a quintessentially American company uses the name of a British shoemaker with a

クを使用したことが起源となっている。このロゴマークと「ピール＆Co.」の名の組み合わせは、「ブルックス・ブラザーズ」が英国ノーザンプトンにあるファクトリー「クロケット＆ジョーンズ」や「アルフレッド・サージェント」などに委託製造している既製靴に残されている。これは1965年の閉店時、商標権を「ブルックス・ブラザーズ」が買い取ったためで、その内容を示す1965年1月4日付けの手紙も残されている。16世紀からの歴史を持つ英国のシューメーカーの名がアメリカを代表する「ブルックス・ブラザーズ」社の既製靴に記されているのはこうした事情からだ。

現在の「フォスター＆サン」に話を戻すと、名職人と謳われたテリー・ムーア氏の引退後、顧客の採寸から木型作り、靴の完成まですべての工程を行うシニアメーカーとして同店の看板を背負うのは、この道20年近くの経験を持つ松田笑子氏だ。

ビスポークの靴作りは木型を作るラストメーカーが最も重要な鍵を握る。優れたラストメーカーこそ店の看板であり、靴の個性となるハウススタイルを作る。靴の上部分を縫うクロージング作業には比較的女性が多いが、固い木材から木型を削り出すラストメーカーは力仕事ということもあり、伝統的に男性の仕事とされてきた。

長年の歴史を持つ英国の靴作りにおいて、老舗のビスポーク店で日本人女性のラストメーカーは前代未聞、当初は女性であることへの偏見もあった。

松田氏は「コードウェイナーズ（・テクニカル・カレッジ）では既製靴の作り方を学んだのですが、ビスポークの靴作りとはまったく違うものでした。テリーには人の手を介して一から作りあげる、本当のビスポークの靴作りを教えてもらいました。今まで大変なこともありましたが、辞めて日本に帰ろうと思ったことはいちどもないんです。ここで靴を作ることが毎日楽しくて仕方がない」と語る。その表情は晴れやかで迷いがない。

1997年に渡英して以来、靴作りへの情熱と高い技術が認められ、それが現在のシニアメーカーの仕事として結実している。

英国で修行した後、帰国して自らのブランドを立ち上げる日本人もいるが、松田氏はここでないと作れないものがあると言い切る。つまり、「フォスター＆サン」の中でシニアメーカーとして働くインハウスの職人であるからこそ学ぶものも多く、自らが理想として追求する最高峰の英国のビスポークシューズが作れるというのだ。

英国のビスポークを手掛けるハウスでは外注を意味するアウトワーカーとハウス専属で働くインハウスに大

lineage extending back to the sixteenth century.

Getting back to Foster & Son, following Terry Moore's retirement, twenty-year veteran Emiko Matsuda took over the position of Senior Maker, thus bearing the responsibility for all steps in the shoe-making process, from measurement to completion.

The last maker performs the most vital step in the fabrication of a pair of bespoke shoes. An exceptional last maker, the pride of any store, determines the house style that gives the company's shoes their uniqueness. While there are many women working as closers, the craftsmen who stitch together the upper parts of a shoe, last makers have traditionally been men, in part due to the arduous nature of carving a last from hard wood. Matsuda is therefore setting a precedent never before seen in the long history of British bespoke shoemaking.

Since her arrival in the U.K. in 1997, Matsuda's passion for shoemaking and her excellent technique have rewarded her well. With a radiant expression, she says, 'I learned ready-made shoemaking at Cordwainers [Technical College], but that was a very different way of making shoes. Terry taught me true bespoke shoemaking, where everything is handmade from beginning to end. There were some hard times, but I never once considered giving up and returning to Japan. Every day I spend here making shoes is truly a joy.'

Many Japanese who receive training in the U.K. return to Japan to launch their independent brands; however, Matsuda stays in-house as a Senior Maker at Foster & Son. She believes that there are experiences and opportunities obtainable only by working in-house, in order to pursue her vision of the ultimate British bespoke shoes.

Bespoke shoemakers traditionally divide the production process into stages such as last making, pattern cutting, and bottom making, but Matsuda has mastered each step herself. The ability to do so is another advantage of learning in-house.

Working in-house furthermore allows her to select the finest materials, down to individual pieces of leather. This is possible due to Foster & Son's long-established relationships with their suppliers. Fame as a London bespoke shoemaker comes not only from the having highest level of technical skill, but also the

20年を超える経験を持ち、すべてのシューメイキングの工程を手がけるシニアメーカー、松田笑子氏。
In her over twenty years of experience, Senior Shoemaker Emiko Matsuda has mastered all the processes required to produce a pair of bespoke shoes.

ラウンドトゥの美しさが際立つフルブローグのオックスフォード・シューズ。
Full-brogue Oxfords bring out the beauty of a rounded toe.

別される。ラストメイキングやパターンカット、ボトムメイキングなど、伝統的に個々の工程は分業制である。一方で、松田氏はビスポークの靴作りのすべての工程を習得している。これもインハウスで学んだ強みと言える。

さらにインハウスで働く場合は使う材料の革のひとつをとっても最上のものを使うことができる。それは過去の長いビジネス上の取引に裏付けされた老舗間の信頼関係があるからだ。例えば、英国に唯一残ったオーク・バークのタンナー、「J&FJ ベイカー」社との付き合いもそのひとつだ。好みの固さや仕上がりを伝えて作ってもらう、それは「フォスター&サン」との長年の信頼関係によって成り立っている。

木型（ラスト）の形に代表されるハウススタイルにも同様のことが言える。「長い年月をかけて出来上がったハウススタイルにはその形になった理由があります。カントリー用の靴にしても、乗馬用の靴にしても、お客様は実用品として必要だから購入されます。ここの持つ歴史と顧客層そのものが財産なんです。その上に自分の経験を積み上げて、お客様の望む靴を作りあげる。今も学ぶことが多い毎日です」

ムーア氏の引退後、変わったことといえば、自分でラインを考えて行うことが自然にできるようになったという。ムーア氏に師事していた間は、尊敬する師ならどう作るのか、それをいつも意識していたが、今は習得したムーア氏のスタイルを受け継ぎながら、フォスターらしさ、そして自分が美しいと思うスタイルを加味している。

こうして松田氏が作る靴は仮縫いは基本1回、仮縫いまで8ヵ月、完成まで5ヵ月、現地価格にして約3600ポンドとなる。

靴を製作し始めると、アートを作る感覚に加え、手を動かしてものを作る楽しさが先に来て、難しさは余り感じない。前後の工程を熟知していないといいものは作れない。やればやるほど、いろいろなことがわかる。「ビスポークシューズは完成までに長い時間がかかります。オーダーを頂いたときから製作の過程で、お客様の望んでいるものが少しずつ曖昧になってしまうこともあります。それをコントロールしてお客様が満足する完成品に作りあげる、それが私たちの仕事です」

もうひとりのラストメーカーのジョン・スペンサー、ここで8年のキャリアを持つパターン・メイキングのエマ・レイキンと、熟練の職人として経験を積んではいるが松田を含めたチームの年齢層は若く、これから「フォスター&サン」の靴作りはますます磨きがかかることだろう。

英国のみならず、全世界的な傾向として、伝統的な職

use of the best materials available. An example would be oak-bark tanned leather from J&FJ Baker, the last tannery in the U.K. that produces it. Thanks to the trust built over many years between these two companies, they can work together to get leathers with exactly the stiffness and finish required.

The same holds true for the lasts that give the shoemaker its representative house style.

Matsuda says, 'There is a reason why the house style we've developed over so many years takes the form it does. Whether it's a pair of walking shoes or equestrian boots, customers are buying them to fit a purpose. Our history and our customer base are our most important assets. They are the base upon which we continue to build our experience, so that we can make the shoes our customers desire. Even now, I'm learning every day.'

The biggest change after Moore's retirement is that Matsuda is now able to create the lines that she feels are most natural. While working under Moore she had to remain conscious of how her mentor would do things, but now she is able to start from what she inherited to produce styles that retain the essence of Foster & Son, but to which are added her own sense of beauty.

Matsuda generally performs basting once, which generally requires eight months from the time of order. Completion will require another five months, and the completed shoes will cost around £3,600.

Matsuda says that once she starts working on a pair, she forgets the difficulty of what she's doing—that is replaced by the feeling of producing art and the enjoyment of making goods by hand.

'It takes a long time to make a pair of bespoke shoes', she says, 'so there are many times where the customer becomes fuzzy with regard to what he originally wanted. Part of our job is controlling that, so that in the end the customer gets a pair of shoes he is happy with.'
Also part of Matsuda's team are last maker John Spencer and Emma Lakin, who has worked here for eight years as a pattern maker. They are young, despite their experience, and we look forward to how they will direct the future of shoemaking at Foster & Son.

Not only in England but throughout the world, the biggest problem with carrying on the techniques of traditional craftsmanship has been finding successors.

人技を継承する上での最大の課題は後継者問題だ。日本でも史上初のイギリス人杜氏（とうじ）が誕生するなど、国境と人種、性別を超えた伝統の継承の例は世界でも増えている。彼らに共通しているのは、その土地に根ざした、歴史が生んだ芸術と文化に対する敬意である。

　その地でなければ作ることのできない、妥協なきもの作りに自らの人生を捧げる彼らの姿は、従来の真摯な職人の姿そのままといえる。松田氏に代表される、国境なき新たな世代、彼らが創り出すクラフツマンシップの未来に期待したい。

Japan recently welcomed its first British brewmaster of Japanese sake, and other countries too are learning to exceed boundaries of race and gender to carry on their traditions. Common to all it is a respect for the art and culture born from and rooted in their adoptive lands.

　Looking to these craftsmen who have devoted their lives to the uncompromising craftsmanship that is only possible in these lands, we can see reflections of the craftsmen of the past who realized their trades. We look to Emiko Matsuda as a representative of this new era of craftsmanship that exceeds national borders.

Foster & Son　フォスター＆サン

*chapter two*
———
*Shoemakers*

# Gaziano & Girling

ガジアーノ&ガーリング

Gaziano & Girling Ltd.
39 Savile Row , London, W1S 3QF
Tel +44 (0)207 439 8717
www.gazianogirling.com

2006年、「ガジアーノ&ガーリング」の登場は靴業界に大きな衝撃を与えた。

ビスポークの靴作りの本流である英国でも、現存するビスポークのシューメーカーはわずかに数店に過ぎない。ビスポークのテーラーに比べると、シューメーカーは圧倒的に少ないのが実情だ。そこに新風を吹き込んだのが、英国を代表するシューメーカーを経たふたりの職人、トニー・ガジアーノ氏とディーン・ガーリング氏である。

「ジョージ・クレヴァリー」を経て、「エドワード・グリーン」のビスポーク・サービスを担当していたトニー・ガジアーノ氏がデザイン、パターン、ラスト（木型）を担当。「ジョン・ロブ」、「クレヴァリー」、「フォスター&サン」など名門ビスポークハウスでフリーランスのビスポーク・シューメーカーとして働いていたディーン・ガーリング氏が製作とマネージメントを担当している。

英国のメンズファッションといえばディスクリート、何事につけ抑制の美を尊ぶのが英国流の美学とされている。しかし、「ガジアーノ&ガーリング」の靴はそれとは

The appearance of Gaziano & Girling in 2006 had a huge impact on the shoe industry.

Compared to tailors, there are only a handful of bespoke shoemakers currently existing, even in the U.K. where the tradition of bespoke shoemaking is preserved. Despite the trend of bespoke shoemakers decreasing, the game changers were two shoemakers from representative English stores—Tony Gaziano and Dean Girling.

First working at George Cleverley and later as the leader of bespoke services at Edward Green, Tony Gaziano is in charge of designs, patterns, and lasts. Dean Girling, who mainly oversees production and management, was a freelance shoe maker working for the London bespoke houses, John Lobb, G.J. Cleverley, and Foster & Son etc.

U.K. men's fashion is known for its discreet look, one that exemplifies a British aesthetic that emphasises restraint in the face of all things. Not so the shoes of

一線を画している。イギリスの正統な靴作りを基本にしながらも、イタリアの靴作りにあるデザインの華やかさと色気を持つ、今までにない英国のビスポーク・シューズだ。

「我々の靴はイギリスとイタリア、クラシックとコンテンポラリー、互いに相反する哲学を融合させている。その独自のバランスに『ガジアーノ&ガーリング』の靴作りの哲学がある」とガジアーノ氏。「さらに重要なのはコンフォート、快適な履き心地だ。履いて馴らすという発想は間違いで、初日から履いてすぐに快適な靴であるべきだ」と語る。

この日、話を聞いたのは2014年春、サヴィル・ロウ39番地にオープンした「ガジアーノ&ガーリング」初のフラッグシップ・ストアだ。2006年にブランドを立ち上げてから、初のトランクショーを日本で行い、当時はサヴィル・ロウ12番地のテーラー「チトルバラ&モーガン」のスペースを借りていたことを思えば、以後のブランドとしての急成長は想像に難くないだろう。

店の中央で顧客を迎えるのはバーガンディ・カラーが

Gaziano & Girling. While retaining the fundamentals of traditional British shoemaking, their shoes exhibit opulent, sensual designs more reminiscent of Italian products.

'We try to bring a fusion of England and Italy to our shoes, conflicting philosophies of the classic and the contemporary', says Gaziano. 'That unique balance is the philosophy behind shoemaking at Gaziano & Girling. Even more important is how the shoe feels when it's worn. We don't believe that shoes should be "broken in"—they should feel comfortable from the first time they're put on.'

I interviewed them at their first flagship store at 39 Savile Row which opened in spring 2014.

Greeting customers in the centre of the store are gorgeous burgundy armchairs by Italian maker Poltrona Frau. They give an air of contemporary luxury, a perfect reflection of the owners' taste. Preferences may vary, but it sets them apart from traditional London

際立ったスクエアトウと華麗なデザインは英国靴のイメージを覆した。
The emphasized square toe and elegant design that revolutionised the image of British shoes.

美しい、イタリアのポルトローナ・フラウ社製のアームチェア。彼らのテイストをそのまま反映するかのように、インテリアのキーワードは「ラグジュアリー＆コンテンポラリー」。好みははっきりと分かれるだろうが、この点でもトラディショナルなロンドンのビスポーク・メーカーとは一線を画している。

ここではシグネイチャーのビスポークに加え、既製靴もよりビスポークに近く、パーソナライズもできる「デコ」、既製靴の「ベンチメイド」と3ラインを展開する。

なかでも彼らの靴作りの哲学をより饒舌に表現したデザイン、エッジの効いたスクエアトウが最もポピュラーだという。

「我々が理想としているのはロンドンのクラシックなビスポーク・ルックだ。英国の多くの既製靴メーカーはクラシックなノーザンプトン・ルックを基本としている。我々はあくまでビスポークの基本に忠実に、テイストは現代的で洗練された最上級の靴作りを行っている」とガーリング氏。「誰もが美しい靴を求めるが、実際の足は幅が広かったり、必ずしも美しくはない。どんな足で

bespoke purveyors.

Gaziano & Girling has three different product categories; bespoke, Deco and ready-to-wear 'bench-made' stock products. The 'Deco' line is a customisable product that is closer to bespoke than ready-to-wear. Best representing their shoemaking philosophy is their most popular design, a square-toed shoe with well defined edges.

'Our ideal is a classic London bespoke look', Girling says. 'Most British ready-to-wear shoemakers keep to a classic Northampton look. We want to stay faithful to the core tenet of bespoke fashion, namely superior quality in a refined, contemporary style. Everyone wants a pair of beautiful shoes, but actual feet aren't necessarily beautiful; they're too wide, or what have you. We create shoes that match what the customer desires, regardless of the shape of their feet, by adjusting overall proportions. Attaining that is the beauty of bespoke.'

あろうと、顧客の足の形に合わせながら、全体のプロポーションを調整して、顧客のイメージ通りの靴を作りあげる。そこがビスポークの醍醐味だ」

ビスポークは約3000ポンドから、フィッティングは通常1〜2回、英国からの注文は納期6ヵ月だが、海外ではフィッティングのタイミングによって異なり、約10ヵ月となる。

靴のディテールを見れば、限界までコバの張り出しを抑えたウェルト、その名の通りバイオリンを想像させるフィドルバックのベヴェルド・ウェスト、極度に強調したシャープなラインとデザインなど、高度な技術によって表現された彼ら独自の美学が如実に伝わってくる。

「既製靴の場合、シューメーカー本人によって経営されているブランドは数少ない。プロダクトラインで問題が起こったとき、我々ならすぐに解決できる。この点もG&Gのクオリティーにつながっている」とビスポークと既製靴、双方を生産する強みを説明した。

次に訪れたのは、ロンドンから電車で約1時間。規模が以前の約2倍となり、こちらも新しくなったノーザ

A pair of bespoke shoes costs around £3,000, requires one or two fittings, and can take up to six months for delivery from the U.K. Depending on the timing of fittings, overseas customers may have to wait as long as ten months.

But the results are spectacular—welts that suppress edge overhang to the extent possible, a fiddle-back bevelled waist worthy of the name, and a design with strongly stressed, sharp lines. It is details like this that vividly express the unique aesthetic of Gaziano & Girling.

Concerning the advantage of carrying both bespoke and stock products, Girling says, 'There aren't many ready-to-wear shoe manufacturers run by the shoemakers themselves. When there's a problem with the product line, we can address it immediately. That directly impacts the quality of our shoes.'

We next visited their factory in Kettering, Northamptonshire, about an hour's drive from London.

ンプトンシャー、ケタリングにあるファクトリーだ。ビスポークの担当はガジアーノ氏を入れて3人で月に約10足、既製靴で週に70〜80足を製造している。

　約20名の職人により、ラスティング、パターンメイキング、クリッキング、クロージング、ボトムメイキング、ポリッシング、すべての工程がここで行われる。既製靴のどの製造工程にも多くの人の手が関わっている。特に最後の工程、ポリッシングでは、指を使い、丹念に磨き込むことで、靴に生命が吹き込まれるように生き生きとした表情を見せていた。このハンドポリッシュによる磨きで一足の靴が完成となる。

　トニー・ガジアーノ氏に続く、もうひとりのラストメーカーのダニエル・ウィーガン氏は、スウェーデンからビスポークの靴職人を志し、渡英してきた。ファクトリーで通常7〜8時間、帰宅してから3〜4時間、一日の大半を靴作りに没頭している。

　「ここで働く前は靴作りに関わっていなかった。10代で働き始める職人を思えば、今、どんなハードワークでもやり遂げる覚悟がある。英国で修行する多くの日本人

Also new, it is about twice the size of the previous factory. Here, Gaziano and two other craftsmen produce about ten pairs of bespoke shoes per month, and seventy to eighty ready-to-wear pairs per week.

Around twenty workers perform each step in the process—last making, patterning, clicking, closing, bottom making, and polishing. Many people are involved in the manufacturing process for ready-to-wear shoes. The last stage in particular—polishing—is done with fingers, painstakingly working the leather to breathe life into it to bring out a vivid expression. When hand polishing is finished, the shoes are complete.

Only one person other than Tony Gaziano performs last making—Daniel Wegan, who came to the U.K. from Sweden to become a bespoke craftsman. Each day he spends seven to eight hours at the factory, and another three or four at home, making shoes.

'I wasn't involved in shoemaking before working here', he says. 'A craftsman that started in this trade in

を見てきたが、彼らもハードワーカーだ。きっと、彼らも気持ちは同じだと思う。家業で靴屋を継ぐ職人に比べ、やりたいことのヴィジョンが明確だし、覚悟もある」

スウェーデンにいた頃からメンズファッション、それもトラディショナルなスタイルに興味があったというウィーガン氏は32歳。従来の英国で生まれ育った昔気質の靴職人とは違う感覚を持つ、ニュージェネレーションの職人だ。「ビスポークは一足一足が異なる。さらに個々の職人が一貫して手をかけることから、そこに作るものの個性や美学が反映される。それがビスポークの靴作りの面白さだと思う」

一方、ファクトリー・マネージャーを務めるデイヴィッド・ラドロー氏は靴製造が地場産業であるこの地域で生まれ育った。15歳で靴製造の道に入り、ノーザンプトンの伝統の靴作りに生涯を費やしてきた、熟練の職人だ。

「時間が良い靴を作る」とラドロー氏は語る。「機械で縫うとしても、美しさを心がけるならば、昔ながらの機械を用いて、ゆっくりと縫うことが肝心だ。このファクトリーで昔の機械をわざわざ使っているのはそうした理由からだ。伝統的なグッドイヤーウェルティッドの靴作りはどの工程にも意味がある」

例えばベッドラスターという機械を用いて行う、アッパー部分のレザーをラストのトウ部分に被せて固定するラスティング（つり込み）の工程も、この機械なくしては行うことができない（142、143ページ写真）。

「スティフナー（踵部分の芯）もうちではレザー製。他のメーカーではヒールにプラスチックを使うところもあるが、その差は歴然だ」

すべての素材を厳選しているが、特にソールには、通常ビスポークにしか使用されない「J＆F.Jベイカー」社のイングリッシュ・オーク・バークの革底を使用。イングランド南西部デヴォンにある「J＆F.Jベイカー」社はローマ時代に建造された革の鞣し場から伝統的製法を守っている唯一のタンナー（革の鞣し製造業）であり、名だたるビスポーク・メーカーはすべて同社のソールを使用している。

ビスポークに近いとされる同社の靴作りだが、ビスポークと既製靴の違いは何かと訊いてみる。

「違いは数えきれないほどあるが、一言で言えばビスポークは軽く柔らかい。軽く快適な履き心地にするためにインソールに薄く軽いものを使用しているからだ。機械で縫うと丈夫だが、縫った部分はどうしても固くなる。ハンドソーンは見た目も美しく、柔らかい履き心地だ」

his teens is prepared to see things through, no matter how hard the work. I've seen many Japanese apprentices coming here to England, and they're all hard workers. I think they feel the same way. Compared to someone who's taking over the family shoe business, they have a clearer vision of what they want to accomplish, and they're willing to do what it takes.'

Wegan, who is now thirty-two years old, says that he became interested in traditional men's fashion while still in Sweden. He is part of the new generation of craftsmen, who bring a differing sensibility from old-school shoemakers born and bred in the U.K. 'Every pair of bespoke shoes is different. They are the product of each craftsman who works on them, and that is reflected in their individuality and aesthetics. That's what makes bespoke shoemaking so interesting.'

Factory manager David Ludlow was born and raised locally in Northampton, an area known for shoe manufacture. He is an experienced craftsman, having started in the business when he was fifteen, and has devoted his life to the traditions of Northampton shoemaking.

'It's time that makes a good shoe', he says. 'If you want beautiful results from mechanical sewing, you've got to do it slowly, using the old machines. That's why we keep all these old machines here in the factory. Every step in the manufacture of a traditional Goodyear welt is important.'

An example is a machine they call the 'Bed laster', which is invaluable in the process of fitting and fixing upper leather onto the toe portion of the last (photos, pp. 142–143).

Ludlow has absolute confidence in the quality of Gaziano & Girling's product: 'We use leather for our stiffeners [heel filling]. Other manufacturers use plastic in their heels, but the results are nowhere near the same.'

While each shoe material is carefully selected, particular attention is paid to the sole; Gaziano & Girling use oak bark tanned leather from J & F J Baker, a feature normally seen only in bespoke shoes. Located in southwest England's Devonshire, J & F J Baker have been tanners since Roman times, and are Britain's only remaining traditional oak bark tannery. All well-

「ガジアーノ&ガーリング」の靴には、全体のプロポーションから細部のディテールに至るまで、彼らのビスポーク・シューズの持つクオリティーとデザイン、さらに履いたときの履き心地の快適さを保ちつつ、いかに既製靴として完成させるのか、独自の哲学が反映されている。

　ビスポークの職人技とグッドイヤーウェルト製法の機械生産の技術、トラディショナルとコンテンポラリーなデザインの美しさ、双方の利点を生かした新たな英国靴の伝統がここで生まれている。

known bespoke manufacturers use their leather.

Gaziano & Girling present their ready-to-wear products as 'close to bespoke', so I asked David what differentiates the two.

'Well, there's any number of differences, but in a word bespoke shoes are lighter and softer. They have thinner, lighter insoles for a more comfortable feel. Sewing machines can give more durability, but the sewed portions invariably become stiffer. A hand-sewn shoe looks better, and will have a softer feel.'

From their overall proportions to their fine details, Gaziano & Girling's stock shoes share the quality and design of their bespoke products, reflecting their unique philosophy of bringing bespoke comfort to ready-to-wear shoes. Their combination of bespoke craftsmanship and machine technology for Goodyear welt manufacture fuse traditional shoemaking with contemporary design, bringing out the benefits of both in a new form of the British shoemaking tradition.

*chapter three*
*Shirtmakers & Accessory Houses*

# Turnbull & Asser

ターンブル&アッサー

71-72 Jermyn St., London SW1Y 6PF
Bespoke 23 Bury Street, London SW1Y 6AL
Tel +44 (0)20 7808 3000
www.turnbullandasser.co.uk

20世紀のメンズ・ファッションにおいてシャツの歴史を築いてきた、世界で最も有名なシャツメーカー「ターンブル＆アッサー」。その名は常に最高のクオリティーのシャツを意味してきた。

　軽く100年を超える歴史は、1885年、ジョン・ターンブルとアーネスト・アッサーがロンドンのチャーチプレイスに店を開業したことに始まる。

　紳士用品を扱う名だたる老舗が建ち並ぶジャーミンストリートで、一際目を引くのが「ターンブル＆アッサー」のウィンドウ・ディスプレイだ。シャツだけでなく、ネクタイにも定評があり、独特の鮮やかな色使いはシャツと絶妙のコンビネーションを見せている。

　伝説の舞台となった現在の店舗に移転したのは1903年。2015年にはこの地で創業130周年を迎えた。創業当時と変わらぬ佇まいを見せるこの店は、変遷の激しいジャーミンストリートにあって、往時のエドワーディアンの面影を今に伝えている。

　メンズ・ファッションがモノトーンを基調とした1920年代、従来の付け替えのできるハードカラー（襟）に

Turnbull & Asser is worldwide the most famous name in men's shirts throughout the history of twentieth-century men's fashion. They have established it as a name that signifies quality.

　Their history began in 1885, when founders John Turnbull and Ernest Asser opened their store in Church Place, London.

　Their current Jermyn Street location is surrounded by well-established shops for gentlemen's accessories, but even so the Turnbull & Asser window display stands apart from the others. They are also famous for their ties, which come in a uniquely vivid palette that exquisitely combines with their shirts.

　They moved to this location—where the bulk of their legend developed—in 1903, and it was here that they celebrated the 130th anniversary of their founding in 2015. Largely unchanging in appearance since its establishment, the Edwardian facade bears vestiges of the transformations that the street has undergone.

Turnbull & Asser　ターンブル＆アッサー

対し、現在のようなソフトカラーとネクタイ、カラフルなシャツが登場したことで、シャツは一躍脚光を浴びるアイテムとなった。

同社の顧客のひとり、小説家F・スコット・フィッツジェラルドもこの時代にシャツに注目を集めることに貢献したひとりだろう。小説『華麗なるギャツビー』、さらに1974年に公開された同名の映画と、同社の鮮明なカラーシャツが宙を舞う名場面は、「ターンブル＆アッサー」の名を世に知らしめた。

「私の好みはシンプルだ。最上のものがあればいい」

そう語ったイギリス首相ウィンストン・チャーチルは、シャンパンは「ポル・ロジェ」、葉巻は「ロメオ・イ・フリエッタ」、車は「ロールス・ロイス」、シャツは「ターンブル＆アッサー」、スーツは「ヘンリー・プール」、靴は「ピール＆ Co.」と、その生涯において常に最上のものを愛した。

同社の長年の顧客として知られるチャーチルは、第二次世界大戦中には、グリーンのベルベット製、上下つながった形の「サイレンスーツ（siren suits)」を注

In the 1920s, a time when men's fashion was largely expressed in monotones, shirts became a key fashion item as they underwent a transition from replaceable stiff collars to the soft-collar-and-tie combination seen today. Author F. Scott Fitzgerald played a role in this, as evidenced by the famous scene in the 1974 film adaptation of The Great Gatsby, in which the protagonist creates a rain of colourful shirts; watch closely, and you will see the Turnbull & Asser name on the boxes.

Winston Churchill, who once said, 'My tastes are simple; I am easily satisfied by the best', smoked Romeo y Julieta cigars, drove a Rolls Royce, and wore Turnbull & Asser shirts. A long-time customer, during WWII Churchill ordered a green velvet 'siren suit'—a one-piece garment designed to be quickly donned during nighttime air raids—and the sight of him in this suit became a symbol of British 'carrying on' during wartime. Today that suit is on display in the Churchill

文している。その独特のスーツを着用した姿は、戦時中でも余裕を失わず、ドイツに徹底抗戦するチャーチルのシンボルとなった。現在、そのスーツは本店地階のチャーチル・ルームに展示されているばかりでなく、チャーチルが好んだポルカドットのボウタイは今でも同社で販売されている。

　50年代からは名だたるハリウッドスターたちがこぞって顧客となり、ロンドンが流行の発信地となった60年代には、同社のマイケル・フィッシュ氏が考案した幅広のキッパー・タイが、それまで細身であったネクタイの流行を一夜にして変えた。

　だが、「ターンブル＆アッサー」の名を「世界で最も有名なシャツメーカー」としたのは、映画『００７』のジェームズ・ボンド、ショーン・コネリーが着用したシャツに違いない。素材はシーアイランド・コットン、ワイドカラーのターンバックのカクテルカフにふたつボタン、胸ポケットなしのこのシャツは、原作者のイアン・フレミングと第１作『007/ドクター・ノオ』の監督であったテレンス・ヤング、双方が同社の顧客であったことから、

Room at Turnbull & Asser's flagship store, where they also sell replicas of Churchill's iconic polka-dot bowtie.

Starting in the 1950s, famous Hollywood movie stars flocked to Turnbull & Asser, and when London was the epicentre of vogue in the 1960s, the store's Michael Fish invented the 'kipper tie', a wide necktie that replaced thinner ties seemingly overnight.

Even so, it was Sean Connery as James Bond that truly made Turnbull & Asser the world's most famous shirt maker. The iconic shirt in that movie was made of Sea Island cotton, and featured design hints such as a wide collar, turn-back cocktail cuffs with two buttons, and no breast pocket. Writer Ian Fleming and Dr. No director Terrance Young were both Turnbull & Asser customers, leading to Connery wearing what was to become one of the most famous shirts in history. The store continues to receive orders for this shirt even today, making it a perennial bestseller.

From Sean Connery to Daniel Craig, many genera-

ショーン・コネリーが着用し、史上最も有名なシャツとなった。現在でも同じ仕様のシャツを注文する顧客が後を絶たない、永遠のベストセラーだ。

それ以後、ショーン・コネリーからダニエル・クレイグまで、歴代のジェームズ・ボンドも「ターンブル＆アッサー」のシャツを着用し、シークレット・エージェントのスタイリッシュなシャツといえば「ターンブル＆アッサー」の名が登場するようになった。

最近では、2014年イギリスで公開されたスパイ映画『キングスマン；ザ・シークレット・サービス』で、コリン・ファース、サミュエル・L・ジャクソンなどメインキャラクターのシャツを担当している。メンズウェア・リテーラーのMr.ポーターでは既製品のシャツ、ガウン、パジャマのコレクションが販売されるなど、老舗の名に安住しない新たな試みも行われている。

こうした映画におけるメンズ・ファッションへの影響に加え、忘れてならないのは、「ターンブル＆アッサー」の名声を築きあげた最高の顧客、「メンズ・スタイルの正統」をリードしてきた英国王室の存在だ。

プリンス・オブ・ウェールズ（チャールズ皇太子）からは1980年にシャツメーカーとしてロイヤルワラント（英国王室御用達）を授与されている。これはチャールズ皇太子にとっても自らが授与した初のワラントだった。ロイヤルワラントホルダーのポール・カス氏は1959年に21歳で同社に入社した。デヴィッド・ニーブンやケイリー・グラントなど著名なハリウッドスターも彼の担当である。1999年に氏が引退した後は、スティーブ・クイン氏がその後継を務めている。

このように、ロイヤルファミリーは「ターンブル＆アッサー」のシャツを代々にわたり着用している。チャールズ皇太子は父エジンバラ公の薦めで同社のシャツを着用し始めたとされている。息子のウィリアム王子も、公式の婚約写真で「ターンブル＆アッサー」製のホワイトシャツを着用したことは大きな話題となった。

当然ながらチャールズ皇太子の採寸は、セント・ジェームズにある公邸クラレンスハウスに担当者が訪問し、チャールズ皇太子が店に採寸のために足を運ぶことはない。だが意外にも、それ以外のロイヤルファミリー、例えばマイケル・オブ・ケント王子は、普通の顧客同様に「ターンブル＆アッサー」を訪れるという。

特徴的に襟足の高いシャツと、その襟足の高さに合う極太のタイは、彼のスタイルのトレードマークだ。これは「ターンブル＆アッサー」が60年代に一世を風靡したマイケル・フィッシュ考案の幅広のキッパー・タイの

tions of James Bond have worn Turnbull & Asser shirts, firmly establishing them as the preferred tailor of style-conscious secret agents for half a century. That tradition continues, with the shop responsible for supplying the shirts worn by stars Colin Firth and Samuel L. Jackson in the 2014 film Kingsman: The Secret Service. In a new effort toward moving beyond their fame as an established bespoke shop, ready-to-wear shirt, gown, and pyjama collections are now available through menswear retailer Mr Porter.

While Turnbull & Asser have no doubt influenced men's fashion through film, even more important to building their name have been the utmost leaders in orthodox men's style—the British Royal Family.

Turnbull & Asser have been Royal Warrant recipients from Charles, the Prince of Wales. The Royal Warrant was given to T&A in 1980 by H.R.H. Prince of Wales. It was in fact the first Royal Warrant that Prince Charles gave to anyone. The warrant was granted personally to Paul Cuss. Cuss joined the company in 1959 at age 21, and since has been responsible for Hollywood stars like David Niven and Cary Grant. Steven Quin took Cuss' place following his retirement in 1999.

The Royal Family has thus worn Turnbull & Asser shirts for generations. Prince Charles is said to have become a customer based on the recommendation of his father, Prince Philip, H.R.H. the Duke of Edinburgh. His son, Prince William, drew attention by wearing a Turnbull & Asser shirt in his official engagement photograph.

Prince Charles did not visit the store to have his measurements taken—store personnel visited his official residence, Clarence House at St. James—but other royals such as Prince Michael of Kent are said to visit the store like normal customers. His shirts have characteristically high necklines with wide tie to match. This is said to have been the inspiration for Fish's kipper tie, so it is interesting to consider the close relationship between the Prince's distinctive style and that of Turnbull & Asser.

Prince Charles visited the company's factory in Gloucestershire as part of a nationwide tour celebrating the 'Best of British' engineering and manufacturing. It showed that a sincere respect by Prince Charles for the

J.F Collar

Short-Point

No 3 Collar

T & A Collar

N Collar

No 3 Tab Collar

Sea Island
Cotton
Quality Cloth

元祖だということを考えれば、ケント王子のパワフルでダンディーなスタイルも、同社が作ってきたものだと理解できる。

2013年、チャールズ皇太子は〝ベスト・オブ・ブリティッシュ〟と題した英国の産業を推奨するキャンペーンの一環で、イングランド南西部グロスターシャーにある同社の工場を訪問した。これも35年にわたり、皇太子のシャツを作り続けてきた同社の企業姿勢とクオリティーに深い信頼を持っていることの表れだろう。

このように数々の伝説を持つビスポークシャツは、本店のビスポーク部門から生まれている。ジャーミンストリートと交差するバリーストリートに位置するビスポーク部門、ここでは顧客の採寸が行われる。壁にはセレブリティーやハリウッドスターなど過去の有名顧客のポートレート、ウィンストン・チャーチルの注文票と実際の型紙なども飾られている。独特の近寄り難い雰囲気が漂う空間はその100年を超える歴史を物語る。

取材時は、勤続40年を超え、「ターンブル＆アッサー」ばかりでなくダンヒルなど名だたる英国ブランドでシャ

quality of the shirts that Turnbull & Asser have made for him for over thirty-five years.

Such legendary shirts are born from the company's bespoke division, which takes customer measurements at their location at the intersection of Jermyn Street and Bury Street. The walls there are decorated with photographs of Hollywood celebrities and portraits of past famous customers. Among those is an order slip and actual pattern for an order from Winston Churchill. The store's century of history is evidenced in its aloof atmosphere.

When I visited I spoke with David Gale, who has not only over forty years experience at Turnbull & Asser, but who has also worked for famous British brands such as Dunhill.

'I'm a master shirt-maker, which means I have learned all the steps in creating a shirt—measurements, fittings, pattern-making, and sewing—and can thus create a shirt on my own. There are few cutters, even

ツ作りの経験を持つデビッド・ゲイル氏にインタビューを行った。

「私はマスターシャツメーカーだ。その意味は採寸、フィッティング、型紙作り、縫製、すべての工程を習得し、ひとりで一枚のシャツを作りあげることができることだ。私と同年代の熟練のカッターたちでさえ、縫製ができる者はほとんどいない。私が過去に学んだすべてを今の若い世代に教えることは難しい。しかし、できる限りの技術を教えるのが私の使命だと思っている」

ビスポークのシャツ作りにおいて最初の工程は採寸となる。ここでは最低18箇所のサイズを採寸する。「脊椎が語る」とゲイル氏はいう。数値ばかりでなく姿勢など体型の癖も確認することが重要だ。

採寸後、ゲイル氏が作った型紙はイングランド南西部グロスターシャーにある自社工場に送られ、CADシステムでデジタル化される。このシステムが導入される以前、型紙は2〜3回使用すると再度作り直していたが、このシステムに変えてから、コンピューターで型紙を管理できるようになった。

experienced ones of my age, who can also sew. It is difficult to pass on everything I have learned to younger generations. Even so, I consider it my duty to do what I can to teach my techniques.'

The first step in creating a bespoke shirt is taking measurements. At least eighteen measurements are needed. As Gale puts it, 'The spine tells the tale'—it is important to look not just at numeric measurements, but also factors such as body shape and posture.

After taking measurements, he sends his pattern to the Gloucestershire workshop, where it is digitalised using a CAD system. Before this system was introduced, patterns had to be recreated after a few uses, but now they are permanently stored in the company's computers.

'Becoming a good cutter requires skill at visualising two-dimensional measurements in three dimensions. I see many college graduates who are quite smart, but don't have that ability.' Laughing, Gale adds, 'An even

「良いカッターになるには2本の腕、2次元の数値を3次元に視覚化できる才能がいる。大学を卒業した人は頭がいいが技術が伴わない人が多い。とにかくカッターとして大事なのはまず顧客を笑わせること。一度、笑わせることができれば大丈夫だ。歳を取って特にその技術は磨かれたね」

そう笑う姿からは、氏の経験に裏付けされた哲学が感じられる。

採寸後、顧客はカラー（襟）、カフス、プラケット（裾）の形、フィット感、生地を選ぶ。見本として12種類のカラー、11種類のカフスがディスプレイされているが、ビスポークのため、基本的にはどんなものも注文可能だ。さらに1000種類を超える生地も用意されている。

特に注意するのはフィッティング。どの程度身体に添ったものがほしいのか、顧客によりその好みは大きく異なる。「試着用のシャツは大きめに作るに限る」と彼が語るのはそのためだ。

採寸して2〜3週間後に試着用シャツが完成すると、3回ほど水洗いして縮み具合を確認する。この段階で気に入らなければ作り直すことも可能だ。再度サイズを調整し、さらに2〜3週間でシャツの完成となる。

価格は生地によって異なるが、1枚235ポンドから。最初の注文単位は6枚だが、次は何枚からでも自由だ。納期は仮縫いも含め、基本的には約2ヵ月となる。体型に変化がなければ来店の必要もなく再注文でき、世界中どこにでも発送してくれる。

ゲイル氏はチャールズ皇太子やエジンバラ公も担当することがあるそうだ。

「彼らは欲しいものを明確にわかっているし、常に同じものが求められるので難しいことは何もない。逆に彼らの身体の方は年齢に応じて変化しているが、その変化を感じさせず、同じ印象を保てるように作ることこそ、我々のビスポークの技術なのだ」

では、「ターンブル＆アッサー」のシャツを特別にしているものは何か。その最大の特徴は独特のカラー（襟）の形状「ターンブルカット」である。首筋から剣先にかけてゆるやかなS字ラインを描いているカラーは、ジャケットのラペルから飛び出すことなく、ネクタイをしない場合でも端正なVゾーンの印象を保つことができる。

立体的なカラーをひろげてフラットな一枚の布の状態にしてみると、そこにあるのは通常の既成のシャツが持つ直線ではない。カフスも同様にやや内側にカーブを描いている。人間の身体に添った曲線で構成されていることが快適な着心地を生んでいる。

more important skill as a cutter is making your client smile. Once you've done that, everything else will follow. That's one skill I definitely learned with age.'

After measurements, customers select a collar, cuffs, placket shape, fit, and material. The store keeps twelve kinds of collar and eleven sets of cuffs for display, but bespoke tailoring means that anything is possible. Over one thousand kinds of material are available for ordering.

Particularly important are the fittings. Customers vary greatly in the extent to which they prefer a close fit. 'That's why it's vital that we create shirts for fittings a little bit large', Gale says.

When a shirt for fitting is completed, two to three weeks after measurements are taken, it is washed up to three times to verify shrinkage. If the desired result is not attained, the shirt is remade with a different sizing, requiring another two to three weeks.

Pricing varies according to the fabric selected, but shirts cost around £235 each. Initial orders require a minimum purchase of six shirts, but subsequent orders can be for any number. Including fittings, delivery generally requires around two months. There is no need to come back to the store for additional purchases—assuming no significant change in body shape—so shirts can be delivered anywhere in the world.

Gale says that he sometimes tailors for Prince Charles and Prince Philip.

'They are easy customers to deal with—they know exactly what they want, and always order the same thing. Of course their body shapes have changed with age, but part of the technique of a bespoke tailor is an ability to maintain the same look so that such change isn't noticed.'

The most distinctive feature of a Turnbull & Asser shirt is the collar, which is formed in what is known as the 'Turnbull cut'. These collars have a unique outward flare to the collar point, which prevents them from extending outside of the jacket lapel and retains a neat V-zone appearance even when a tie is not worn.

Flattening a collar out and viewing it as a piece of cloth rather than a three-dimensional form, one notices none of the straight lines seen in typical ready-to-wear products. Cuffs too have a slight inward curve. Forming

こうした人間工学に基づいた型紙も、本店の地下に保存された1万2000人分の型紙のコレクションより考案され、代々のカッターによって長年の間に作りあげられてきたものだという。

　ボタンはすべてマザー・オブ・パールを使用。ビスポークシャツには通常スペアボタンは付けないが、その理由は専用の機械で丈夫に取り付けられたボタンは取れることはない、そのことに自信を持っているからだと「ターンブル＆アッサー」では説明している。

　グロスターシャーにある自社工場では既製品とビスポーク、2つのラインが稼働し、月間500種類ものシャツを生産する。

　耐久性が必要なサイドシームなどは4層の生地を3ライン、約5ミリ以内で縫うといった熟練の職人の手による機械縫製が施される。まさに第二の皮膚として、一生涯着用できることを前提にすべてが作られている。

　「我々は流行とは関係なく、昔から同じやり方を続けてきた。人の個性はそれぞれに違うが、いちど自分に似合う最上のものを見つけたら、それを変える必要はないのだから」

　最後にゲイル氏はそう語った。この言葉こそ、20世紀のシャツの歴史を作り、常に最上のものを追求してきた、同社の哲学を如実に物語っていた。

（取材当時の2014年、ゲイル氏は「ターンブル＆アッサー」に在籍。その後の2015年、ジャーミンストリートにあるシャツメーカーのビスポーク部門に移っている）

shirts in this way to better fit the human form makes them more comfortable to wear.

Ergonomic patterns like this are the result of applying the many years of experience of generations of cutters to the patterns for over 12,000 customers stored in the main store's basement.

All buttons are crafted from mother-of-pearl. Turnbull & Asser explains with confidence that the buttons are tightly and intricately sewn, so that they will never come off in the first place.

The Gloucestershire factory has separate lines for ready-to-wear and bespoke products, and between the two of them produce five-hundred kinds of shirt per month. Some areas particularly requiring durability like side-seams, which have three rows of stitches within a width of five millimeters through four layers of fabric, are performed by experienced seamstresses using machines. Each shirt is fabricated with the assumption that it will be worn as a second skin for the customer's entire life.

'We stick to the old ways of doing things, regardless of what's popular at the time', Gale tells me. 'Every customer is unique, but once they find the perfect shirt for them, there's no need to change to anything else.' These words are a vivid reflection of the philosophy that has guided Turnbull & Asser in forging the history of twentieth-century tailoring as they pursued the perfect shirt.

Note: Gale was a Turnbull & Asser employee when we interviewed him in 2014, but in 2015 moved to a position in the bespoke division of Jermyn Street shirtmaker.

*chapter three*
## Shirtmakers & Accessory Houses

# Swaine Adeney Brigg

スウェイン・アドニー・ブリッグ

7 Piccadilly Arcade,
London, SW1Y 6NH
Tel +44 (0)207 409 7277
www.swaineadeneybrigg.com/

トップハットやボーラーハットを被り、きつく巻き上げた細い傘を持つイングリッシュ・ジェントルマンの姿、それはかつてロンドンを象徴する風景のひとつだった。惜しくもその習慣は失われたが、他の紳士洋品と同様にセント・ジェームズのエリアには多くの老舗が今も存在している。

革製品と傘を扱い、ロイヤルワラントを持つ「スウェイン・アドニー＆ブリッグ」は、過去オーナーが変わる度にセント・ジェームズ周辺で移転を繰り返してきた。現在はロンドンの中心、ピカデリーストリートとジャーミンストリートをつなぐピカデリーアーケードの中に店を構えている。もう1店舗はファクトリーのあるイングランド東部のケンブリッジに位置し、ロンドンとケンブリッジの2店舗でその製品は販売されている。

第二次世界大戦最中の1943年、馬具用革製品のメーカーである「スウェイン・アドニー」は傘メーカーである「トーマス・ブリッグ＆サンズ」と合併し、現在の「スウェイン・アドニー＆ブリッグ」となった。

「スウェイン・アドニー」の歴史は、1750年、ジョン・

At one time, no true gentleman would have considered leaving home without a hat and umbrella.

The image of a gentleman sporting a top hat or bowler and carrying a tightly wound umbrella is iconic of the traditional London. While such customs have sadly passed, there remain many stores in central London, St. James's area, that sell such accoutrements.

Royal Warrant holders Swaine Adeney Brigg have moved throughout St. James's with each change in ownership. Their current store is in the Piccadilly Arcade, which connects Piccadilly Street and Jermyn Street. Their other store is in Cambridge, the site of their workshop.

The current company was formed when equestrian goods maker Swaine Adeney merged with umbrella maker Thomas Brigg and Sons.

Swaine Adeney's history began in 1750 when founder John Ross opened a store selling mainly horsewhips at 238 Piccadilly. This store was purchased in 1798 by

Swaine Adeney Brigg　スウェイン・アドニー・ブリッグ

ロスが乗馬用鞭を主力製品としてピカデリー238番地に創業したことに始まる。1798年にジェームズ・スウェインが買収、1845年に相続人エドワード・スウェインの甥がパートナーシップを継いだことにより、社名が現在の「スウェイン・アドニー」となった。

18世紀には国王ジョージ3世より初のロイヤルワラントを授与され、これを契機に、国王ジョージ4世やエリザベス2世など、乗馬用鞭のメーカーとして英国王室からのロイヤルワラントを保持していた。

一方で、1836年、セント・ジェームズ・ストリート23番地で創業し、19世紀にヴィクトリア女王より初の傘メーカーとしてのロイヤルワラントを授与されたのが「トーマス・ブリッグ&サンズ」である。

共に王室御用達の長い歴史を持つ両社だが、現在のロイヤルワラントはプリンス・オブ・ウェールズ（以下、チャールズ皇太子）よりブリッグの製品である傘に授与されている。ハンドル部分に付けられたカラー（金具）にはチャールズ皇太子の紋章が入り、このカラーを見ると、この傘が王室御用達であることが誰にでもわかるようになっている。

チャールズ皇太子はブリッグの傘を公私にわたり愛用しているらしく、英連邦歴訪などの際には、ハンドルが取り外しできる「マラッカ・トラベラー」を手にしている姿も見られる。時代やトレンドに一切左右されず、一度気に入ったものは長く愛用する、皇太子の服飾に関する嗜好はこの傘にも表れている。

同社を代表する、その名もプリンス・オブ・ウェールズ・モデルと名付けられた商品は、マレーシアのマラッカ海峡を産地とする藤椰子をハンドルに用い、職人が4日かけて成形したものを使用している。他にもスターリングシルバーのノーズキャップとカラー、本体部分の素材は通常のナイロンの他に贅沢な手織りのシルクなど、ビスポークといっても差し支えないほど、素材とデザインには選択の幅がある。

17世紀にはファッションとして剣と一緒にステッキを持つことが流行したが、それが19世紀になると細身の傘がステッキに代わるアクセサリーとなった。それまで重く無骨であったフレームの素材が鯨骨からスチールへと変わる技術革新があり、軽量で細身の傘が作れるようになったからだ。

前述のように、ボーラーハットに細身の傘という姿が英国紳士の代名詞といわれるようになったこの頃、ブリッグでは濡れた傘にアイロンをかけて、再び細身に巻き直すサービスをシティで行っていたという。

James Swaine, and in 1845 inheritor Edward Swaine took his nephew on as partner giving the company its name.

The company received its first Royal Warrant in the eighteenth century from King George III as a supplier of horsewhips, and subsequent Warrants followed from King George IV and H.M. Queen Elizabeth II.

Thomas Brigg and Sons were founded in 1836 at 23 St. James's Street, and in the nineteenth century became the first Royal Warrant holder for umbrellas by appointment to Queen Victoria.

So both companies have long histories as Royal Warrant holders, but their current Warrant is for supplying umbrellas by Brigg to H.R.H. the Prince of Wales. This is shown by the inclusion of Prince Charles's royal seal on the handle collar of every umbrella they sell.

Prince Charles reportedly uses the company's umbrellas both in public and in private, and can be seen carrying the company's 'Malacca Traveller', a model with a removable handle. The Prince is known for his resistance to trends and fads, instead consistently using fashion items like this umbrella that express his personal tastes.

The Briggs model called the 'Prince of Wales' uses cane from Malaysia's Strait of Malacca for its handle, which requires four days of a craftsman's time for forming. It furthermore features a sterling silver nose cap and collar, and can be fabricated with either a nylon or hand-woven silk canopy, touches of extravagance and an array of choices only available in a bespoke product.

Seventeenth century fashion called for a walking stick in addition to a sword, but by the nineteenth century a slim umbrella replaced the former as a de rigueur accessory. Previous umbrellas had used whalebone for the frame, making them heavy and unrefined, but new technologies for steel fabrication allowed the creation of lighter, slimmer models.

This was when the bowler-hat-and-umbrella look became proper attire for the British gentleman, and at around this time Brigg introduced a new customer service—ironing and rewinding umbrellas that had got wet.

ハンドルの成形から、生地の裁断、軸削り、縫製にいたるまで、すべての工程が職人による手作業を経て完成する同社の製品には、ハンドメイドでなければ作り得ない凝った仕掛けの製品も多い。

なかでも、ハンドル部分にウィスキー用のフラスクが仕込まれた傘は、白洲次郎による注文記録が残る逸品だ。これも同社のベストセラーとなっている。またゴルフなどの観戦用にハンドル部分が簡易的な椅子になるものまである。

使い捨ての傘とは真逆にある、一本の傘に驚くような凝った仕掛けを施す趣向は、ビスポークの醍醐味のひとつに違いない。

一方、「スウェイン・アドニー」を代表する革製品は、英国製最高級ブライドルレザーを使用し、丈夫で堅牢。使い込むほどに艶と風格が増す逸品とされている。特にこの店ではここでしか注文できない特別なケースが存在する。それは誰もが一度は目にしたことがあるに違いない、英国諜報部員ジェームズ・ボンドが映画『007/ロシアより愛を込めて』で携帯したブラックレザーのアタッシュケースのことだ。

映画では弾薬、50個のソブリン金貨、隠しナイフ、0.25キャリバーAR7フォールディング・ライフルを搭載するための隠しポケットが付いていたが、現在販売されているのは残念ながらケース本体のみ。顧客のイマジネーションに合わせて、どんな隠しポケットも作ることができるというのがなかなか面白い趣向だ。

ケンブリッジにある自社工場は今では残り少なくなった英国内の革製品の工房のひとつである。伝統的製法により作られる製品は、50年を超えて祖父から孫の代へと受け継がれている。その品を受け継いだ家族から修理を依頼されることも稀ではないという。英国のハンドメイドの伝統を受け継ぐ同店では一生ものの真価を体感できることだろう。

Even today, every step in the manufacturing process—from forming the handle and cutting the cloth to milling the shaft and sewing—is performed by hand by a craftsman. Much of the workmanship involved is only possible because everything is handmade.

One example is the model with a whiskey flask built into the handle, a bestselling product for which the company still has a copy of the order sheet filled out for Japanese politician Jiro Shirasu. There is also a model that can easily transform into a simple chair for watching golf and other sports.

The diametrical opposite of a 'disposable' umbrella, such surprising contrivances are no doubt the true pleasure of bespoke craft.

The leather products of Swaine Adeney are fashioned from the highest quality British bridle leather, are durable yet lightweight, and are known for the gloss and distinctive character they take on through use. Of particular note are the many cases and folios that can only be ordered through this store. You have likely seen some of them yourself, such as James Bond's black leather attaché case in From Russia With Love. The case in that movie had secret compartments to hide 50 gold sovereigns, ammunition, a hidden knife, and a folding 0.25 caliber AR-7 sniper rifle, but unfortunately the standard product is for a bare case alone. Should hidden compartments be desired, you are limited only by your imagination and budget.

The company's Cambridge workshop is one of the few left in the U.K. still producing leather products. Their products are produced there using traditional crafting methods, and are often passed down from generation to generation over decades. They frequently receive requests to restore such inherited products, a testament to the value of the British handmade tradition.

*chapter three*

---
*Shirtmakers & Accessory Houses*

# Lock & Co.

ロック＆コー
6 St.James's Street, London SW1A 1EF
Tel: + 44 (0)20 7930 8874
www.lockhatters.co.uk

歴史を飾ってきた偉大な男たちの装いは、常に「ロック&コー」の帽子と共にあった。

紳士服の源流となった軍服とラウンジスーツが意味するものは権威と階級である。頭部の保護と防寒の役割で発達してきた帽子は、18世紀に軍帽が権威と階級の象徴となり、19世紀にはトップハット（シルクハット）とクック（コーク）ハット（山高帽）が富と地位の象徴になった。

創業1676年の「ロック&コー」は、現在もプリンス・オブ・ウェールズ（チャールズ皇太子）とエジンバラ公、ふたつのロイヤルワラントを持ち、創業者一族が経営する世界最古の帽子店である。

国の保存建築物に指定されているセント・ジェームズ6番地の本店は、1765年にこの地に移転して以来、変わることなく紳士淑女の帽子を提供し続けてきた。

著名人の写真に登場している帽子は、その多くが「ロック&コー」で作られたものだ。ウィンザー公といった歴代英国王室、ウィンストン・チャーチルなどの政治家、ローレンス・オリヴィエなどのハリウッドスターたちもその顧客だった。

希代のダンディー、ボー・ブランメルも帽子を注文し、オスカー・ワイルドは未払いの請求書を残した。現在はチャールズ皇太子がお気に入りのスコティッシュツイードを持ち込んで作るフラットキャップなど、興味深いエピソードにも事欠かない。

「ここはまるで帽子のミュージアムだ」と語るのは、リテール・マネージャーのアンドリュー・バセルジア氏。これを裏付けるかのように、「ロック&コー」のキャビネットには2つの軍帽がディスプレイされている。

「明日の今頃は、爵位を授けられているか、ウェストミンスター寺院に葬られているかのどちらかだ」

1798年のナイルの海戦において、英国海軍ネルソン提督は、この有名な言葉を残した。同店の注文台帳によれば、彼の注文はカルヴィ攻略戦で失明した右目の保護用にシルク・グリーンのカバーが付いた特注のものとなっている。最後の注文記録は1805年9月9日。英国に勝利をもたらしたトラファルガー海戦での戦死は10月21日であり、最後の帽子も彼と運命を共にしたとされている。現在、新しく設置されたアーカイブルームにディスプレイされているのは復元された軍帽で（189ページ写真）、オリジナルはウェストミンスター寺院にある。

もうひとつ、ここにディスプレイされているのは18世紀の陸軍総司令官のオリジナルの軍帽であるという（188ページ写真）。

The military uniforms and lounge suits that have traditionally provided the foundations of men's fashion were symbols of authority and class. Hats were originally developed to protect the head and keep it warm, but in the eighteenth century military caps were used to show one's influence and status, and in the nineteenth century it was top hats and bowlers that represented wealth and social standing.

Founded in 1676, Lock & Co. are the oldest hatters in the world still run by the founding family. Today, they hold two Royal Warrants, in service to H.R.H. The Prince of Wales and H.R.H. The Duke of Edinburgh.

Since moving their store in 1765 to 6 St. James's Street, a building that has been designated a national preservation site, they have continued providing headwear to fashionable men and women.

Many of the hats you see in portraits of famous persons were created at Lock & Co. including those worn by Royal Family members such as the Duke of Windsor, politicians like Winston Churchill, and Hollywood stars like Laurence Olivier. They have had orders from the original 'dandy' Beau Brummell, and Oscar Wilde left behind an unpaid bill. They have created a flat cap for H.R.H. The Prince of Wales, using a favourite Scottish tweed that he provided. The store is a never-ending source of such fascinating tales.

'It is almost like a hat museum', says Retail Manager Andrew Baselgia. He points to a cabinet, in which are displayed two military hats.

During the 1798 Battle of the Nile, Admiral of the British Navy Lord Horatio Nelson is famous for having said 'Before this time tomorrow, I shall have gained a peerage or Westminster Abbey'. The shop's order ledger lists purchases by him, including a hat with a green silk protector to cover his right eye, which had been blinded during an attack at Calvi. The last order from Lord Nelson is dated 9 September 1805. Nelson died in action at the Battle of Trafalgar on 21 October, and it is said that this hat went down with him. The original is preserved at Westminster Abbey, while a replica is on display at the shop in the newly created Heritage Room. The other hat belonged to a British Army Field Marshal in the 18th Century.

Alongside these hats of great heroes, Lock & Co. are

これらの軍帽に加え、「ロック&コー」を代表する帽子といえば、英国紳士のスタイルの代名詞、トップハットとクックハットの名が挙がるだろう。

　クックハット（別名ボーラーハット）は、1849年、エドワード・クック（綴りはCokeだが、英語ではクックと発音）の依頼により同社が作成したのが始まりだ。後にロックのチーフ・ハットメーカー、トーマス・ボーラーが同型の帽子を発売し、ボーラーハットの名が一般に定着した。「ロック&コー」では、160年以上にわたり、この帽子を作り続けていることになる。現在でもトリルビーとクックハットは同社のベストセラーだ。

　20世紀にはいると、ロックの帽子はスーツ姿の紳士の装いに必要不可欠なものとなった。ウィンストン・チャーチルは結婚式にトップハットを被り、公務にはホンブルグを愛用した。チャップリンが被り、映画『007／ゴールドフィンガー』に登場する山高帽もロック製だ。

　このように「ロック&コー」が老舗たる由縁といえば、ただ販売するだけでなく、メンテナンスから修理まで徹底したアフターサービスを行っていることだろう。

famous for their top hats and bowlers, style elements that are synonymous with English gentlemen's fashion.

　Originally fabricated in 1849 on order by politician Edward Coke (pronounced 'cook'), this hat is still sold as the 'Coke' at Lock & Co., but is better known for its naming after Lock's chief hatmaker, Thomas Bowler. Lock & Co have made and sold this hat for over 160 years, and alongside the 'Trilby' it is their bestselling product.

　Entering the twentieth century, a Lock hat became an indispensable part of a gentleman's attire. Winston Churchill wore one of their top hats at his wedding ceremony and a Homburg while working. Lock made Charlie Chaplin's bowlers and the one seen in the James Bond film Goldfinger.

　Lock not only sells fine hats, they offer extensive services such as hat maintenance and repairs. Baselgia is responsible for servicing soft hats like Trilbies. He showed me how he reshapes a collapsed crown (the

トップハットなどハードタイプの帽子には頭のサイズとシェイプを調整するコンフォーミターが不可欠だ。
A conformateur is vital to adjusting top hats and other stiff hats so that they properly fit one's head.

　前述のアンドリューはトリルビーなどソフトハットのアフターサービスを担当。崩れたクラウン（帽子の山部分）の形を成形し直す、リシェイピングの工程を見せてくれた。
　トリルビーの表面に状態を確認しながらたっぷりとスチームをかける。クラウンの中折れ部分も馴れた手つきで形を作っていく。形が決まったら、フエルトの表面を撫でるように、柔らかい豚毛ブラシをかけると、12年前のものというくたびれた表情の帽子が端正な佇まいを取り戻した。
「ここに持ち込まれる帽子の中には30年前のものもあるが、こうして定期的にメンテナンスすれば、ほぼ一生ものだ」
　そう語る彼の表情に、この店の帽子への強い愛着と誇りを感じる。
　一方、トップハットを担当するのはアシスタント・マネージャーのジェイッシュ・M・バゲラ氏、通称ジェイ。
　トップハットが作られ始めた18世紀にはビーバーの毛皮を使用していたが、ビーバーの乱獲により入手が

uppermost part of the hat).

　He begins by generously applying steam while carefully monitoring the hat's surface. His sure hands work to form the crease running through the crown, and once the shape takes place uses a soft pig-bristle brush on the felt. Before long, the twelve-year-old hat is restored to its original neat appearance.

　'We have got customers who bring in hats we made thirty years ago', he says, pride and love for his company's products evident in his expression. 'With proper care, they should last a lifetime.'

　On the other hand, top hats are the responsibility of Assistant Manager Jayesh 'Jay' Vaghela.

　Beaver-skin top hats were popular in the eighteenth century, but in the nineteenth silk became predominant. The shop stopped making silk top hats in the 1960s; today, most are made of felt. Lock & Co. instead buy silk hats, which they sell as 'vintage' or 'renovation' top hats. A vintage hat is one in which the

以前は狩猟用品の老舗「パーディー」に勤めていたリテール・マネージャーのアンドリュー・バセルジア氏は英国の良き伝統を心から愛している。
Retail Manager Andrew Baselgia, who once worked at famed hunting goods store Purdey, has a deep love of English traditions.

| | | |
|---|---|---|
| | SILK TOP HAT | SIL |
| | Quality of Plush A1  Height of Crown 5¾" | TOP HA |
| | Size 7⅛ BARE 57.5 | A1 7⅛ FULL |
| | Price £1,000 | £2, |

| 159 | VINTAGE |
|---|---|
| SILK TOP HAT | SIL |
| Quality of Plush A1  Height of Crown 5½ | TOP H |
| Size 7⅛ BARE 57.5 | A1 7⅛ |
| Price £2,000 | £2,50 |

| 123 | Renovated | 154 |
|---|---|---|
| SILK TOP HAT | | SILK TO |
| Quality of Plush A1  Height of Crown 5¾ | | Quality of Plush A1  H |
| Size 7⅛ FULL 58 | | Size 7⅛ BARE |
| Price £2,700 | | Price £2,500 |

| 020 |
|---|
| SILK Renovated |
| HAT |
| FULL 5¾" 58 |
| 600 |

| | S6 | 12/14 |
|---|---|---|

SIL
TOWN
Quality of Plush A1
SIZE 7⅛
£
2,

困難となると、19世紀にはシルクプラッシュが主流となった。そのため、シルクハットの名が定着している。シルク製トップハットは1960年代に製造を中止し、現在製造されているものはフエルト製が主流だ。「ロック＆コー」ではシルクハットを買い取り、ヴィンテージ、リノベーションの2種類に分けて販売している。ヴィンテージはライニングなどが交換されていないもので、リノベーションより当然高価となる。

ジェイがシルクハットの手入れ方法を見せてくれる。水を吹きかけ、時計方向に繊維に添ってトップからサイドへと、豚毛のブラシを丹念にかけていく。かつてあった輝きをシルクハットが取り戻し、本物だけが持つシルクの強い輝きには厳かな風格さえ宿っている。

「通常販売されているフエルト製のトップハットは395ポンド。リノベーションとヴィンテージはサイズとコンディションにより価格は異なり、平均して2000ポンド近いが変わらぬ人気がある」

1960年代より以前に製造されていたシルクプラッシュ製、正真正銘のシルクハットは、傷みやすいライニングなど、何もパーツを交換していないオリジナル、フル・ヴィンテージのものは希少性が高く、3000ポンド近いものもある。

「同じサイズでも人の頭の形はさまざまだ。西洋人は楕円形、アジア人とアフリカ人は円形に近い。そのため、トップハットの販売には顧客の頭の形に合わせて成形するサービス、コンフォーミングが不可欠となる」

150年以上使っている専用の器具コンフォーミターは「ロック＆コー」には2台ある。これでサイズとシェイプを計り、専用の型紙を作る。この型紙は30年間保存されるそうだ。クラウン部分を温め、樹脂が柔らかくなったところに器具をはめ、頭の形に成形する。こうしたコンフォーミングの工程を行うところは今ではほとんど存在せず、これも老舗ロックならではだろう（この頭部の型紙はウィンザー公など著名人のものが本店にディスプレイされている）。

ところで、こうした帽子の需要は今でもあるのだろうか。そう訊ねると、前述のアンドリューは誇らしげにこう語った。

「街を歩いている人を見たら、みんな帽子を被らなくなったと思うかもしれない。しかし、実際はそうじゃない。いつの時代も帽子なくして装いは完成しない。アスコット競馬や結婚式にはシルクハットが、シューティングや釣りなどのスポーツにはツイードのフラットキャップが、軍などの式典にはダークスーツにコークハットが必

lining has not been replaced, and of course is the more expensive option.

Jay kindly showed me how to maintain a silk hat. He sprays water on it, and thoroughly brushes it with a pig-bristle brush, working clockwise and top-to-sides in the direction of the threads. This restores the silk to its previous sheen, a stately glow that can only be obtained from the real thing.

'Our standard felt top hats run to £395', he tells me. 'Prices for our renovation and vintage products vary with condition, but cost around £2,000 on average. Even so, they remain quite popular.'

Silk plush and true silk hats fabricated before the 1960s have easily damaged linings, and fully original vintage hats with no replaced components are quite rare, raising their price to nearly £3,000.

'Even people of the same size have different head shapes. Europeans furthermore have oval heads, while Asian and African people have heads that are rounder. It's therefore important that top hat purchasers also use our conforming service, so that we can fit the hat to their head.'

Lock & Co. have two conformateurs, hat-shaping devices that they have been using for over 150 years. They measure customers' head size and shape to create a resulting pattern, which is retained for thirty years. The crown is heated until the shellac within becomes soft, then the hat is affixed to the device and formed into the desired head shape. Jay tells me that there are very few places that perform such a conforming process, a service only available at a well-established shop like Lock. (Visit their main store if you would like to see patterns created from famous heads like that of the Duke of Windsor.)

I cannot help but ask Baselgia if there is still demand for hats like this.

He proudly answers, 'Walking down the street you might get the impression that nobody wears hats any more, but that's not actually true. No outfit is complete without a hat, regardless of the times. You'll want a silk hat to wear to the Ascot races or a wedding, and a tweed flat cap for sports like shooting or fishing, and a dark suit and Coke hat for military or other ceremonies. There's also demand from Hollywood and the fashion

ジェイッシュ・M・バゲラ氏は今では希少なトップハットのスペシャリストだ。
Jayesh Vaghela is one of the few remaining top hat specialists.

18世紀の陸軍総司令官の軍帽は大英帝国の栄光を今に伝える。
The hat was belonged to the British Army Field Marshal in the 18th century.

本店に飾られたネルソン提督（右）の軍帽のレプリカ。ネルソン提督の注文台帳も残されている。
The hat once belonging to Admiral Nelson (right/replica). Admiral Nelson's name remains in the store's orders ledger.

要だ。さらにハリウッドやファッション業界からの需要もある。今は英国だけでなく、世界中からこの店に顧客がやってくるのだから」

　長年の経験と技術から生まれる最高級のクオリティー、あらゆるシーンに対応できる幅広い品揃え、最大65センチまでのサイズ展開があり、ここに来れば必ず自分の帽子が見つかる。さらに一生のメンテナンスもしてもらえる。これこそが長年の顧客からの絶対的な信頼につながっている。

「ロック＆コー」にあるのは340年を超える「メイド・イン・イングランド」のクラフツマンシップ、そして顧客へのロイヤリティーである。

industry. We have customers not only from the U.K., but around the world.'

　A visit to Lock & Co. is sure to result in finding the hat for you. They have a wide selection covering all your hat needs, at sizes up to 65cm, all produced with the quality and techniques born of their many years of experience. They will also provide lifetime servicing, another factor behind the absolute trust they have garnered from customers over 340 years of producing 'Made in England' craftsmanship.

*chapter four*
―――――――
*Luxury Service*

1765年まで遡る顧客の体重を記した台帳には詩人のバイロン卿の名もある。
Two and a half centuries of customer weights, including that of poet Lord Byron.

ベリー・ブラザーズ&ラッド
BERRY BROTHERS & RUDD
3 St.James's Street, London SW1A 1EG.
Tel +44 (0)20 7022 8973
www.bbr.com

# Berry Brothers
# BR
# &udd

ロンドンのセント・ジェームズ界隈には「英国最古」の老舗が建ち並び、独特の雰囲気を醸し出している。そのなかで一際目を引く堂々たる構え、英国最古のワイン＆スピリッツ商である「ベリー・ブラザーズ＆ラッド」は1698年に創業した。ボーン未亡人がコーヒーハウスを開いたのがその始まりだ。初のコーヒーハウス「パスカ・ロゼズ・ヘッド」がロンドンに開店したのが1652年。当時のロンドンでは紅茶に先んじてコーヒーが大流行していた。「ベリー・ブラザーズ＆ラッド」は、セント・ジェームズ界隈にコーヒーを卸し、これにより王室のワイン商として最初の礎を築く。当時は現在のワイン以上にコーヒーは贅沢な嗜好品だった。1765年に同店に設置されたコーヒー用の巨大な木製のスケールは、現在も同社のシンボルとなっていて、表の看板にもコーヒーミルが描かれている。

　300年を超える歳月は、現在の7代目当主サイモン・ベリー氏に至るまで、創業者一族であるベリー・ファミリーにより経営されてきた。1698年の開業以来、その輝かしいアドレスはセント・ジェームズ3番地。セント・

As home to the oldest stores in England, London's St. James's exudes a unique atmosphere. Among the shops there, one that is bound to attract your attention is Berry Bros. & Rudd, the oldest wine and spirits shop in the U.K. It started in 1698 as a grocery, founded by a woman known only as the Widow Bourne. Coffee was a highly prestigious commodity at the time (the first coffee house in London—Pasqua Rosee's 'The Turk's Head'—was established in 1652, so it seems that coffee was all the rage in London even before tea), so the store took a coffee mill as its symbol, and continues doing business under that mark today.

Three hundred years later, the store is still under management by the same families, represented today by seventh generation Chairman Simon Berry. It also continues to do business at its original address, 3 St. James's Street, across the street from the St. James's Palace and Prince Charles's residence, Clarence House. The store became wine suppliers to the Royal Family

7代目当主サイモン・ベリー氏は王室セラーの管理責任者〝クラーク・オブ・ロイヤル・セラーズ〟も務めている。
Seventh generation Chairman Simon Berry has been designated Clerk of the Royal Cellars.

ジェームズ宮殿とチャールズ皇太子の住むクラレンスハウスの向かいに位置する。

同社が王室に初めてワインを納めたのは1760年、ジョージ3世時代にまで遡る。1903年にはエドワード7世のワイン商として王室御用達を授与されている。

現在も同社のオリジナルとして販売されている生姜のリキュール「キングス・ジンジャー」は、王の名を名乗ることが許されたリキュールであり、特別にエドワード7世のために調合されたものだ。

この逸話が示すように英国王室と同社の縁は深く、現在はエリザベス女王とチャールズ皇太子、ふたつのロイヤルワラントを授与されている。加えて、会長であるサイモン・ベリー氏は、2008年に英国王室セラーの管理責任者である〝クラーク・オブ・ザ・ロイヤルセラーズ〟にも任命されている。

「この職務に任命されたのは非常な名誉です。シェフやワインライター等を含む5人の管理委員会メンバーと共に、ロイヤルセラーの管理運営を行っています。具体的には王室が開催する式典やレセプションに使用する

in 1760, under the reign of George III. In 1903 they received a Royal Warrant as wine merchants from Edward VII.

As such incidents suggest, the company has had a long relationship with the Royal Family, and today hold Royal Warrants from both Queen Elizabeth and Prince Charles. Since 2008, Simon Berry has furthermore been designated Clerk of the Royal Cellars, making him responsible for managing and supervising wine and spirits for the Royal Household.

'It's quite an honour to have received this appointment', Berry says. 'I manage the Royal Cellars along with five other committee members, which include a chef and a wine critic. We are specifically tasked with selecting and purchasing the wines to be served at official royal ceremonies and celebrations.'

He tells me that one might be surprised at the wines that are served at such events.

'We are not there to sell our own wines—it's

ワインを選定し、購入を決定します」
　意外にも、王室では特別に高価なワインを購入することはないという。
「私たちが要求されるのは我が社のワインだけでなく、選択にバラエティーとバランスを考慮すること、そして予算です。ロイヤルセラーは国費とは異なる女王のプライベートアカウントから供出され、常に適正価格での取引は必須です。ロイヤルワラントを維持することは簡単ではない。ワインの品質のみならず、サービスも含め、すべてにおいて完璧であることが要求されるからです」
　ベリー氏は1977年に入社、2005年に会長に就任。その間、同社は劇的な変革を遂げてきた。現在、扱うワインとスピリッツは4000種を超え、支店は香港、日本、シンガポールにある。基盤であるヨーロッパに加え、近年は拡大するマーケットとしてアジアにも大きな焦点を当てている。なかでもベリー氏が300年を超える歴史で最も画期的なプロジェクトだと語るシステムが、BBX（ベリー・ブローキング・エクスチェンジ）だ。
「我が社は1994年にウェブサイトを開設しました。これはグーグル社に先駆けてのことです。現在も世界最大のワインのオンラインウェブサイトですが、この強みを生かして開発したのがBBXです。顧客が購入したワインを保税状態で保管し、市場価格を参考に顧客自らがウェブサイト上で希望者に販売、希望者は手数料なしで購入できるシステムです。現在、顧客のワイン400万本を保税状態で保管し、毎月100万ポンドを超える売り上げがあります。アジアを中心に、今後もこのシステムは成長を続けるでしょう」
　英国最古のワイン商としてばかりでなく、現在はワイン投資のエキスパートとしても世界的に認知されている。この強みを最大限に生かし、アン・プリムールとセラープラン、通常とは異なるワイン販売と投資のシステムも積極的に行っている。このふたつの違いは株式投資と投資信託のようなものと考えればわかりやすい。
　アン・プリムールとは、瓶詰めで販売される以前にワインを購入するシステムを指す。ボルドーがメインだが、ブルゴーニュも行われている。ケース単位で購入し、通常は収穫から2〜3年後にワインは瓶詰めされ、購入者のもとに届けられる。
　支払い後、数年経ってから納品されるので、購入する時点ではどんなワインになるかという保証がない。一方で、事前に支払いをすることで作り手側には現金が入ることがメリットであり、購入者には瓶詰めよりリーズナブルに購入できることがメリットとなるシステムだ。

demanded that we provide variety and balance, but within budget. The Royal Cellar is stocked not with public funds, but from the Queen's own private accounts, so it is vital that we always make reasonable purchases. Retaining a Royal Warrant is no small task. We can't just focus on the quality of our wines; we must also seek perfection in everything, including service.'

Berry joined the company in 1977, and was elected Chairman in 2005. The interim has been a time of dramatic transformation for the company. Today they carry over four thousand varieties of wines and spirits. They have been focusing on Asia in recent rapid expansion beyond their base in Europe, and now have branch offices in Hong Kong, Japan, and Singapore. Berry describes their Berry's Broking Exchange (BBX) as the most innovative project the company has undertaken in its 300-year history.

'We created our first web site in 1994, so we even beat Google to the Internet. We're the largest online source for wines in the world, a strength that we've leveraged into developing the BBX. The system allows sellers to keep their products in a bonded warehouse and set prices according to current market value. Buyers can purchase those wines online with no added fees. We currently have four million bottles in our warehouse, and sales of over a million pounds per month.'

Berry Bros. & Rudd are not only the oldest wine merchant in U.K.; they are also now recognised worldwide as leading experts in wine investments. They are leveraging these strengths to create a system of wine investment allowing non-standard purchasing, such as 'En Primeur' and company-managed 'cellar plans', the wine equivalent of futures purchases and mutual funds. En Primeur refers to purchasing wines—mostly Bordeaux, but also some Burgundies—before they are released to the public. Purchases are by the case, and bottling and delivery normally occur two to three years following the vintage.

Since the purchase is made years before delivery, there is no guarantee regarding what kind of wine will be received. This is of benefit to both seller and buyer; however, as the former receives income from their product years earlier than they normally would, the latter could buy wines at far lower prices than if they

EXTRA CUVÉE DE RÉSERVE
CHAMPAGNE
Pol Roger

DUMMY BOTTLE

95B

1990 Ch. Montrose (MAG)
1995 Ch. L'Eglise-Clinet
1996 Ch. Ducru-Beaucaillou
1996 Ch. Montrose

1943 Ch. Cheval-Blanc
1945 Ch. Margaux
1945 Ch. Lafite-Rothschild
1952 Ch. Latour
1960 Ch. Mouton-Rothschild
1961 Ch. Batailley
1985 Ch. Le Pin (Mag)

Lanzan-Ségla

96B

同社には日本支店があり、アン・プリムールも扱われている。そのHPによれば、2005年ヴィンテージのシャトー・ラフィット・ロートシルトが、2006年6月に保税倉庫留置のアン・プリムールでは1ケース3760ポンドで発売された。このワインは2008年の夏には保税倉庫留置で1ケース1万ポンド弱の価格をつけたとある。

　つまりアン・プリムールのワイン購入システムは、投資として思わぬ高値がつく可能性を秘めている。どんなワインになるかという不確定要素を補うのはワイン商の経験と顧客との信頼関係だ。しかも商品が手元にない前提での前払いであるから、ワイン商と顧客、さらにワインの作り手であるシャトーやドメーヌ、双方の間に信頼関係がないと成立しないシステムといえる。

　アン・プリムールがワインの知識も充分にある上級者向けだとすれば、セラープランは一般のワイン愛好家にも参加が容易なシステムだ。1ヵ月250ポンドまたは500ポンドを積み立てると、同社のエキスパートが投資するワインの銘柄やタイミングなどをアドバイス、オーダーメイドのセラーを作ることができる。既に英国では20

purchase them after bottling.

Berry Bros. & Rudd have opened a branch office in Japan, which also conducts En Primeur sales. En Primeur purchases hold great potential as an investment. Making up for the uncertainty regarding the quality of the final wine is a relationship of trust between merchant and buyer. Since everything is prepaid, the system also relies on trust in the châteaux and domaine producing the wine.

The Cellar Plan is more approachable for casual wine enthusiasts. For monthly payments of £250 or £500 per month, an expert advisor will provide advice regarding labels and timing, allowing you to develop a personally customized cellar. They already have over twenty years experience offering this service in the U.K.

In ways such as this, the company's 300 years of history are not simply applied to regaling past accomplishments. As befitting their location in London, home to some of the wealthiest individuals in the

年以上の実績があるという。

　このように、同社の300年を超える歴史が語るのは過去からの遺産だけではない。ロンドンでは世界最高の富裕層の存在を背景に、最先端の投資であるワインにも英国王室御用達の老舗が君臨している。

　最後に、英国最古の王室のワイン商としての歴史と共に、同社が飛躍的な躍進を遂げることができた理由は何か、ベリー氏に訊いてみた。

「私が入社した当時は、ここは非常に保守的な会社で、たとえば、ガレージに入ったヴィンテージの美しいロールスロイスのようなものでした。高い価値があるが、誰にでも運転できるものではなかった。世界中、これは普遍的な事実ですが、歴史ある企業が生き残るためには変革が必要です。我々は変わらなければならない。王室に対してばかりでなく、個々の顧客に対して、品質、サービスも含め、最上級である必要がある。最終的にいつも私の念頭にあるのは、ひとりの顧客として、そこからワインを買いたいと思うかどうか。すべてはそこに集約されています」

world, Royal Warrant holders Berry Bros. & Rudd reign supreme over the cutting edge of wine investment.

Before leaving, I asked Berry why the company is so successful in making such amazing advances.

'When I first joined the company, it was an extremely conservative place. Something like a vintage Rolls Royce that never left the garage—a very precious thing, but not something available for the enjoyment of all. The survival of an organization with some history behind it requires the occasional revolution, and I believe that's true throughout the world. We need to remain the best in terms of both quality and service, not just for the Royal Family but all of our customers. In the end, what I'm always asking myself is, "If I were a customer, would I want to buy wine from this shop?" That's all there really is to it.'

*chapter four*
---
*Luxury Service*

# Floris

フローリス

89 Jermyn Street, London SW1Y 6JH
TEL +44 (0) 20 7747 3612
www.florislondon.com

FLORIS  89

顧客ひとりひとりのリクエストに合わせて作られ、そのすべてに異なる独特の嗜好がある。それはひとつとして同じではない。ここにビスポークの真髄があるのだとすれば、体臭によって千差万別に変化するフレグランスほど、ビスポークの美学に叶ったものはないだろう。

一年も経てば店が入れ替わっていることも珍しくない、変遷の激しいジャーミンストリートで、シャツの「ターンブル＆アッサー」とともに、大英帝国が築いた優雅な時代のメンズスタイルの象徴が、英国最古の香水商「フローリス」である。

エントランスの89番地を示すモザイクタイル、ヴィクトリアンの面影を残すフットスクレイパー、建物そのものが政府の重要指定文化財であるこの店の随所に、その時代のエッセンスを見つけることができる。

店の中央に鎮座するのは、1851年の万国博覧会で購入されたスパニッシュ・マホガニーのショーケース。重厚な輝きが美しいケースの中には、300年近い歴史を物語るハンドメイドの鼈甲（べっこう）の櫛（くし）、シェービングブラシなどが陳列されている。一歩店に入ると、現代とは違う時間がこの店には流れているのを誰もが感じるに違いない。

創業者のジュアン・ファメニアス・フローリスは、当時英国領であったスペインのメノルカ島より英国へ渡り、1730年にロンドンのジャーミンストリート89番地に理髪店を開いた。1870年にメアリー・アン・フローリスがジェームス・R・D・ボーディナムと結婚。これにより、現在の9代目エドワード・ボーディナム氏に至るまで、「フローリス」は創業者一族であるボーディナム家によって経営されている。

創業当初は理髪店として故郷メノルカ島原産の鼈甲から作られた櫛、ブラシ、シェービング用品を販売。櫛製造と同時に、当時は希少であった植物由来の精油やエッセンスをヨーロッパから輸入し、顧客のリクエストに応じてオリジナルのフレグランスを調合、販売した。このフレグランスは当時流行の発信地であったセント・ジェームズで大きな評判を呼び、これが香水商として輝ける歴史の始まりとなった。当時の顧客にはジョー・ボー・ブランメルやオスカー・ワイルドもいたとされている。

英国王室との縁も深く、初のロイヤルワラントは1820年の国王ジョージ4世のものであり、以来、約200年にわたり継続してロイヤルワラントを保持している。現在のロイヤルワラントはエリザベス2世とプリンス・オブ・ウェールズ（チャールズ皇太子）から授与されたものだ。

Amidst the constant churn on Jermyn Street, where it is not uncommon for stores to appear and be replaced within a year, the perfumery Floris stands alongside shirt-maker Turnbull & Asser as symbols of the era of elegant fashion that developed within the British Empire. Their perfumes are created one-by-one by request of the individual customer with each a unique expression of taste. The effect of a perfume will vary according to who wears it, so such individualised creation is the very essence of the bespoke aesthetic.

The mosaic tile and boot scraper at the entrance are remnants of the Victorian era, and the building itself is registered as a national preservation site. Entering the shop is like stepping into another age, and you will find remnants of the past throughout.

Presiding in the middle of the shop is a Spanish mahogany showcase purchased at the 1851 Great Exhibition. Within that stately gleaming case you can find handmade shaving brushes, tortoiseshell combs, and other items from Floris's nearly three hundred years of history.

Founder Juan Famenias Floris moved to England from the Spanish island of Minorca, a British possession at the time, and in 1730 opened a barber at 89 Jermyn Street. In 1870, then-owner Mary Ann Floris married R.D. Bodenham. The shop has been run by the family since, and is currently represented by ninth-generation Edward Bodenham.

As a barber, the store originally sold tortoiseshell combs, brushes, and shaving supplies crafted in Juan's birthplace. They also imported rare essential oils and essences from Europe, from which they started making original fragrances from customer requests. St. James's was a centre of fashion at the time, and their history began just by the word of mouth of their perfumes. Past customers have included the likes of Beau Brummell and Oscar Wilde.

They have maintained a long relationship with the Royal Family, receiving their first Royal Warrant from George IV in 1820. They have maintained Royal Warrants over the nearly two centuries since, currently with warrants from Elizabeth II and Prince Charles. For the 2013 Diamond Jubilee in celebration of the sixtieth year of Elizabeth's reign, the company released

2013年にはエリザベス2世の即位60周年を祝うダイアモンド・ジュビリーを記念し、〝ロイヤル・アームス・ダイヤモンド・エディション〞が発表された。これは1926年のエリザベス女王の誕生を祝うために、フローリスで作られたフレグランス〝ロイヤル・アームス〞のオリジナルの調合をもとに、現代のエッセンスを加え、復刻させたものだ。イングランドの国花であるローズをベースとしたフレグランスは、「フローリス」の倉庫から1914年の新聞紙に包まれた状態で発見されたアンティークのクリスタル・ボトルに詰められ、バッキンガム宮殿で2013年7月に開催されたコロネーション・フェスティバルで披露された。

現在は他の香水商同様に「フローリス」でも既製品が販売されているが、創業者ジュアン・ファメニアス・フローリスの時代から、顧客ごとに異なるオリジナルの調合が革の台帳に記録、保管されていた。このビスポークの伝統は変わることなく、現代でも続けられている。〝ビスポーク・パフューム・デザイン〞は、専属の調香師との最低3回のコンサルテーション、納期約6ヵ月を経て、4500ポンドでオリジナルのフレグランスを作ることができるサービスを行っている。

「このコンサルテーションが行われる空間は『ミュージアム』と呼ばれています。第二次世界大戦時、ドイツ空軍によるロンドン大空襲からこの部屋が免れたのは実に幸運でした」とボーディナム氏は語る。

本店奥に位置するミュージアムには、その名の通り、1863年のクリミア戦争後のナイチンゲールよりの礼状、アンティークのクリスタルのフラコンやボトルなど、同社の歴史を彩ったアーカイブが並んでいる。

ここで圧巻なのは1940ページにも及ぶという顧客台帳だ。中には写真家セシル・ビートンや英国首相ウィンストン・チャーチルの名もある。スーツは「ヘンリー・プール」、シャツは「ターンブル&アッサー」、フレグランスは「フローリス」と、チャーチルの贔屓の店は当時の英国の上流階級が好んだスタイルの縮図でもある。注文記録によれば、チャーチルが好んだフレグランスは1890年にロシアのオルロフ公爵のために調合された〝スペシャル No.127〞。ベースはシトラス・フローラル、アクセントにベルガモットとオレンジが使用されたフレグランスであり、その名は顧客台帳の127ページにあったことに由来する。

1950年代になると、ヨーロッパからアメリカへと「フローリス」はマーケットを拡大し、多くのハリウッド俳優にも愛された。

its 'Royal Arms Diamond Edition' perfume. This is a reproduction based on the original 'Royal Arms' blend, developed in 1926 in commemoration of Elizabeth's birth, to which Floris added some updated essences. It is a rose-based scent—the rose being the national flower of England—and was presented in July 2013 at the Coronation Festival at Buckingham Palace in an antique crystal bottle found in a Floris warehouse, wrapped in a newspaper dated 1914.

Like other perfumeries, Floris also sells premade scents. However, preserved records show that they have been making original blends for individual customers since Juan's days, and this bespoke tradition continues even today. Bespoke perfume design involves at least three consultations with an assigned perfumer. Delivery will require around six months, and the cost is £4,500.

'We call the room where we conduct our consultations the Museum', Bodenham tells me. 'We are so fortunate that it was spared during the Blitz.'

As its name implies, the Museum—a room deep in the interior of the store—stores various artefacts of the history of Floris, including a thank-you letter from Florence Nightingale dated 1863, following her famous involvement in the Crimean War in 1853, and antique crystal flagons and bottles.

Most spectacular is their client ledger, which now extends to 1,940 pages. Within, you will find names such as Cecil Beaton and Winston Churchill. Churchill bought his suits at Henry Poole, his shirts at Turnbull & Asser, and his fragrances at Floris—his favoured shops present a fashion map for the upper crust of British society in his time. Purchase records show that Churchill's preferred fragrance was 'Special No. 127', a blend developed in 1890 for Russia's Grand Duke Orloff. It has a citrus and floral base, with accents including bergamot and orange. Its name comes from the page in the 'Specials' formula book in which the recipe was recorded.

In the 1950s, Floris expanded its market across the Atlantic to the United States, where its fame spread to many Hollywood actors.

Ian Fleming, author of the James Bond series of spy novels, was a fan of fragrance 'No. 89'. The Floris

Floris フローリス 211

『007』の原作者イアン・フレミングはフレグランス「No. 89」を愛用し、1958年に出版した『ドクター・ノー (Dr.No)』にも同社の名が登場する。当時、人気絶頂であったこのスパイ小説によって「フローリス」の名を知った読者も多かったことだろう。この件に感謝して7代目当主マイケル・ボーディナム氏から送られたイアン・フレミングへの礼状も同社には残されている。

1989年にイングランド南西部デヴォンに自社工場を設立するまでは、このジャーミンストリート89番地でフレグランスは製造されていた。ボーディナム氏の記憶に鮮明に残っているのは、本店の地下でフレグランスが調合、製造され、梱包が行われている情景だ。1950年代に撮影された画像では、本店地下でハンドメイドでフレグランスを調合している、祖父マイケル・ボーディナム氏の姿がある。

この89番地に由来し、フローリスを代表するのが〝No. 89″だ。まず爽やかなシトラスのクールさ、加えてオレンジ、ベルガモット、ラヴェンダー、ネロリがアクセントとなって香り、最後にムスクやシダーウッドの温かみのあ

name even appears in Dr. No, published in 1958, likely spreading its notoriety among fans of the genre. The store has on display a copy of a thank-you letter from seventh-generation operator Michael Bodenham to Ian Fleming in appreciation for the mention.

Until the company's Devon workshop was built in 1989, all fragrances were prepared at the store on 89 Jermyn Street. A photograph taken in the 1950s vividly depicts his grandfather Michael Bodenham blending, preparing, and packaging fragrances in the store's basement.

Named after the store's street address, Floris's 'No. 89' adds to the refreshing cool of citrus hints of orange, bergamot, lavender, and neroli, topped off by the warmth of musk and cedar. Our modern-day fragrances are said to have their origin in the eau de colognes developed in the eighteenth century. 'No. 89' successfully blends the potentially clashing characters of a light, classic cologne with the gravitas of wood.

る香りに変化する。ファーストノートで訪れるのは、現在のフレグランスの起源ともなった18世紀に生まれたケルンの水、オー・デ・コロンである。クラシックなコロンの清涼さとウッドの重厚さ、ふたつの相反するキャラクターを〝No.89〟は合わせ持っている。

男の装いの中で最も繊細であり、かつ感覚と記憶に訴える〝香りというスタイル〟。それは一滴のフレグランスに結実し、今も多くの男たちの幻想をかき立てている。

How one smells is one of the subtlest aspects of a man's fashion, yet which is the most influential of constructing a man's desired style. A 'fashion of fragrance' is brought together by a single drop of fragrance; an important consideration in any man's attire.

*chapter four*
*Luxury Service*

# Truefitt
# T
# &H
# ill

TT & HILL

020 7493 2961

トゥルフィット＆ヒル
71 St James's Street
London SW1A 1PH
Tel +44 (0)20 7493 8496
www.truefittandhill.co.uk

「王の理髪店」としての矜持を守るマスターバーバー、デニス・ホーンズビー氏。
Dennis Hornsby, proud barber to royalty.

　身だしなみが紳士を創るという。ロンドンのセント・ジェームズに店を構える理髪店「トゥルフィット＆ヒル」。世界のジェントルメンの身だしなみの規範はここから生まれてきた。

　その創業は1805年にまで溯り、世界最古の理髪店としてギネスブックにも登録されている。その年はネルソン提督がトラファルガー海戦で勝利し、国王ジョージ3世と共にウィリアム・ピットが首相として摂政に当たっていた。このリージェンシーの時代に、国王の鬘（かつら）によってトゥルフィットは一躍名を挙げ、そこから現代まで続く男性専用のグルーミング技術へと発達させていった。

　創業者ウィリアム・トゥルフィットが授与されたジョージ3世からの王室御用達が始まりとなり、「王室の理容師」として継続した歴史を持つ。現在はエジンバラ公によるロイヤルワラントを保持している。

　200年以上もの歴史を誇る顧客名簿には、英国王室ばかりでなく、ロシアのニコライ皇帝など各国の王室関係者、さらにイギリス首相ウィリアム・グラッドストーンやウィンストン・チャーチル、ウェリントン公爵にモント

　It is grooming that makes the man, and Truefitt & Hill, legendary barbers in London's St. James's, that sets the world standard for men's grooming.

　Established in 1805, the store is listed in the Guinness Book of World Records as the world's oldest barbershop. Founded during the regency of King George III and under Prime Minister William Pitt the Younger, in the year in which Admiral Nelson won the Battle of Trafalgar, Truefitt launched to fame as a wigmaker for the King. They have continued developing techniques for men's grooming ever since.

　They have maintained Royal Warrants since being awarded one from George III to the founder William Truefitt, and have been known as the barbers for the men of the Royal Family. They currently hold a Royal Warrant from Prince Philip, the Duke of Edinburgh.

　Spanning two centuries, their client books also contain many illustrious names from outside the Royal Family, including Tsar Nicholas II of Russia, Prime

Truefitt & Hill　トゥルフィット&ヒル

ゴメリー将軍など著名な政治家、軍人らの名も並ぶ。チャールズ・ディッケンズ、オスカー・ワイルド、ウィリアム・M・サッカレーといった英国を代表する作家の小説にも「トゥルフィット＆ヒル」の名は登場している。ハリウッドにもファンは多く、アルフレッド・ヒッチコック、ローレンス・オリヴィエ、フレッド・アステア、ケイリー・グラントなど、サヴィル・ロウのスーツ、その周辺のビスポーク・シューズとシャツと共に、英国紳士とそれを目指す人々にとってこの店のグルーミングは必要不可欠のものであったようだ。

サービスの項目の中に、無料の靴磨きサービスがあるのも、「靴はつねに磨かれているべき」といった紳士の要求に応えてきた伝統を物語っている。

1935年にトゥルフィットが「エドウィン S. ヒル＆Co.」を獲得したことにより、現在の「トゥルフィット＆ヒル」が誕生した。老舗の名に相応しく、最高級の天然アナグマの毛を使用したシェービング・ブラシ類や、200年近く変わらぬ調合で作られるグルーミング用品はすべてが「メイド・イン・ブリテン」。そのクオリティーには定評

Ministers William Gladstone and Winston Churchill, and famous military and political figures such as the Duke of Wellington and Field Marshal the Viscount Montgomery of Alamain. The store has been mentioned in the books of famed British authors like Charles Dickens, Oscar Wilde, and William Thackeray. They have also been patronized by Hollywood personalities such as Alfred Hitchcock, and Cary Grant etc. Indeed, it seems that for any British gentleman (or those hoping to emulate one), no trip to Savile Row to procure a bespoke suit would be complete without stopping in at Truefitt & Hill for grooming.

In 1935 Truefitt acquired Edwin S. Hill & Co., giving them their current name. As befitting a shop of such stature, their natural badger-haired shaving brushes and grooming accessories, many of which have remained nearly unchanged for over two centuries, all sport a 'Made in Britain' label. These renowned high-quality products can also be purchased online, or at

がある。これらの製品はオンラインのほか、インドやシンガポール、アメリカなど世界各国の直営店でも販売されている。

ロイヤルファミリーをはじめとして、歴代の顧客の肖像が飾られた店内は、正統派理髪店の趣きを湛える。セント・ジェームズという場所柄、付近にあるザ・リッツやザ・ドーチェスターなどのホテル、ジェントルメンズクラブから紹介の顧客も多く、現在の顧客は世界各国からと国籍もバラエティーに富んでいるそうだ。

王室御用達の証しとして、エジンバラ公からのロイヤルワラントの認定証も理容室の中央に飾られていた。約800を超えるワラント認定企業の中で、エジンバラ公によるものはわずかに20に過ぎないが、「トゥルフィット＆ヒル」はそのうちのひとつである。

この道50年の経験を誇るのがマスター・バーバーのデニス・ホーンズビー氏だ。「トゥルフィット＆ヒル」で働いていたエジンバラ公の担当者が引退したことにより、この名誉ある役職を受け継いだ。

「最初の頃はエジンバラ公を担当するのは緊張したが、エジンバラ公は良ければいい、悪ければ悪いと率直に言う方だ。今ではジョークを言われたり、お会いするときに特に緊張することは何もないよ」と笑う。

2011年にはエジンバラ公の90歳を祝う公式祝賀行事が開催された。ホーンズビー氏と妻がその会に招待されたのも、生涯で忘れられない思い出だと語る。

「難しい顧客はいるか？」と質問してみる。「難しい客はいないね。もし1回来て、ここが嫌だと思ったら、二度とうちには来ないだろう？」と真顔で言うジョークがイギリス人気質を思わせる。

ホーンズビー氏愛用の道具のうち、切れ味の鋭さが自慢の鋏は意外にも日本製。バーバーチェアも日本製とのことだ。バリカンは「昔は必需品だったが、使える者は少なくなったね」。200年の歴史を誇る理容室にも時代の変遷の波が訪れている。

だが、時代を経ても変わらないものがここにはある。それは創業以来の「トゥルフィット＆ヒル」の哲学である最上のサービスであり、ホーンズビー氏を含む4名の理髪師たちの経験と技術が築きあげた顧客との信頼関係に違いない。

「良いバーバーになるには顧客と会話すること、カットやシェービングを楽しむことだ」

何よりも、そう語る実直なホーンズビー氏の笑顔がその事実を物語っていた。

their franchises in locations throughout the world, including India, Singapore, and the United States.

The shop interior honours the flavour of an old-world barbershop, and is decorated with portraits of generations of famous patrons. Many customers are brought to the store through introductions from St. James's neighbourhood hotels like the Ritz and the Dorchester, as well as local gentlemen's clubs. Their current customer base represents nationalities that span the globe.

Master Barber Dennis Hornsby has plied his trade for over fifty years. He gained his current prestigious position upon the retirement of the previous barber assigned to the Duke of Edinburgh.

'I was quite nervous the first time I cut Prince Philip's hair, but he's a straightforward customer who doesn't hesitate to say what he likes and what he doesn't. Nowadays we can joke around, so there's no more of that initial nervousness.'

In 2011 there was an official celebration of Prince Philip's ninetieth birthday. Hornsby and his wife were both invited to the event, which Hornsby says he will never forget.

I asked him if he ever has difficult customers, to which he replies in a typically wry British fashion.

'Not really. I suppose anyone who visits us and doesn't like the services won't come back, so I wouldn't hear their complaints.'

He tells me, 'Clippers used to be considered a requisite item, but today there's only a few who can use them properly'. Clearly, even a barbershop with over two centuries of history cannot escape the winds of change.

Even so, there are aspects to their craft that will never change. Most important of all is Truefitt & Hill's philosophy of always providing the highest levels of service, and the extensive experience and technique that provides the basis for the trust relationship built between customers and its four barbers.

As Hornsby puts it, 'Becoming a good barber requires conversing with the customer, and enjoying cutting and shaving'.

More than anything, the honesty behind Hornsby's smile is a testament to that fact.

These are to Certify that by direction of

## His Royal Highness
## The Prince Philip, Duke of Edinburgh

I have appointed

---
TRUEFITT & HILL
---

into the place and quality of

---
HAIRDRESSERS
---

to His Royal Highness
To hold the said place until this Royal Warrant shall be withdrawn or otherwise revoked.

This Warrant is granted to

---
A.G. HOLGATE ESQUIRE
---

trading under the title stated above, and empowers the holder to display His Royal Highness' Arms in connection with the Business but does not carry the right to make use of the Arms as a flag or trade mark.

The Warrant is strictly personal to the Holder and will become void and must be returned to the Treasurer to His Royal Highness in any of the circumstances specified when it is granted.

Given under my hand and Seal this ___First___ day of ___January___ 19 __98__

## 主要参考文献一覧（Bibliography）

Amies, Hardy. *The Englishman's Suit.* London: Quarter Books, 1994.
Howarth, Stephen. *Henry Poole, Founders of Savile Row: The Making of a Legend.* Bene Factum Publishing, 2003.
Persson, Helen. *Shoes Pleasure & Pain.* V&A Publishing, 2014.
Sherwood, James. *The London Cut: Savile Row Bespoke Tailoring.* Fondazione Pitti Discovery, 2007.
Sherwood, James. *Bespoke: The Men's Style of Savile Row.* Rizzoli International Publications, Inc., 2010.
Singer, Barry. *Churchill Style.* Abrams Image, 2012.
Stanfill, Sonnet. *Italian Style: Fashion Since 1945.* V&A Publishing, 2014.
Storey, Nicholas. *History of Men's Fashion.* Pen & Sword Books Ltd., 2008.
Walker, Richard. *The Savile Row Story: An illustrated history.* Multimedia Books Ltd., 1988.
Windsor, Edward. *A Family Album.* Cassell & Company, 1960.
C.W. ミルズ『パワーエリート』東京大学出版会 1969年
キャリー・ブラックマン『メンズウェア100年史』Pヴァイン・ブックス 2012年
J・アンダーソン・ブラック『ファッションの歴史 上』Parco出版 1985年
J・アンダーソン・ブラック、マッジ・ガーランド『ファッションの歴史 下』Parco出版 1988年
出口保夫、小林章夫、斎藤貴子『21世紀イギリス文化を知る辞典』東京書籍 2009年
長澤均『流行服』ワールドフォトプレス 2013年
深井晃子『世界服飾史』美術出版社 1998年
渡邊研司『ロンドン 都市と建築の歴史』河出書房新社 2009年

## 初出一覧（First Appearances）
本書は下記に掲載された記事に追加取材、加筆修正をしたものです。

Men's Precious（小学館）Winter 2014
Men's EX（世界文化社）February 2015
The Rake Japan（ザ・レイク・ジャパン）March 2015
The Rake Japan（ザ・レイク・ジャパン）May 2015
The Rake Japan（ザ・レイク・ジャパン）July 2015
GQ JAPAN（コンデナスト・ジャパン）June 2015
GQ JAPAN（コンデナスト・ジャパン）August 2015
GQ JAPAN（コンデナスト・ジャパン）November 2015
The Rake Japan（ザ・レイク・ジャパン）January 2016

## 撮影協力（Cooperation）
chapter two ジョン・ロブ（John Lobb）オールドハット（Tokyo）03-3498-2956
http://oldhat-jpn.com/

プロフィール

著者：長谷川喜美　はせがわ よしみ

ジャーナリスト。イギリスを中心にヨーロッパの魅力を文化の視点から紹介。メンズファッションに関する記事を雑誌中心とする媒体に執筆。著書に『サヴィル・ロウ』『ハリスツイードとアランセーター』（万来舎）など。

**Author: Yoshimi Hasegawa**

A freelance journalist who covers the cultural appeal of Europe, particularly Britain. Recent publications include *Savile Row, Harris Tweed and Aran Sweater* (Banraisha Ltd.).

撮影：Edward Lakeman　エドワード・レイクマン

フォトグラファー。ビスポーク・シューズ、ミリタリー・テーラリングに造詣が深く、アフガニスタン、北米、ヨーロッパなどを取材対象に、雑誌掲載記事やドキュメンタリー作品の分野で活躍中。著書に『サヴィル・ロウ』（万来舎）がある。

**Photographer: Edward Lakeman**

Lakeman is a freelance editorial photographer, who is deeply versed in the worlds of bespoke shoes and military tailoring. His photographs of Afghanistan, North America and Europe have appeared in magazine articles, and his documentary works include *Savile Row* (Banraisha Ltd.).

## BESPOKE STYLE ビスポーク・スタイル
### A Glimpse into the World of British Craftsmanship

2016年4月21日　初版第1刷発行

著　者：長谷川喜美
撮　影：Edward Lakeman
発行者：藤本敏雄
発行所：有限会社万来舎
　　　　〒102-0072
　　　　東京都千代田区飯田橋2-1-4 九段セントラルビル803
　　　　電話　03(5212)4455
　　　　E-Mail letters@banraisha.co.jp

装幀・本文デザイン／引田 大 (H.D.O.)
翻訳／Tony Gonzalez（株式会社オフィス宮崎）
印刷所：株式会社東京印書館
© HASEGAWA Yoshimi, Edward Lakeman 2016 Printed in Japan

落丁・乱丁本がございましたら、お手数ですが小社宛にお送りください。
送料小社負担にてお取り替えいたします。

本書の全部または一部を無断複写（コピー）することは、
著作権法上の例外を除き、禁じられています。

ISBN978-4-908493-03-4